Bottom Dog Press
Working Lives Series

WRITING WORK

WRITERS ON

WORKING-CLASS WRITING

Edited by
David Shevin
Janet Zandy
Larry Smith

Bottom Dog Press
Working Lives Series
Huron, Ohio

Cover art an adaptation
of a drawing by J. A. Cooney
Cover Photos:
Top left: © Charles Cassady, Jr.
Top right: "Two Garage Mechanics. Southeastern Pennsylvania, 1993"
©Martin J. Descht from exhibit *Faces from an American Dream*
Bottom left: © Malinda Sommers "Ohio Pig Farm"
Bottom right: © Charles Cassady, Jr.

Book Layout and Design
Larry Smith

Copy Editing Assistant
Anna Smith

Acknowledgements:
We thank the following for permission to reprint materials:
Scott Russell Sanders for "Writing from the Center" © Scott
Russell Sanders, first appeared in *The Georgia Review*; collected in
author's *Writing from the Center* (Indiana University Press, 1995)
and Will Percy and *Double-Take Magazine* Spring 1998 for
"Will Percy Interviews Bruce Springsteen: Rock and Read."

We acknowledge the continued support of
The Ohio Arts Council in sponsoring work
that raises our literacy with our humanity.

Ohio Arts Council
A STATE AGENCY
THAT SUPPORTS PUBLIC
PROGRAMS IN THE ARTS

Writing Work — Table of Contents

"In the twenty years I bore and reared my children, usually had to work on a paid job as well, the simplest circumstances for creation did not exist. Nevertheless writing, the hope of it, was 'the air I breathed, so long as I shall breathe at all.' In that hope, there was conscious storing, snatched reading, beginnings of writing, and always 'the secret rootlets of reconnaissance.'"
 -Tillie Olsen, *Silences*

WRITING WORK: AN INTRODUCTION

This is a book about perspectives, in many ways challenging stereotypical views of working class culture and art with the authentic accounts of those who live and work there. In focusing on working class culture our goal is not to create class conflict nor to raise class consciousness beyond a level of understanding that might free us from views that restrict our collective humanity. Jesse Jackson asserts rightly that we in America talk about class even less than we do race. We are not giving in to that. for here is good and thoughtful talk about class in America.

The essays assembled here are the "work" of a few for the many. These are writers who use their writing as a witness to experience and as a connection to others–before and to come. The conflict between what is said and what we know, what we hear about our culture and what we experience creates a tension that many seek to remedy through expression. We have found the prime motivator of most working-class writing is a drive to bridge this perceptual gap with the truth.

We asked the writers here to do three things: to relate their own experience of a working class culture, to describe their own process of coming to write, and finally to tell of the impact of other working class writers and writings. They were asked to help make that bridge with and for our readers. Taking our cue from the authentic directness of feminist criticism, we seek to lay the foundation for a working-class criticism here. As editors we were moved by the way these writers and writings present what is best in our human way of building knowledge. These are "connected knowers," those who learned not to doubt their experience but to trust it, to read it in a context that is richly complex, to trust subjective knowing but to also link it to objective fact and to truth.

While all of the essays assembled here contain aspects of these three elements, we saw a clear grouping by emphasis into primarily memoir or analysis. We have so divided them. All of the writers use narrative to explain and reveal what matters. Each writer speaks his or her life sincerely, answering Henry David Thoreau's primary requirement of any writer for a "simple and sincere account" of his or her life.

In the memoir section we begin with family and neighborhood backgrounds in two diverse accounts by Joe Mackall and Heidi Shayla. Wayne Rapp then takes us deep into the world of labor in his description of working the mines. Thomas Rain Crowe follows his youthful accounts of work-

ing near home to the 1970's San Francisco and his apprenticeships with writers Jack Hirschfield, Jack Micheline, and Gary Snyder. In "Failing," Paul Christensen tells his family story of facing poverty in America. Jean Trounstine takes us with her into the women's prison camp at Framingham to reveal the way writing still matters in people's lives. Curt Johnson draws class conclusions in his tough contrast of working and privileged classes. Finally Arthur L. Clements connects family roots with his own apprentice-ship with poet Randall Jarrell and his own work as a writer and teacher. Not surprisingly teaching is a common element among these working-class writers who still work their way home by repaying others with words and understanding.

We begin the analysis section with a revealing interview between Southern writer Will Percy and singer and songwriter Bruce Springsteen. The "Boss" proves himself to be a worker and rebel at heart in his deep concern for others and his understanding of writing. Eddy Pendarvis re-veals how her life and work has been enlightened by reading–from fantasy to comic books to the vital world of poet Lucille Clifton. In "Thirteen Ways of Looking at a Working-Class Background," Karen Kovacik connects her past with the motives and methods of writing by other contemporary women writers. Helen Ruggieri creates a bright and revealing story of her writing relationship to that of Ernest Hemingway and other heavy shadows of American literature. In "Writing from the Center" Scott Russell Sanders ties his work and life to the relevance of place–our roots in time and place helping us to find our ground as writers. Bob Fox then bridges the work of early leftist writer Michael Gold and his classic novel *Jews Without Money* with that of Frank McCourt's recent *Angela's Ashes*.

Finally our three editors Zandy, Shevin, and Smith supply personal accounts and cultural analyses of the elements of culture, race, and work-ing-class films and their impact on the identity of the working-class life. Our wish here is to do good work and lay some groundwork for those bridges that connect us. We do so by adding good talk, telling stories, and revealing insights from our world so as to make us one neighborhood.

Larry Smith, Firelands College, January 1999

GETTING THERE

PRIMARILY MEMOIR

JOE

MACKALL

In 1990, Joe Mackall earned a master's degree in English with a creative writing emphasis. He also has an MFA from Bowling Green State University, and a Ph.D. in English from Indiana University of Pennsylvania. After working as the editor of *Cleveland Magazine*, Mackall became an assistant professor of English and journalism at Ashland University. He has published articles and essays in a number of magazines and newspapers, including *The Washington Post, Cleveland Magazine* and *The Cleveland Plain Dealer*. He lives with his three children, and his wife, children's author Dandi Mackall, in rural Ohio.

I grew up in a suburb of Cleveland, where I swear I did not see the sun fully until the age of nine. With the sun's light first needing to push through the thick clouds of a nearby factory, my vision evolved. My father, a homicide cop who feared a factory life for his oldest son, insisted I attend college, and to get that message across, he forced me to accompany him to jail, often.

Fearing jail and its necessary atrocities, I graduated from Cleveland State University in 1982 with a degree in English. After graduating, I lived in Georgia, Virginia, Kentucky and Maryland, where I wrote for various publications and worked at an assortment of jobs: bricklayer, construction laborer, saute chef, landscaper, reporter. In 1985, I moved to Washington, D.C. and spent the next two years working for *The Washington Post*, writing feature articles, reviews and hard news. Part of my stint at the *Post* was spent as the night police reporter, where I was responsible for covering—though not committing—all crime from Baltimore, Maryland to Richmond, Virginia.

Writing with the belief that, as Scott Russell Sanders says, "...memory and hope are kindred powers, binding together the scraps of time," I am currently working on a collection of creative nonfiction titled, "The Private Wars of a Dying Storyteller."

The Stories of the Working-Class Lights

Joe Mackall

We walked along the banks of the creek we called a river, Mole River. Rick and I knew what we had to do. We'd planned the hunt all summer, and the back to school signs accosted us everywhere we turned. With our new bows strung over our shoulders and arrows tucked in the loops of our jeans, my best friend and I stalked the fields surrounding our blue-collar street, fields shrinking with the arrival of department stores and industrial parkways, fields vanishing as quickly as our childhood summers.

Without success we'd shot at sea gulls that haunted an abandoned drive-in and missed pigeons that polluted the streets. We had the ammunition; we had the urge. Something had to die.

Rick and I reached Mole River by ten in the morning, a trip we thought would take us until at least noon. For our base camp we picked a willow tree whose wispy branches stretched limply over the water, shadowy skinny fingers reaching out to Mole River. We placed our bagged lunches against the willow's trunk in innocent imitation of our fathers' working-class routines. We, after all, had a job to do. I remember thinking that our sandwiches and cans of pop would stay cool and fresh if hidden in the willow's shade.

I don't recall how many moles died that day, although I do know that I killed only one. I stepped on its tail. The mole jerked back and forth, frantic to escape, its body reduced to a futile pendulum of flesh. I fired. Missed! Fired again. Missed! Thought about the possibility of accidentally running an arrow through my foot. Again, I pulled back the bow and released the arrow. This time a kill. I lifted the mole impaled on the tip of my arrow the way kids roast hot dogs over a campfire.

What else happened that day, I honestly don't know. I'd like to say that Rick and I ate our lunches in silence in the shade of the willow while we considered life and death or the gratuitous violence of our morning. But I can't. I can't because I don't remember. The rest of the day has fallen into the river of time and decomposed. What's left are Rick, a couple of weapons, a willow tree, a living mole, a dead mole, two characters, a story.

For that's what we were that day: characters. And by the time I went mole hunting for the first time, I understood in a way I couldn't yet articulate that the people in my working-class neighborhood would teach me more about storytelling than anyone outside of a book ever could. The storytellers and the characters of my formative years were men who pushed steel in the Chevy plant, the women who packed their lunches—some of whom also pushed steel at Chevy—and the kids who called the steel pushers parents.

It was about the time of the mole hunt that I saw the green light for the first time as it shone in the darkness from a place I could only imagine, a place I suspected but didn't really want to identify.

Although I didn't know it then, the "writers" of my childhood, the men and women who inspired me to dream of becoming a writer, held a pen only to endorse a check or sign a child's report card. It seemed that no matter where I went as a child, stories were as common as the people who told them.

All of my cousins—particularly, male cousins—measured themselves, as I did, against the story of my grandfather leaving kith and kin and sailing from Italy to the United States as a twelve-year-old. A twelve-year-old alone and dreaming. I wished I would have asked my grandfather what he saw in the green light held by the green lady of Staten Island.

This same grandfather, Cosimo Leo Gervasi, drove a milk truck for years. I grew up hearing stories about how he would let poor families drink milk now and pay for it later. Not only did this story establish my grandfather as a caring and generous man in my young mind, it also revealed a world where people like our family, people without much money, had to stick together or we wouldn't make it.

On one memorable morning, my grandfather dragged one of his three boys out of bed before dawn to help him on the milk truck. Because in warm weather Cosimo drove his truck with the side doors open and because one of my uncles was still half asleep, a sharp turn hurtled him out of the truck and onto the street. All the grandchildren laughed at this story, as did my aunts. My uncles did not. To them it was another story of a too-hard father, a man who pushed his sons ruthlessly and showed them his love not at all.

Shortly before my grandfather would have been eligible for a pension, his milk company "let him go." After years of service, pre-dawn rides and listening to the working-class music of milk bottles rattling metal cages,

Cosimo Leo Gervasi was on his own. The moral of this story, according to every member of my extended family, was that "big business" did not care about the little guy. A long line of liberal Democrats emerged.

I believe members of my extended family told these stories because they had to. And I needed to hear them, just as I now need to tell them. I pass them on as I have passed on my DNA. I do not want the line to end. There's too much to lose. I do not want my grandfather forgotten. I do not want the compassionate milkman and the poor family to fall into the silence. I want to remember the morning a son flew out the side of a milk truck. I want to see the red brake lights shining suddenly in the still-cool darkness of early morning. An angry son picking specks of gravel out of his palm. I need to know I came from these stories, these people.

I know this: sometimes telling the blue-collar stories of generations feels like a kind of loving. Stories are the headlines of the working people. As Leslie Marmom Silko writes, "Stories aren't just entertainment. Don't be fooled. They are all we have, you see, all we have to fight off illness and death. You don't have anything, if you don't have the stories."

My grandmother's house acted as a kind of storytelling central, our family's collective campfire. Stories told in her house seemed to be told in one of two places, either around the dining room table or seated at the kitchen table, and each table seemed to produce a different kind of story.

At the spotless, metal kitchen table, my grandmother sat at the head. She would begin by bringing her visitors up to date on all members of the family who were not at the table. I listened to tales of a child's ballet lesson, a toddler's first steps, a cousin's new job. Soon there were stories about an uncle's divorce, a lost job, a teenager in trouble. Because my grandmother had over twenty grandchildren when she died, the stories increased in number as the family increased in size. Soon great-grandchildren became characters in her family stories. Despite all of her storytelling, my grandmother's only writing took place at five in the morning hunched over a rickety wooden desk, where she wrote hundreds of Christmas cards.

Surprisingly, girlfriends, boyfriends, and then even husbands and wives not originally part of the family, heard this family folklore not as stories, but rather as banal and boring esoteric gossip. But I knew better. When I heard stories about an elder male cousin earning a 4.0 G.P.A. at a private Jesuit high school, I immediately began measuring myself and my accomplishments against his. This was no mere esoteric gossip; this was a burgeoning family myth. I feared becoming a minor character in a family saga.

My namesake, Uncle Joe, spent his storytelling time at the table weaving tales of the past; he was one of my favorite storytellers. He knew enough about the art of storytelling to tell me tales about my youth, which were important not only because of their subject but also because of the teller's perspective.

"Jumping Joe," he'd say, rubbing his chin pendulum-like across his chest in a nervous gesture or a performer's routine. "You were always jumping up and down in your crib and your PLAYPEN. One day you jumped right OUT." On the final word of every sentence (depending on the story) his voice would seem to leap loudly out of his mouth in a kind of oral high jump.

Uncle Joe also told other tales, but these he told mostly from the dining room table, a huge, old oak table behind which hung a table-size painting of the Last Supper, a painting that inspired greed in the years ahead. He told one story about his time as a soldier in World War Two. Somewhere in Europe (I cannot believe I never asked where; I was always too anxious to get to the small story's huge climax.), Uncle Joe came upon the body of a dead German soldier. My uncle found a letter in the soldier's uniform pocket. Somebody in my uncle's platoon could read German and read the letter to the other troops. According to my uncle, the dead soldier had written a letter home to his wife and kids, telling them he loved them, telling them how much he longed to be home, telling them that sometimes he didn't know what all the fighting was about.

He took the letter and had it mailed to the dead man's family.

When we were at the dining room table, it usually meant the entire family had gathered for a festival of some kind. My grandfather's birthday. My grandparent's anniversary. Around the dining room table, the stories always put the family in a larger context. Here I listened to stories of the old neighborhood. When I heard stories about the people from the old neighborhood, people who existed only as characters for me, I began sizing up my own friends and their value as characters in future stories told to as yet unborn children sitting around as yet unbuilt tables. (Even while the mole twitched beneath my boot, I imagined myself preparing to tell that story.) We listened to literal war stories. We heard stories about earlier times in difficult marriages. We heard about the time my uncle Jim ran away from Cleveland at the age of fifteen, and how my grandfather tracked him down in a pool hall in New York City. I have often wondered if this was my uncle's naive and bungled teenaged attempt to live up to his father's story of emigration and independence.

On the last family reunion I remember (aside from funerals) my cousins and I reintroduced alcohol to our gatherings. Alcohol appeared to leave our family parties after one year when several of my uncles vomited in the back yard and one of them tried to hide the detritus of their debauchery by covering it with a blanket. It was at least a decade after the beginning of this family-agreed upon prohibition that drinking resurfaced. It seemed like we needed it then. Too much had gone down: an uncle's murder, my grandfather's death, my mother's death, a cousin's fatal car accident, divorces. That night it all seemed to be forgotten. Nearly thirty of us sat around the table, laughing and joking, until somebody successfully coaxed my grandmother into singing "The White Cliffs of Dover," as Christmas week snow fell past the dining room window. The room fell into the sounds of my grandmother's frail and wounded voice singing a song of war and hope. Soon her juiced up family joined her, believing, I imagine, that she was singing our song.

Recently I visited the street on which I lived from the time I was four until I graduated from college, one field over from where I killed a mole. As I drove I half expected to see the "old neighborhood" just as I had left it. But what I was probably feeling was a common nostalgia to relive my childhood, to play football until I feared frostbite, to "call" for Mick, Jeff, Rick, and see if we couldn't get a game going, to visit the homes of the men who worked the line at the Chevy plant, to once again see the boy who wanted to write the stories he was always being told.

I grew up in a world filled with Catholics, a parish of working men and mothering women. There were parish picnics, parties, baseball teams, and Friday fish dinners. Nuns were virgins clad in black habits, and priests were collared mini-gods. What amazes me now is how large these families were. Parents with ten or twelve children were forced to clothe their kids in hand-me-down jeans and sweatshirts as they lived from paycheck to paycheck with a ban on birth control and a demand for Catholic school tuition.

Some of these parents—along with thousands of other working-class parents—watched as their sons were sent to Vietnam. Several houses down from the house where I grew up lived a family whose son, Hank, was in Nam. Hank's younger brother, Mike, joined us for football and baseball games, but he never talked about his brother or the war, nor do I remember any of us asking Mike about him, or it. Mike played sports as if he were fighting a war. Tackling him in football hurt the tackler far more than the

tacklee. He ran with his knees high and arms flying. He felt hard and looked hard. His black hair hung in greasy strands on his face, looking like a wet, ripped stocking. His face was prepared for anything, constantly on alert. His sharp nose could pass for a weapon. Unlike the rest of the neighborhood guys, he never invited us into his house. Hank's mother kept a star in the window. Her son came home.

Late one summer night we crept into the armory at the head of our neighborhood and spent the night in the back of an army truck. Only three of us survived the night without having to leave in fear; those who retreated were no doubt taunted with invectives, aspersions on their manhood. Most of the night the survivors told stories about waking up in Vietnam ready to fight, kill, die. I slept like a baby. I acted like a fraud. I knew where I stood on the thought of going to war. The Vietnam War moved with its own unending momentum. My father, a Korean War veteran, assured me he would personally drive me to the Canadian border if I were drafted. I loved him for this, and yet I did not completely understand his willingness to make a draft dodger out of his oldest son. Now I have a son. Now I understand.

Nearing the end of what was once my street with the Chevy plant looming ahead of me just in front of the setting sun, I almost thought I heard a whistle, my father's whistle, a familial frequency heard across the back lawns and in the benign woods of my neighborhood, a whistle meant for nobody but me, yet understood by neighbors as a beacon of my boyhood. When I'd hear the whistle, I'd bid goodbye to afternoon friends, sprint through the yards and over the lawns of the Smiths, Fays and Murphys; and then, panting, I'd enter the linoleum light and warm smells of a just-dusk kitchen, where a mother now dead and a man who sang by blowing air through his lips would be waiting for me with love as certain as sound.

And yet, despite the fond memories of good friends and love-certain whistles, I grew up feeling the sense of something lost, as if as a member of another generation of working-class kids I would be on the silent side of the secret people like me would never know. Living in the shadow of Cleveland fed this feeling. Being the country's punch line did not sit well with the ethnic pride of Clevelanders. Ironically, when there was the worst pollution of air and water, there were also the most jobs. Cleveland's Rust Belt economy and mentality held up its people and encouraged their dreams of sending their kids to college. Despite the jokes, Clevelanders had work. And then Japan made a better car and Cleveland suffered and lost.

And the loss surrounding me and as palpable as sweat in nearly all the stories told by steel pushers, and grandparents whose dream for their

grandchildren involved little more than "a job with benefits," also fed me as a fledgling writer. Living with pain and loss—by this I mean, of course, living at all—demanded that stories be told by people as common as a couple of kids killing a mole.

So years later when I read the stories of Raymond Carver and Richard Ford, Bobbie Ann Mason and Jayne Anne Phillips, I recognized the characters in their stories, and I'd already heard stories just as full of meaning.

In my freshman year of college and not long before my mother died of cancer, I walked onto our front porch having just finished reading "The Great Gatsby," written by, perhaps, the most un-working-class writer alive or dead, with the possible exception of Henry James. But Fitzgerald knew this about working-class Americans: he knew we were capable of dreaming the stories of our lives.

And when I walked onto the porch that night more than twenty years ago, I dreamed of seeing not Gatsby's but my own green light, the green light that shone for a twelve-year-old boy immigrating to America, the light a friend and I saw emanating from the Chevy plant after a small kill, the light I saw in the eyes of the blue-collar storytellers of my youth. The green light that told the blue-collar story: Go.

HEIDI

SHAYLA

Heidi Shayla was born in Florence, Oregon and raised in the logging community of Deadwood, Oregon—population 400. She has lived in Madison, Wisconsin for five years. Besides working as a choker setter and chaser, she has been a farm hand, a bookkeeper, and has worked all sorts of retail jobs. She attended Lane Community College in Eugene, Oregon for two years, then graduated from the University of Oregon with a degree in history. She is currently working on her MFA in creative writing at Vermont College. Her work has been published in *Back Home Magazine* and *Denali Literary Journal*. She is completing a novel about a Pentecostal family living in the mountains of the Pacific Northwest.

My grandfather said that stories were the way we held onto each other, like a rope that keeps us from getting separated, and so I think of myself more as a rope maker than a writer. With such a definition of myself, everything becomes an exercise in twisting the strands together tightly, so that my life and my people do not begin to unravel.

A teacher once told me to "write my soul," which was just a poetic way of saying "write what you know." Everything I know comes out of growing up in the Coast Range of Oregon. My view of the world is clouded by images of those green mountains and the men and women who scale them day in and day out. My father was a logger and my mother has the heart of an artist; I am the uneasy place between them. Papa taught me to steer a D7 Cat and set chokers when I was eleven. Mama taught me to see the way the evening light falls on the river and to notice the way cattle loom out of the early morning fog. It is no wonder, really, that I became a writer – if only because the mix of my life takes some explaining.

I have three children, all of whom write stories, and a wonderful husband who does not, but who tells them very well.

Working Poor
Heidi Shala

My eight year old daughter came home from school recently with a poem she'd written about herself. It said she was as fast as a horse, as agile as a monkey, as soft as a butterfly. It also said she wrote like her mama. I wonder a lot about that final sentence. I wonder because I doubt its truth. My writing is limited. Hers is not. When I write, I find myself constantly exploring and re-exploring where I come from, as if I am simultaneously trying to explain and understand my experience. I seem to perpetually write in the circle of my childhood, which is to say that I am trying to negotiate having grown up in the hard cupped palm of the rural working poor. Perhaps this need to sort it out on paper is a symptom in itself of my ongoing belief that life is tenuous at best, that everything I have achieved can be swept away like so much dust. So hanging on tightly to life becomes important and leaving some tangible evidence of my process is the only way to not get lost in the anonymity of my class, where one workday blurs into the next. It is a lesson I learned at the knee of my father.

Papa always told me to prepare for the worst. Being Irish and a logger, he'd had enough of both to know what he was talking about. Optimism, in his mind, was shortsighted and gentleness and literacy were qualities you fought to create a space for, not a right you could expect. Papa read a lot; it is what he did every evening to relax after twelve-hour days as a catskinner and timber faller. His taste in books ran toward genre westerns, especially Zane Grey whose characters were noble, intelligent, and could break your jaw or shoot you dead as necessary to protect their families and their homes. In some ways, what Papa read was only an extension of what he lived, further evidence that life was and will always be a battle

My own writing has come to mirror this as well; it has grown partly from the fact that I have rarely read anything that gave honest voice to the people I know and the way we have lived. Men have certainly written about it, but I have come to believe that it has always been the women who have gone all the way to the hard rock of it, who have unflinchingly exposed on paper what it is like to be solidly mired in the working poor. Dorothy Allison comes to mind with *Bastard Out of Carolina* and Carolyn Chute with *The Beans of Egypt, Maine.*

But before them was Betty Smith and her novel *A Tree Grows in Brooklyn.* When I read this book, as a teenager, I cried at the shock and relief of seeing characters that I could recognize from my own life—hard working and hard loving and deeply flawed characters who struggled to feed themselves and held hope for the future by putting coins in a tin can. As important as that was, the fact that Smith's characters also read—read books for the love of it in the moments between the work—was what overwhelmed me with some kind of enormous grateful appreciation. *A Tree Grows in Brooklyn* stood up against the stereotypes of the working poor; it announced–for me anyway–that we were neither too stupid nor complacent to free ourselves. And with that understanding, I began to find other women who wrote the truth of it all.

I came upon Rebecca Harding Davis in a used bookstore. She wrote before the turn of the century, back in the hard years of the Civil War, and she wrote in secret so that no one could stop her writing. Her stories were about Cornish miners, or about women artists who were stymied by Nineteenth Century convention, and about children raised in the black industrial smoke of steel towns. They were about people in struggle, about folks who were striving to survive in body and heart.

I read Rebecca Harding Davis' *Life in the Iron Mills* when I was working a retail job, trying to feed my three children and keep my old car together on a combination of minimum wage, food stamps, and duck tape. The book came to me at just the right time, when I needed most to believe in the touches of art and writing I could give myself late at night, after the work was done and the children were asleep. *Life in the Iron Mills* is the story of a steel mill furnace tender who, "under all the vileness and coarseness of his life, [had] a groping passion for whatever was beautiful and pure..." (Harding Davis 22-23). He was a man who left little behind at the end to show of his having been alive at all, only a handful of people he'd worked with and a rough carving of a mill-woman he'd cut from korl. It occurred to me that that was as appropriate a legacy as any a working man could ask for—to be remembered well by the people you worked beside and something tangible to show you had a soul as well.

It made me think about what my own family had left behind. I have two cast iron skillets and a spatula from my grandmother. My grandpa left some woodworking tools and a jar of pennies he'd been saving. There are still some enormous dark pieces of furniture my great grandfather built out of scrap wood and a ukulele my mother's mother played as a teenager. One

quilt. Some yellowed photographs of weddings and babies. A family Bible. Grandma's old black purse with a couple of paperclips inside. It is not much to divvy up between all the living members of our family. And what there is of it was divided by practical means, just as it was used.

I am the good cook in the family, like my grandma, so I got her pans and the spatula. Seeing them brings up old memories of her sweating over the stove in the evenings and on weekends, with her hair plastered against her forehead and wet spots of sweat growing out of the armpits of her dress and from between her breasts. It makes me remember my grandpa coming in from plowing and how he wiped the rivulets of sweat from my grandma's neck and then how he bent to kiss her there. And how the plowing drove up a dust that wafted over the clothesline and earned my grandfather a cussing from Grandma as she took down the laundry and went to wash it again. And how later she would walk across the tilled rows to him, to apologize for cussing him when he was just doing the work that needed to be done. This is the legacy left to me. Skillets, spatulas, memories of the work they accomplished, and of the loving in between.

There is a way that literature wants to romanticize this life. There is a way that I also want to. I want to remember the times that Grandpa kissed Grandma's sweaty neck and squeezed her hip in his big hand. But every time I am with my father and he rolls up his sleeves, I see the scars he got falling timber with a crosscut saw, when it snapped back and cut through his arm to the bone. Then I am reminded again that the moments of softness were few and far between, that mostly those situations where we all had sweat running down our faces were not romantic at all, just hard and unpleasant, except for the fact that we were together. I am not interested in books that pretend there is some finer glory to working so hard your body becomes a victim to your efforts.

* * *

Not long after my grandparents died, Papa took me to our cousin's farm to butcher a steer. My cousin stood out in the field, in the middle of the herd of grazing cattle, and picked out one of the fat yearling calves. He shot it with a rifle as long as my leg and it fell with a look of shock and bewilderment in its eyes. It was the first time I had looked hard into a dying face since I held my grandmother's hand as she convulsed with the spasms of a heart attack. I had held Grandma to keep her from swallowing her tongue or her false teeth. My logic in holding her was twofold; I thought she might

want the comfort and I didn't want her to choke on her own body parts. Not that it did any good; she died anyway and she looked like the steer when she did it, shocked and bewildered. I think I must have looked the same.

But by the time my cousin shot the steer down in the pasture, I was prepared for it. I cut that calf open like it was a ripe watermelon splitting open in the sun, revealing its contents and pouring its red red juices onto the green wet grass. You watch enough death, it'll do that to you–make you ready for anything. And since death comes with the territory when you come from a logging family, we all walk around ready for anything, prepared more for death sometimes, I think, than for living.

* * *

My grandma had her heart attack while cooking her breakfast in one of the cast iron skillets and with the same spatula that I use now in my kitchen. She managed to turn off the burner and make her way to her bedroom to lie down before it really took her. When the ambulance came to rush her to the hospital, I stood in her kitchen on her stool because I was only seven and not tall enough to reach the sink. I threw her egg into the trash and washed her pan and spatula because I knew that Grandma would not have liked to leave a dirty kitchen. It was the least – and the most – that I could do.

* * *

And all of this is why I wonder about literature and the working poor. It is why I searched most of my life for authors who could look at our experience and not flinch from it. It is why I have again and again turned to the women writers, who can hold the rock of it in their hand and find the softness within the hard, down in the cracks and fissures of the stone. It is down there that our story really lives. It is there that I grew up and it is that place that informs all of who I am and, in particular, that piece of me that is a writer. I wonder about that as hard as I wonder about my daughter's poem or Papa's pile of Zane Gray westerns.

A friend once pointed out that every piece of fiction I have ever had published had something to do with death. The truth of that took me by surprise because I had not noticed, in the same way you do not usually notice you are breathing. I think if something is so natural and a part of you that you do it without conscious thought, you can not be held completely accountable for your actions. That is my only excuse.

My daughter does not write like me, if only because she does not feel compelled to make excuses for what her characters say, or how they act, or that they are both poor and smart, or the fact that someone will, inevitably, die too young. But she only just today told me the title to her newest story— "The Land Where Souls Were Kept in Trees"—and I recognized a thread of myself there. That place that I come from, where people are loggers and their souls are in the mountains and the trees as much as in their bodies, is inside her as well. It makes me wonder what kind of legacy I am passing on, along with the cast-iron skillets and the spatula.

WAYNE

RAPP

Wayne Rapp was born in Bisbee, Arizona to a copper-mining family. After graduating from the University of Arizona as an English major, he began a career in California working as a film/video writer-director in the aerospace industry. He also began working as a freelancer for some of the Hollywood-based production companies. After moving to Ohio, he continued corporare writing in the fields of automotive, electronics, utilities and automation. In 1988, Rapp left corporate employment and began working as a full-time freelancer. His career has taken him from a mining town in Arizona to 13 foreign countries and two U.S. Territories. He also writes a great deal for the print media, and his real love is fiction. His stories have been published in *The Americas Review, Thema, Grit, and Fall Creek Press*. His fiction has been honored by a grant in Creative Writing by The Ohio Arts Council.

I was losing my working-class role models. That's the main reason I wrote the essay for this collection. My mother died in February of 1998, and my father, who has been hospitalized a number of times since then, is in hospice. By the time this book is published, he, too, will be dead. I wrote the essay to let people know that what my parents taught me by their example stuck. I will continue, as best I can, to follow their legacy.

The summer job working in the mines that I wrote about helped me in my effort to go to college and realize my ambition to be a writer. Football helped more. The athletic scholarship I had at the University of Arizona opened a new world to me. I was introduced to many great writers by good teachers, and I was able to take the giant steps needed to start sharing some of my writing in classes without fearing rejection. College helped further my desire to be a writer and gave me many of the tools I needed. My payment was a couple of lost teeth, broken bones, and scars on my knees. Too big a price? I don't think so. Not when I think about the return.

It all started at home. Kay and Charlie, this one's for you.

Lessons from Underground

Wayne Rapp

I try to look nonchalant as I follow the miners to the lamp stand, grab a battery with an attached lamp, and hang the metal pin with my ID number on a peg. This is an important step, the first lesson I learn. Leaving my ID pin when I take a lamp lets the authorities know that I am underground. That knowledge could be critical in case of a cave-in or other major accident where rescuers must determine who is missing and where they were assigned.

It is 6:15 in the morning, and about twenty-five of us stand around under the huge gallows frame. There is little conversation among the men. I hook the battery on my belt and place the lamp in the clip on the front of my miner's hat. As I look around at the men, I am self conscious about how clean my clothes are. Everyone else is dressed in grimy copper-stained garb. My new miner's hat sparkles among the battered, nondescript ones of the veterans. All of the men wear heavy shirts, and some wear jackets. Although it is an Arizona summer morning, and the temperature will be in the nineties on top, many spots underground will be cold.

Suddenly, the wheel in the gallows begins turning, breaking the faint early morning murmur. Cable whistles through the huge steel pulley until the shaft opening is filled with the middle deck of the three-deck cage which will carry me underground to my summer job in the copper mines. The toplander opens the gate in front of the shaft and lifts the safety bar. Men move silently onto the cage.

"Where you workin'?" the toplander asks me.

"Main pump station."

"Don't get on this deck. You get on the bottom one."

The toplander finishes stacking men onto the middle deck, drops the safety bar, and grabs a short rope attached to the side of the shaft. He pulls a rhythmic code that tells the hoisting engineer what to do next. The middle deck rises and is replaced by the bottom deck. The toplander motions to me, and I join several others on the cage. He pulls the signal cord again, and we drop. My stomach jumps, but we quickly stop, and I realize we are only two deck-lengths underground. Now the top deck is being

loaded. Those workers like me who are going to the higher elevations are put on the bottom deck of the cage.

This is my second lesson of the yet early morning. The bottom landing of this network of mines is at water level, and the hoisting engineer has only small marks on the cable to judge the position of each deck. If he misses the mark, or the cable is stretched a bit, his inability to accurately spot the bottom deck could trap the occupants underwater. This precaution gives him about an eight-foot leeway in hitting his mark. When the cage is 3200 feet underground, that doesn't seem like a lot.

Without warning, the cage just drops. My breath is taken away. There is nothing to hold onto. I open my feet a bit for balance and avoid looking at the older men, certain that they will be getting a kick out of my uneasiness. The cage rides loosely in the shaft, vibrating as we descend, and every few seconds a quick shaft of light breaks over the safety bar in front of me. These are the landing lights at 100-foot levels. We pick up speed, and the lights flash by faster and faster. 1300 ... 1400 ... 1500 feet below the surface And then we are slowing down, and the 2200 feet landing comes up in front of me. One of the miners lifts the safety bar, and we hop off the bobbing platform. He replaces the bar and yanks a code on the rope, and the cage drops away. The miner looks at me and points down a tunnel to a light in the distance. "Main pump station's down that drift," he tells me. "You'll go better if you turn your lamp on," he adds and walks away.

Sheepishly, I reach up and switch on my lamp. I move cautiously by myself toward the light, trying to avoid tripping over the railroad track and ties along the floor of the drift. By the time I get fifty yards from the landing, moving toward an ever-increasing torrent of noise, I realize how truly dark it is without my small illumination.

The main pump station is an oasis in the huge, dark pit. It is very well lighted and filled with gleaming machinery, gauges, and dials. The noise from the large piston-driven water pumps is unceasing and deafening. I find the pumpman right away. He is an older man, big-bellied and mean. He has a decided limp and looks like he is in pain walking. I hand him my papers, which he quickly puts aside without checking. He mutters something about college kids who don't want to get their hands dirty and walks away from me.

I follow him, and he almost knocks me down as he turns quickly and starts to retrace his steps. When he pushes by me again, I holler, "What do you want me to do?"

He stops and limps back to me. "I want you to work. What do *you* want to do?"

I put as much conviction into my 18-year old voice as I can muster. "I came here to work. I need this summer job, and I thought I could learn something,"

He cocks his head and gives me a queer look as if that possibility had never occurred to him. He crooks a finger at me, and I follow him inside a makeshift structure that cuts down the noise considerably. He has retrieved my papers on the way, and now he studies them. When he turns to me, he has a smile on his face. "Why didn't you tell me you were one of Charlie Rapp's boys? Hell, your daddy and me mined together years ago at the Campbell. Then he went to caging at the Dallas, where I was timbering. Now your daddy, *he's* a worker. Everybody likes to work with Charlie. He always does his share ... plus some. Charlie Rapp's boy, huh?"

That was my third lesson of the day, and one that has always stayed with me. For a young man starting a summer job in the mines, if you were from a family that had a reputation for hard work, that meant something to the men you were expected to work with. Too often, the miners had to deal with managers who were trying to find something to fill their kids or their friends' kids summer hours until they returned to school. They resented it. But I was different. I was from a working family, and in Bisbee, Arizona, a mining town, that meant a lot. No matter how inexperienced I was at that moment, I was one of them. I squared my shoulders and looked the pumpman in the eye. I wanted him to see how proud I was to be Charlie Rapp's son.

I spent the following weeks determined not to let my father down by tarnishing his hard-working reputation. I worked by myself mostly, shuttling among the different levels of the mines where secondary pumps pushed the copper water to the main station. I made repairs, took chemical readings, kept logs, and added hundred pound bags of lime to neutralize the acidity of the copper water. Our group's function was a 24-hour-a-day, seven-day-a-week job. We had to keep the pumps operating, or the mines would flood. That meant I often worked on weekends and was completely alone for an entire shift. I worked in areas where the humidity was so high it was difficult to breathe, and water dripped constantly from the roof. I worked next to fire doors that were too hot to touch. The temperature varied considerably in the mines, and walking between stations, I was frequently cold. My clothing was always wet.

Besides earning a much-needed and appreciated paycheck every other Friday, the difficult demands of a summer job in the mines that first

year—and the ones to follow—brought me in touch with my laboring heritage. I am the product of several generations of German and Mexican miners on my father's side and English farmers and miners from Kentucky on my mother's. My mother's father left part of his foot underground when they pulled him from a cave-in. Severe hernias from heavy lifting drove my father's father from the mines before he could retire.

Despite these injuries, the family continued to mine into the next generation. Why?

During the Depression and prior to being exposed to new vistas during World War II, people like my father felt they had few other choices. A person was lucky to be working, they felt. Let alone worrying about how hard the work was and what dangers might be present. Men and women worked because they believed they were brought into this world to be self sufficient through work. To them, work of any kind was noble.

My father and mother were certainly of that belief. My father went into the mines when he was eighteen and didn't leave for forty-seven years. My mother was a homemaker, a stay-at-home-mother when we four children were younger, but when we were in high school, she went to work in the hospital kitchen. A series of cutbacks, strikes, and layoffs had put the family in a situation where an extra paycheck was needed to get by. She worked a split shift. That meant she went in early in the morning to work breakfast and stayed through lunch. She came home for several hours in the afternoon to do her housework and prepare her family's dinner; then, she returned to the hospital and worked from dinner preparations through dishes. She did this six days a week. To complicate this schedule, my mother couldn't drive and had to depend on a bus system to get to and from her job. I still don't know how she did it, but she often said she was glad to have the work. We needed the money. As I learned to be proud of my father's work ethic and history, I was equally proud of my mother's. I was Kathryn Rapp's son as well as Charlie's.

Because being hired to work was a contract to my parents, both of them went to work every day regardless of how tired or sick they might be. But they also found it quite difficult to maintain a family on laboring skills alone. They wanted a better opportunity for their children, so they pushed education as the means, even though they knew that they couldn't offer much in the way of financial assistance. There wasn't an educational institution closer than a hundred miles from our southern Arizona home, so they couldn't even provide room and board. Being big and tough, my twin brother

and I found the one route to education that was available to those mine and mill kids who had the physical ability along with the grades: football. When we were offered football scholarships to the University of Arizona, we were the first ones in the Rapp family to go to college. And with the scholarships, part-time jobs at school and in the summer—like the job I had in the mines—we were able to stay in school and get our degrees.

Even before the underground revelation that one should take pride in being the product of the working-class, I had been drawn in my reading to stories which glorified the working person. John Steinbeck was then, and is still, a favorite. Katherine Anne Porter's stories captivated me. In one, María Concepción's hard work earns the money to get married inside the church instead of behind it, which was less expensive and more common. In "He," a hard-working farm couple struggles to support a retarded son. In another of her stories, Granny Weatherall, at the point of her death, looks back over her life and remembers digging the post holes to fence in a hundred acres. She declares that doing something like that changed a woman. And just as probably a man, I guessed. Stories like these prepared me to appreciate Studs Terkel's book of interviews about the glory of work later in life.

When I discovered Frank Norris and his book, *The Octopus*, I got caught up in the story of the California wheat farmers trying to resist the power-hungry railroad that threatened their livelihood. It was the same story I knew from my experiences and knowledge of labor relations in Bisbee—just different players. I grew up in a town where mine owners captured strikers by gunpoint one early morning, loaded twelve hundred of them in railroad boxcars—packed in so tightly they couldn't sit—and *deported* them to New Mexico because they had the audacity to go out on strike. I knew about owners wanting their way regardless of the cost in human misery.

But it wasn't just the conflict of owners and workers that drew me to these writers. It was the writers' ability to ennoble the working people in their stories. A perfect example can be found in a favorite novel of mine: *How Green Was My Valley*. In this story dealing with the hardships of mining in Wales, Iestyn Evans, the son of the owner of the mines, wants to court Angharad, the daughter of one of the mine workers. Perhaps thinking that a man of his position didn't have to adhere to protocol, he approaches and speaks directly to the girl outside of Sunday School. He is immediately decked by one of her brothers. When the brothers return home, Mr. Evans is there with his son threatening court action. After questioning his sons, Angharad's father finds out that the young man had spoken to his daughter

without his permission and says to the mine owner that had the action occurred in his presence, the boy would have received worse. In effect, he asserts his rights as a father and does not cower under the power and position of the mine owner. Mr. Evans is forced to admit that the father is within his rights to take such a stance.

The movie deals with the subject in a nonviolent way but with the same results. Donald Crisp, a wonderful old actor, plays Angharad's father. He is soaking his feet and reading the paper on a Sunday morning when Mr. Evans arrives at his door unexpectedly. It is an awkward moment for the improperly dressed employee to face his wealthy and powerful employer. However, as soon as Donald Crisp discovers that Mr. Evans is there seeking permission for his son to call on Angharad, his demeanor changes. He puffs himself up and becomes the proud father, master of the family's home, fully exercising his right to give or withhold permission to any man who would court his daughter. Bare legs and all, the old miner is ennobled.

Think of the Joads in *The Grapes of Wrath* continuing to struggle against almost insurmountable obstacles to find another crop to pick, to feed their family another meal, to survive for just one more day. To me, the most powerful and moving act in all of modern literature occurs at the end of that book. The scene is not repeated in the movie, and I can understand why it wasn't. To have a character (Rose of Sharon) who has just given birth to a stillborn baby offer her milk-swollen breasts to save a man from dying of starvation is the most ennobling act I can imagine. As written, the act was not sensual; it was not sexual. It comes as close to portraying what I think God's work on earth should be as anything I've ever read.

The movie, even without that scene, had a similar strong appeal. For me, Jane Darwell was the quintessential mother. She was big, hardworking, loved her children unconditionally and had a full, soft bosom where you could lay your head. Just like my mother. I remember being in the operating room one time ready to receive anesthesia. I'd had several surgeries, and was generally pretty calm. For some reason, this time I was very apprehensive. While I lay there, a Jane Darwell-like nurse came to me and took my hand. She patted it and said, "It's OK. Just relax. We're going to be on the other side of this before you know it."

I held her hand tightly and almost said, "Because we keep acomin'. We're the people that live. They can't wipe us out; they can't lick us. We'll go on forever, 'cause we're the people." I remembered so well Ma Joad's speech to Pa Joad at the end of the movie. Under the soft gaze and reassuring nod of my mama-nurse, I closed my eyes and went to sleep.

My degree in Liberal Arts with a major in English let me escape the mines. But through my desire to know my fellow human beings well enough to write about them, I have also kept connected to my working-class background. I married a teacher, a full-blooded Italian whose parents were also working-class. People who were accustomed to going to work every day regardless of the circumstances. She was from an eastern mill-worker family; I was the product of southern farmers and western miners. We ended up in the Midwest where we've raised our four children. We've worked hard to keep our two sons and two daughters connected to their heritage in the mill and mining towns of their grandparents. We made it important for them to visit their grandparents often while they were alive, and we prompted the elders to tell their stories, so that our children could understand the rewards of hard work even under difficult conditions.

My laboring background and the influence of my wife and our hard-working families has been the fuel for my fiction. I write about ethnic people (Mexicans and Italians) who try to keep a sense of their roots even when transplanted to areas of the country where they have no cultural anchor. I write about the land and what it means for families to be part of it. I write about a laboring class who struggles for its just due from bosses who recognize people simply as resources and not as individuals. I write about parents who try to impart some sense of what is important in this life to their children. That's what it means to me to be a working-class writer.

I learned three lessons that first day I went down into the mines. Two of them I haven't needed since I left the mines and began reflection on this piece. No one ever had to come looking for me underground, and I never even got my feet wet from being on the wrong deck of the cage at the bottom level of the mines.

But when I learned that being the product of a hard-working family was a point of pride, I took something away from the mines that has been a part of me ever since. It has influenced everything I've done. It helped me choose a mate and to have values and a philosophy of life to offer her and to share with my children. When I was employed in corporations, it helped me continue to give what I promised to my employers (a full day's work for a full day's pay), even when they were not keeping the promises they made to me. And now that I'm a freelancer, my working-class background helps me deliver on my word, to meet deadlines, to put in extra work when the project calls for it, whether it's in the budget or not. The way I live my life and write my fiction will continue to reflect the most important lesson I learned 2200 feet underground.

photo by
Mark
Olencki

THOMAS
RAINE
CROWE

Thomas Rain Crowe was born in 1949 in Chicago, and grew up in the rural southeastern US. He has lived in France as an expatriot, worked on farms in the Midwest as a hired hand, swung 15 lb. hammers laying track for the PB&NE R.R. in Pennsylvania, and in 1974 moved to California where he was a vital figure in the 2nd San Francisco Renaissance during the 1970s as editor of *Beatitude* magazine and books, founder/director of the San Francisco International Poetry Festival and was heralded as one of the "Baby Beats."

In the 1980s he returned to his boyhood home of western North Carolina to become a founding editor of *Katuah Journal:A Bioregional Journal for the Southern Appalachians* and founder of New Native

Press. As a poet and translator, he has published to date ten collections of both original work, translations, and one anthology including, most recently, *The Laugharne Poems* (which was published in Wales and written at the Dylan Thomas boathouse in Laugharne), *Writing The Wind: A Celtic Resurgence* (a first comprehensive collection in translation of contemporary Celtic langauge poets from Ireland, Scotland, Wales, Brittany, Cornwall and Isle of Man), and *In Wineseller's Street* (versions of the Persian Sufi mystic Hafiz).

As a poet-activist, I have been involved in projects over the years concerning Native American Rights issues, ecological issues and conservation organizations, and First Amendment Rights issues involving the arts. As an essayist and arts reviewer over the past twenty years, my articles and interviews have appeared in many periodicals, journals and books both in the U.S. and abroad.

In 1994 I founded Fern Hill Records—a recording label catering exclusively to the collaboration of poetry & music. At the same time, I founded my spoken-word and music band The Boatrockers which has performed on the East Coast and in the Midwest. I continue to live in the Smoky Mountains of North Carolina, where I am currently Editor-at-Large for the *Asheville Poetry Review* while writing a memoir in the style of Thoreau's *Walden* based on four years of living alone and self-sufficiently in the woods of Polk County, N.C. from 1979-1982.

Author-educator Jim Wayne Miller has written: "Crowe's work takes into account culture in the broadest sense and engages life in all its political, economic, and spiritual diversity. His work is part of a movement in American writing that is perhaps the most significant development in American poetry since the emergence of the Beats and the New York School in the '50's."

Chores

Thomas Rain Crowe

San Francisco, during the 1970s, was my testing ground as a young neophyte poet and as an urban working class stiff. In those days we often referred to our urban literary and working class lifestyles as "the university of the streets." Sitting at the feet of any number of our boyhood heroes and working whatever jobs were available and advantageous to our more profound priorities, we eeked out a living in order to be in close proximity to what truly fed us—the poet's life.

As a young boy I had grown up in a rural mountain community in the highlands of western North Carolina where there was so little work for those of age that 60% or more of the male population "worked off," as we referred to this local paradigm, as much as six months of the year. The local work to be had was, exclusively, logging, and the related mill work for a lucky few at Bemis Lumber Company whose front gates were not much more than a hundred yards from the front door of my parents' home.

My high school years were spent in a working class town in the Shenandoah Valley of Virginia — a factory and mill town with a minority of upwardly mobile families, but with a majority of the population working manual labor or long shifts.

While my parents were not exactly blue collar, my friends and their families most definitely were, and even as I grew older and traveled and lived away from these early working class communities, my unconscious preference is always to befriend and be with those whose needs were simple and whose speech and heritage runs close to the earth. Formal education, from the very beginning, and its institutions were lost on me, and I have always preferred common sense and working class perspectives to those of the 'learned' and the 'elite.' Preferred the lessons of nature and the wild to the halls of higher learning and the estate.

ESTATES

And who will be the slave that drives
the slaver to drink or be drunk on his own wine,
that tips the end of one life over to meet the
other like spilt blood or a tail chased-and-whipped

without anything to eat? O why O why
must those who sweat blood and work for those
shy of blisters make love to only
the sharp end of coins? Silver salivating
over the price of meat.
Happy are they that share. That give
back equal to what is their weight in love.
While those that think they own the land
feed forgetfulness with exotic wine which
puts them to sleep.
Soft of wages. Through long ages.
Unwritten pages in history's
blind ink begging for nothing
more than a promise of a prayer and a wish
for all those broken dreams.

My early friends were sons of farmers, or mill hands who grew large gardens. I grew up in tobacco fields and potato patches, picking beans and shucking corn—a lifestyle that I have carried over into my adult life when and wherever there has been available ground to till and fashion into a place for the propagation of plants. In those early days, I was part of the child labor force in my community—a necessity in those places and in those times. But work to a young virile boy was more akin to play than the energy I expend now as I hill the potato rows in my large patch in Tuckaseegee. Farm work, shelling walnuts, or carrying water from the well was an excuse to be with my pals, and everything we did, workwise, was soon transmogrified into spontaneously inventive games and fierce but friendly competition.

My first real jobs were also manual labor jobs paying usually less than minimum wage. Caddying on the local golf course. Peeling bark at the local veneer mill. Laying track for a small regional railroad. And things haven't changed much over the years since becoming a professional poet/writer—always working at something close at hand to pay the bills. During the past 30 years, I've worked as a roofer in Pennsylvania, as part of construction crews in Georgia, picked grapes in the south of France, worked as a hired hand on a family farm in Indiana, washed dishes in California, run printing presses in North Carolina, worked as a heavy machine operator, worked assembly lines, painted and built houses, worked for tree surgeons

and sign makers, to name a few of the odd jobs I've done to keep a writer's motor running.

All this time at 'hard labor' and contact with the working class in this country and abroad, has informed both my politics and my tastes and preferences in literature. The early Beat influences were reinforced by foreign poets with roots deep in the blue collar castes of their countries. Poets and writers who had distanced themselves from the ethics of academia and the institutions that had created an intellectual and false chasm between life and art. I think of Shelley, the Spanish poets Jiminez, Hernandez, Otero, the Russians — Mayakovsky, Klebnikov, Kruchenik, Esenin, and later poets like Yevtushenko and Vosnesensky — then poets like Appolinaire and Benjamin Peret in France, and others, who embraced their own particular culture's peasantry and praised it in print.

On a more personal and intimate level, my life and work have been heavily influenced by a handful of American poet/writers who have, in their own ways, alligned themselves with the American working class. Among these there are a few whose lives and work have been instrumental, as models, for the development of my own work and priorities where the written word is concerned. Writers whom I have worked with and known well, as journeyman artists—meaning that they not only have found ways to support themselves by their writing and various related activities, but that they are engaged in working class issues which are as much a part of their daily lives as is their work as poets, as writers.

My years spent during the 1970s in San Francisco's North Beach with Jack Hirschman working on a populist, internationalist resurrection of *Beatitude* magazine and press, set the tone and focus for much, if not all of my work since. Jack's uncompromising devotion and dedication to "text," as he referred to the written and printed word, to "book," and to translation and social activism in behalf of oppressed, marginalized and disenfranchised artists and peoples world-wide, made, and continues to make, lasting impressions on me. (It was Jack who encouraged me to pursue my interests in translation, and in fact he who handed me the first book in French which I world translate in its entirety). Overlooking certain eccentricities, his work in behalf of organizations and issues pertaining to the values and ethics of a worker-based socialism, coupled with his perpetual crusade against global capitalism, has been more than admirable, and has continued to be at the very foundation of his prolific literary output. His books, such as *The Bottom Line* and *The Xibalba Arcane* are classics in the field of American

political poetry and poetics. No one poet that I know of in this culture has been more politically diligent and outspoken, while continuing to write experimentally with quality, than has Jack Hirschman. His deep abiding love of the working classes and his rage against the monied elite and their crimes against the poor and disenfranchised have been praise-worthy if not profound in the face of the current state of political and cultural affairs in this country.

Perhaps Jack's greatest gift has come to me from being witness to his work habits—his perpetual practice of painting (agitprop), writing and correspondence, always done with enthusiasm and love, have, in later years become habits of my own as well. Jack's commitment to and his control of language affected me greatly during those North Beach years during the 1970s; and his statement, taken by example from his life, that art and life are not mutually exclusive and should not be segregated from one another, has served to reinforce my own beliefs drawn from as far back as early childhood.

I went to the West Coast to learn about BEING a poet. Jack Hirschman, by his example, showed me how this is done.

Tangential to my association with Jack Hirschman during the San Francisco/*Beatitude* years, was also my association with Jack Micheline. Jack was, quite literally, the first elder poet to take me under his wing and 'show me the ropes.' He remains one of this country's preeminent working-class poets, and his true gift is in his ability to translate everyday experience into a language inherent with music. His 'politics' (ironically, even more arcane than are Hirshchman's) are clearly class-conscious in that they come form his own working-class heritage in the streets of New York — where he developed his ear for the music intrinsic in common speech as well as his unique lyric cadences and performance voice. With and from Jack Micheline, I learned the life of the urban streets. He took me to the track (horse racing), introducing me to a whole working-class subculture I'd never experienced. He introduced me, also, to eminent yet unheralded (much like himself) Beat Generation poets such as Bob Kaufman and Jimmy Lyons — both pegged early on as 'jazz poets' who, along with Micheline, worked primarily with the musicality within words. From Jack Hirschman I had learned about the literary voice of the street, and from Jack Micheline: the lyric voice of the street. No wonder then, that my first collection of poems when published would be titled *The Personified Street!*:

THE PERSONIFIED STREET

If the truth be known
every mountain is a hill.
Every blade of grass a tree.
Is this confusing size with sex?
Or only something like rain with snow.
Let's pretend there's a meadow in your dream
and we're both trains.
Who will finish first?
Dance or dove?

Peace is like a parade
through the heart of New York.
Sex is the street.
I am the fifty-second floor of mankind
that covers you in a confetti of lovenotes
falling like martyrs from my eyes...
You are looking up and saying yes with
your thighs wide at the crossroad.

Brass bands passing into the womb.

If "the two Jacks," as we fondly referred to them, had been my
urban models as working-class artists, then Gary Snyder was their rural
equivalent and counterpart. After several years in San Francisco, I moved
further north into the Sierra foothills to a community along the North San
Juan Ridge populated largely by former urbanites who had been transformed
into part of the West Coasts's "back-to-the-land" movement. During the
year and a half I spent living in the Sierra foothills north of Nevada City as
part of the North San Juan Ridge community, farming, commune-style, fo-
cusing on crops such as elephant garlic, popcorn, and culinary and medici-
nal herbs—which we grew in concentric circles around a hill and mound
that was central as part of a much earlier Maidu village—the central pre-
scient metaphor for me was Gary Snyder's notion of "the real work." This
was something that I had gleaned from meeting Snyder during my years in
San Francisco and from the earlier collection of essays of the same title—
focusing on land-based ethics and communal (community) politics.

My time spent on "The Ridge" and with Gary was critical to my decision to eventually return to the mountains of western North Carolina and to help establish a bioregional sensibility (which included the creation of one of the early bioregional publications: *Katuah Journal*) in the East. My proximity to Gary and his priorities pertaining to "place," resurrected dormant memories and parental feelings I had about the Smoky Mountains of my boyhood, which were, by this time, under attack from developers, tourists, and an economic-minded Forest Service. In fact, it was Gary who finally suggested that I should think about "going home"—which, late in the year 1979, I did, moving into an old abandoned cabin along the Green River in Polk County with an awl-pierced ear, a new name, and began three and a half years of a Thoreau-like existence that would give rise to my second collection of poems: *New Native*—a working metaphor I had carried back with me from those beginning days of the bioregional movement on the coast.

What Micheline was to Hirschman for me during the urban 1970's, Wendell Berry was to Gary Snyder in my mind during those "Walden" years after having returned to the Blue Ridge Mountains of western North Carolina. I'd met Wendell Berry through Gary while still in California, and had contacted him not long after I'd gotten settled in to homesteading the small piece of land I'd been lent to live on there in the Polk County woods. Wendell Berry, from a distance on his farm in Kentucky, became something of a practical role model for me in those years, as someone in his own way who was also practicing what he preached. A farmer, in every sense of the word, and at the same time a literary voice of far-reaching consequence. A dynamic and model I embraced both tangibly and idealistically as I worked at becoming self-sufficient as a writer and mountain gardener in the fashion of a bioregional pioneer—using the line from one of his poems, "Work is the health of love," as something of a spiritual credo from which I attempted to ground the work of my life. An ethic that later appeared in poems such as "Occam's Razor" and "Chores" from the *New Native* collection.

OCCAM'S RAZOR

for Wendell Berry

"Work is the health of love."
The best path.
Something as simple as wood.

As wild
as a tree. Or
the perfect essence of space —
These ways.
Like the magic of hands:
 gone, with trace....

In a small world,
I live with the things I grow.
Careful of what comes.
Letting nothing go.

CHORES

Where will they go
these men and women of earth?
This man whose sweat
waters grain.
This woman
whose milk is the strength in human bone.
As the seeds they have saved
from great grandparents to be given
to children not yet born
are eaten by the fiery incinerators of banks.

How can they replace the pain
of what their bodies have become:
(like cells in the tradition of blood
that feed the body is)
this farm
that feeds those that rule to crush this Land.
A million years of digging in dirt,
now passed on as the nightmare
of empty hands.

Who will separate, now,
the wheat from the chaff?
Now there will be nothing

but tears that go into the rows
that once furrowed their dreams.
What kind of food can be grown from
the water in salt?
From the lonely song of a dry desert air.

Friends, think of the music gone from
the symphony of those fields.
The dance of breakfast
being born there for the human race.

Life out of balance
lost like the homeless in city streets,
like walking suicide.
Deprived of their chores.

Still living in the Smoky Mountains of western North Carolina with
many years and much water gone under the bridge between here and the
years on the West Coast, I continue, through the mail, the dialog with Jack
Hirschman and Gary Snyder that began a quarter of a century ago. Now,
more a colleague than "the kid," I can carry on a correspondence that
facilitates the work—the "real work" as Gary would call it, or the "agit-
prop": the lyripolitics as seen by Jack. These two working-class writers
who have fathered me into my own maturity, luckily enough, are still there
for me to come back to, as touchstones, as counsel for those things which
we continue to work towards actively as well as what comes with struggle
and epiphany through the ink. In this and in these associations I have been
blessed. I give thanks for being graced with their friendship, as mentors,
much as I am grateful to this place on earth which I am happy to have been
able to call home."

A SONG OF DEVOTION

after David

The earth is my body, and I
shall not want:
it beckons me to lie down in green
pastures.

It shares with me its clear waters; and
 it nurtures my soul.
It leads me along the paths of right thinking
 for its own sake....

Even though I walk through
 valleys among shadows of darkness,
 I fear no evil;
for the earth is with me;
 its mountains and its seas
 they comfort me.

O, great Earth, you have set a banquet before me
 in the hearts of my enemies;
have filled my mind with revelations,
 and my wonder grows!
Surely the deer and the seasons shall
 follow me
 all the days of my life;
and I will live in the beauty of
 this world
 forever. Hey'when-i. Amen.

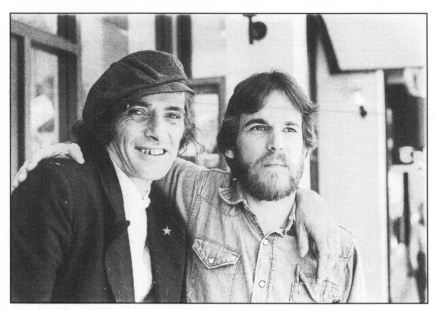

Jack Hirshman & Thomas Rain Crowe, City Lights Books 1976;
photo by Lisa Brinker

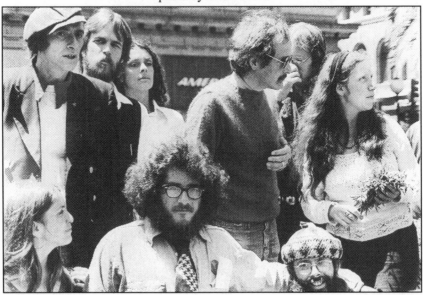

Back (l-r) Jack Hirshman, Thomas Rain Crowe, unidentified person, David Meltzer,
Philip Daugherty, Diane DiPrima; front Kristen Weterhahn, Neeli Cherkovski, Peter
Pussydog at Union Square Park, San Francisco, 1976; photo by Lisa Brinker

PAUL

CHRISTENSEN

Paul Christensen's new memoir, *West of the American Dream: An Encounter with Texas*, is his account of the effort of Texas culture to acknowledge its epic geography and ancient cultures. In 1991, he received a National Endowment for the Arts poetry grant and was inducted into the Texas Institute of Letters in 1997. He was a senior Fulbright lecturer to Austria and Norway, and has given lectures and workshops in France, Malaysia, Norway, Italy, Austria, and the U. S. He has taught modern literature and writing at Texas A & M University since 1974. Among his books are *Charles Olson: Call Him Ishmael; In Love, In Sorrow: The Complete Correspondence of Charles Olson and Edward Dahlberg;* and *Minding the Underworld: Clayton Eshleman and Late Postmodernism.*

I was born in 1943 in West Reading, Pennsylvania, Amish country, a stop in my father's itinerant career as a prison guard in the federal penal system. When my father was drafted, my mother took her three sons back to New Orleans for the rest of World War II. Afterward, I lived in Philadelphia, and moved to Virginia when my father entered the Foreign Service. At twelve I was dropped down into the middle of Beirut, Lebanon, a French colonial town that ticked like a bomb in the middle-1950's.

A year later, I ended up in a boarding school in the mountains of Luzon while the rest of my family lived in an old planter's villa in Saigon. The Vietnam War was about to erupt when I registered for the draft in the American embassy there. I spent my college years marching for peace, and was a graduate student when Watergate finished the process of destroying the public's trust in government.

I was neither one thing nor another, an American who grew up abroad, and an oddball in a society of joiners. I now live on the edge of the social basket weave of academic life. My poetry and personal essays analyze the emotional pains of family life, my mother's fight to keep the family talking and sharing against a backdrop of mechanical existence.

I discovered mentors through my studies of rebel poets, Charles Olson, Edward Dahlberg, and Clayton Eshleman. From childhood I have looked for writers who wrote about the working classes and about themselves as creatures from the social depths; even in the mid-1950's, when my reading interests began, I was aware that an era of social conscience was closing and that the working class and poor were no longer significant parts of literature or commentary.

The corporate appropriation of the media has allowed television and film to purvey the illusion that we are a nation of young high-earners living in suburban houses without pressures or emergencies. The act of writing now is to destroy these veils and delusions and to commit one's imagination to telling truth even though the means for publishing and disseminating an opposing view is precarious and fading.

Failing

Paul Christensen

We are taught from an early age to dread failure, to avoid it at any cost. It teaches nothing, it only holds us back from our fulfillment and joy. There is no coyote in the Protestant world, no necessary trickster or capering goat undoing the work of civilization. That is our tragedy.

Failing intrigued me even as a child. Nothing could quite upset my father the way failure did. He would wince at its coming, and stoop over with a tired look to hear how one of his three boys had gotten himself badly used or had lied or cheated and now stood exposed. His mouth would go dry and you could make out the deep ravines of his flesh as he fought for his words. The offense seemed to reach below the earth and touch the raw ore of being itself. He would go off a moment and gather himself and come back without much to say, though his silence was meaning enough.

My mother was different. She seemed to think failure was a lesson and could be taken as a message from the upper world. She read cards and sometimes told my father's future, as if she were trying to avert a failure for him. "A dark man will come into your life," she would say, tapping the backs of the cards with her painted fingernail. Then she would throw off stacks of threes and turn up a card and say, "Avoid him. He brings trouble." I would sit on the stairs in my pajamas eaves-dropping on these events. It thrilled me to see my father humped over the table listening with child-like interest to these words from the cards or my mother's vivid imagination.

She descended from an old Sicilian peasant line out of Agrigento, grape growers and vintners who had brought over to New Orleans a long heritage of violence and failure. Her family had come to depend on failure as a part of the rhythm of life. When one of her uncles failed, it was a message sent down from the great chalk statues of St. Louis Cathedral, from Mary herself, perhaps. Candles were lit, money squeezed into the poor box, an extra rosary said in the red gloom of my grandmother's bedroom altar, with its palm crosses and saints' pictures glued to the big old lyre-frame mirror. Failure was the whisper of spirits to turn back, and inevitably the Italian faces of my mother's family bore the meandering dark roads of a map of failure. Rarely did anyone find the path that led to money and prestige, though it happened.

When my mother heard of our failings, she would draw in her lip and sit down, sigh, fidget, make a mouth between laughter and crying. Then she would serve tea and cookies, and have a long chat. She would tell us about her own struggles during the Depression, the hard times when her father was laid off at the cabinet factory, and they went without meat or fish. Failing put the family on the raw edge of life, when a bit of extra food for dinner was cause for laughter and dancing barefoot on the wooden porch. You could feel the earth turning in her stories; the saints and the trinity were simply the new faces painted on ancient star deities from the depths of the human past.

My father was different; he solemnly believed in his autonomy in the world, and looked to no one but himself for the outcome of his actions. He descended from old Norwegian stock who had lived a long time in the little factory village of Akland, near the Oslo fjord. Several generations of his line rose to the rank of foreman at the Akland foundry, which made wood stoves, farm tools, and nails. Two years ago in a museum in Arendal, near Akland, I gazed into an old photograph of iron workers, at their crossed eyes and scarred cheeks, their toothless grins and blank stares. They were covered in soot from the kilns and looked battered and beaten.

A huge drop forge stood in the middle of the foundry compound, gone now but for a few buried stanchions poking up through the grass, which was used to flatten ingots. The hammer would fly apart after a few years and someone would catch the shrapnel in his head and go off an idiot or die a lingering death. The idea wasn't to be secure and comfortable, but to work to live. And the wages were scaled to pay for food and little more.

Three generations had lived on the grounds in the small company cabins along one side. Out of that meager life my great grandfather one day took his working clogs and woolens and walked down to the little fishing town of Risor and booked passage to America. It was 1861 and he joined the Civil War on the union side. From then on, it seems, he started winning. The girl he left behind in Norway, in the farm town of Homme, down the road from Akland, he managed to bring back and marry in Illinois. When the war ended, he took a post at the federal arsenal in Rock Island, Illinois, on the river, and lived a long and easy life as a guard. He passed on his work to my grandfather, a good machinist, and then to my father, who began working as a prison guard and rose up the ranks of the Civil Service and then the Foreign Service. He retired at the top of his profession and now lives comfortably in the moist delta country of southern Louisiana.

Failure haunted the line of my father, and beckoned as a foundry in the cold north country where men went about with half their heads and a

short, tubercular manhood living in the coal dust. Behind everything my father strived for was the sense that if he didn't do it right or only half way, he might be pulled back to the nightmare of ice and blackened kilns.

The fear he bore found a home in his body; he came to associate failing with giving in to the flesh. He was not a religious man and yet he accepted the doctrine that the flesh is the beginning of evil and the doorway to hell. He ate well and he made love with a noisy physical exertion, but he would not heed the voices inside him that wanted indulgence, good times, a riskier life. He took the straight path and bent to his duties, and regretted the weak wills of his three sons.

I could have learned something from him had he known himself better, or searched his emotions. I might have accepted the burden of fear and batted my way up the mountain behind him. But he was inarticulate, and found nothing behind his will but the stark, silent dread of a past he had not actually experienced. Fear of failing molded the soft features of my father's body. He rounded, and his shoulders sloped down from his neck. He walked with a slight roll that gave a determined lurch to his feet. He wore white shirts and silk ties, and pulled on roomy suits and expensive polished shoes. He wore thin stockings that expanded and revealed the whiteness of the flesh beneath. He had no hair on his legs and when he crossed his knees, the cuffs of his trousers rode up and revealed the moon-white calves and the profound caution of his entire being.

This whiteness spread across America and covered the foundry at Akland, as if Christo had draped it with muslin. The foundry is in every American's past, whether it is in Africa or Norway or Ireland or the mining towns of Poland. Everyone has the black faces and the scarred, cross-eyed workers lunging toward the box camera on the thrill of a phosphor flash in the middle of some bleak winter afternoon. Everyone has some ancestral blood that was hopeless and bound to a system of masters. This is the myth of the American, that he or she comes from a land of suffering and meaningless toil and now has the freedom to escape from it into a new life.

But Americans go on living in a general fear of failing. They have no place for the coyote in their metaphysics; they only have Bugs Bunny and a few other innocent pranksters who never offend, merely outsmart. On the other side, we have the coyote hunters who rid our world of any real trouble. Dick Tracy and Bat Man and Super Man and a host of Perry Mason types are the heroes of our psychology of fear; they face the enemies that would take away our freedom. In almost every case, the "enemy" represents some sort of coyote who would undo our cities or government or our way of life. And they almost always look like creatures out of wild

nature—with dark shadows of beard, low foreheads, brutal speech and attitudes, and dumb instinctual blondes for lovers. They hate civilization and must be routed out of America, because, alas, America is not a natural but a human paradise. And these enemies mean to break up the dream and bring back the discord of wild America.

Nothing will remove the nightmare of hardships from the American psyche, and the criminal is the scapegoat of our history. Without the prisoners my father guarded, and the poor blacks scrabbling for a foothold in the old South, without them, there would have been no way to displace the hard, dull paranoia about the old world.

That is why I always liked reading about the down and out, the degraded poor of urban America. Studs Lonigan, James T. Farrell's great underdog of the Chicago southside, was my hero. *Studs Lonigan: A Trilogy* (1935) was my bible, and Studs and his gang, especially Danny O'Neill, were like the two unexpressed voices of my own character. I would sneak out the books from the adult section of the local library, books like Richard Wright's *Native Son* (1940), with Bigger Thomas as the very core of hatred and violence at the center of urban chaos, black Chicago. He *fails* to live, to free himself, to rise, to become white. He failed gloriously, in epic size, which made me think there was a hidden esthetics to failing to be found in the illicit, the hidden, the black market literature of America.

That hidden esthetic was everywhere the moment I looked. I found Henry Miller's *Black Spring* (1936), about another childhood on the streets, this time Brooklyn. Later, in college, I would come across books like Dreiser's *Sister Carrie* (1900) and Stephen Crane's *Maggie: A Girl of the Streets* (1893), but they were too remote, too much the story of 19th century America to thrill me with the real stink of garbage, the hard knuckles, the dark rooms with transoms blowing in old men's odors from a flophouse hall.

Whatever it was *down there* in the bottom of America, among the Mills Hotels and alleys, it was always dim, as if to live like that meant being close to the animal world, the lost frontiers. Down there was Freud's laboratory, where the unconscious was on the surface, living every day like a normal citizen. They say the poet Mina Loy went to live in the Bowery to be near the bums; she wrote about them in very high-flying poems mixing Einstein and the barstools in the same paragraph. Tom Waits went there, too, as if to be poor, to be where the booze smells sweet from the airshaft, is to be finally touching truth. I read everything twice and sneaked it back to the shelves from under my sweatshirt. The rest of the library was all

brightness and hope.

Walt Disney understood America down to its root ends. He knew fear ate at the national heart, and that behind my father's will was nothing but fantasies, a vacuum in which to create theme parks and television series that acted like pain killers on the fear that grew there. He created a film empire that rules over the psychological terrain which is greater than the British empire and the Roman Empire combined. A thousand years of bitter serfdom had secreted a religion of luxury based on the rumors of how kings and queens might have lived in the dark ages. Disney made his millions with animated cartoons retelling the old peasant fantasies of slender princes and beautiful paupers in a painless, ethereal style to suggest our dreams. Then he made parks in which the dark psychic monsters were gelded and mechanically reduced to knacking their jaws, and letting out programmed roars from their artificial jungles.

There was one small hope I clung to like some holy card on my grandmother's mirror. That was the early novels of Edward Dahlberg; the first was *Bottom Dogs* (1929), which D.H. Lawrence reviewed while holding his nose. It stunk, he said, of the unconsciousness of America, its cold, mechanical beings living in a trance of numbness, mere golems in the industrial nightmare. Dahlberg lost his nerve, raised the literary level of his next book, *From Flushing to Calvary* (1932), with a hint of the toilet in the title. But it rang true, a boy and his mother, a woman barber, a Sister Carrie without looks or luck, hard scrabbling, taking in zoot suit lovers who always stole the money and left her with the empty toothpaste and the "kid." Lawrence hated it because it was the genuine stink of his own childhood, the miner's stink, the sooty clothes in the damp kitchen, the colliery whistle, the funerals after the mine collapse. Dahlberg wanted out of these memories, just like Lawrence. Both wanted to run away from that past, but their souls glowed in it, their imaginations feasted on it.

Failing became a heavy burden to me as I aged. It brought me up against the other American myth of progress, a confection of logical illusions concocted in the 18th century to get rid of the Catholic monopoly and to liberate the newly risen merchantocracy. I should have taken control of my life, but it didn't happen. I came to resent the rules and policies of the institutions that raised me. I refused to go along with the orderly anesthesia that was my education; I slithered along like an unrepentant serpent in this paper Eden. My teachers hated me. One of them, a fay Latin teacher, referred to me for a year as the *persona non grata* of the class. The coaches forced me onto teams that would otherwise prefer to leave me out. I was

not part of any organized group at school or after it, only a drifter, a tag-along, an unwilling conformist.

I was dreamy and would laze about in my bedroom by the hour. I was hoping to recover some part of my lost soul in those hours of anesthetized idleness listening to radio, reading comic books, picking my nose with uncanny diligence and devotion. I learned to masturbate in these inflexible afternoon vigils. And to desire the haggard housewife who put up her laundry in the yard beneath my window. Her small breasts and loose face were objects of my lust, and I conceived various unworkable schemes for seducing her. She was dull and drained, and moved about with the sluggish motions of an old zoo animal. I was reading the later Miller now, and some William Burroughs, *Junkie* (1953), and Kerouac's *The Town and the City* (1950), where kids were coming up the hard way, barely making it.

The lot stretching out behind our house was the last remaining strip of pines and poison ivy left from an old forest, bounded by an Italian restaurant at one end, and a gas station at the other. It would fall to the bulldozer soon as another block of brick row houses filled in the last open stretch from here to the Delaware River. A billboard faced the highway on the other side and I would creep up among its catwalks to find my cigarettes, which I had secreted into a sheltering niche. There, on the top planks, with my head sticking up over a massive photograph of an Amana refrigerator and a smiling housewife, I would smoke my Lucky Strikes until woozy and watch the cars grind by in the summer heat. It was a little touch of earth and I would confront the blistering leaves of poison ivy to get to it. Along the way to the billboard were rags of clothes, condoms, the occasional pint bottle of whiskey, where others had also gone in search of rawness.

It seemed whatever I wanted in life I failed to get. I wanted to be a good student and came out below average; I wanted to earn money in summer and buy a car, but I got fired or quit early and sat around with my equally penniless friends. I wanted to be a lover, but girls showed no interest in me. I was unwilling to play the sort of games that led to success. Teachers favored those who made their jobs easier, and rewarded them for their willingness to behave, to do the work. Teachers liked students who didn't need to be taught. Managers at the food markets liked clerks who needed no managing. Girls wanted to love boys who required no particular loving. If one departed from these painless relations, the game was up and failure was the only outcome. I failed at everything.

But failure began to teach me a little something about itself. I could begin to detect that failure was like some old Chinese principle of the life force. If you ventured off from the boundaries of the human will, you encountered disapproval, warnings, and eventual exile. If you stayed within the "city" humans make of the wider world, you would do all right. If you mastered the rules of that "city," you did well. God help you if you got too curious and went looking into the no man's land beyond this city of order. There lay the insane asylum, the precinct house, Herbert Huncke's world, the junkie's underground.

Failure was a return to the wilderness, and to a dependency on forces that were outside the human brain. A will existed in the wild hinterlands of the city, a will that was once the overpowering force of ancient gods. Priests tried to know this feral authority in the planet's heart, and rose to power on their abilities to predict rain, tremors, eclipses, eruptions, Nile floods, and the length of winter. My mother fit into this tradition of the shamans in some lowly capacity, in an age when the arts of sortilege and geomancy had been routed out of mind. Her third eye still pierced the darkness and made out the spectral procession of certain earth spirits. She understood failure the way an augurer might perceive a face in the entrails of a chicken hawk. She laid a hand onto the planetary pulse and could tell my father things about dark men bringing trouble. Her imagery was the faint vestiges of the old Tarot deck, which she knew nothing about. But the figures of old prophetic books coursed through her brain and bore some lingering trace of the old religions that was now all we meant by the term failure.

The social disgrace of failure was a terrible burden to me and my courage broke from time to time. I could not go on failing at everything; at some point I must wander back and accept the laws of the human universe or die. I eked out a passing grade from student life and made my way in the female world, lightly touching the surface of their primal depths but always withdrawing for fear I would ruin every relationship I entered. I dared not pursue what I really desired in their love—the animal struggle to devour each other in the death trances of copulation. I wanted their filth and misery and degradation in my mouth, my eyes, my soul, but they feared those waters and had broken with the past. Love was the sort of loveless politeness dictated by a culture of morose fears. Henry Miller had said it all before me; I had no way of pushing his discovery much further. Every woman desired to be the cuntless Cinderella of fantasy, the seamless white underside of Sleeping Beauty among her emasculated dwarfs.

I was a real failure because I still believed in success and pursued it. Others gave up and let anything happen to them. They went the way of drugs, a few tried gambling; some shot their brains out in motel bathrooms. A few merged into the invisible masses of America, the faceless sea of life and accepted their fate with a frozen look. But I was struggling, I was the burlesque version of my father's success; I soft-shoed and capered my way down hill imitating the hard smile and the bent shoulders that got him to the top. I half believed that failure was an empty slot, a limbo for the weak and the bungling.

It was many years of failure before I sat down one afternoon with my dunning letters, pink slips, the sordid mess of my emotional life and discovered that failure was a door covered in weeds. An iron door at the back of an abandoned garden, where someone had long ago put a chain and lock around the rusty handle. The hinges had rotted shut forever, and the mesh over the little window had turned black with grime. But the breath of the underworld came out of it, a cold, moldy odor of death, sleep, and forgetting.

I came back to my mail and sat down to think about it. The hours stretched into night and then night went on under the ceiling light and became dawn again. I was not sleepy. I had lost my appetite. I was quiet now, my heart steady. I felt a firmness in my legs and arms that spoke nothing of my having sat still all day and night. I was perfectly composed, and under the solemn skin of my mind, a joy spread out like the grayness over a lake at daybreak. I was preparing to enter the door and go down into the world I knew nothing about.

My father never inquired into the roots of his success, or sat down to figure out why the stairs he climbed to the top were plushly carpeted and lined with marble and gilded mirrors, and that a crowd of men got to the top with him. He was a member of a generation, the only one, that benefited directly from the expansion of government. After 1933, the federal powers moved permanently into the economy to control employment, goods, and prices. To pay for it meant plundering the national treasure until the coffers were bare, and the money was lavished on men who rose up quickly and took home big salaries, and found everything they needed or wanted at the end of their requisition forms. The government squandered wealth and prestige on this generation to reassure business, to coddle the public, and to warn the East that communism would never work.

My interest in the 1950s as a writer opened my eyes to this crazy, mixed up period of American life. The war leveled the old America of

mom and pop stores, real neighborhoods, whole wheat and rye, and dark beer. Like the population, which aspired to be whiter, the whole range of food and consumable goods was going white and thin, always more diluted, more controlled, more corporately beautiful, more democratic. I wrote a lot about this shift in my early years—this transformation of the real into the synthetic slab of margarine and Wonder bread. My poems were oriented to the rainbow of stink and rejection, and so increasingly were my essays – about the young Olson eating his teeth over the fall of New England's once regional, real culture of fishermen and small farmers. I was a very good student of William Carlos Williams on the immigrants of Passaic, in his long poem, *Paterson*. A novel of my own, *Freak of Nature*, was so blunt and intimate with a deformed, slowly dying protagonist who juggles and travels over America on a bike-caravan, it remains in my drawer. The editors found it an abomination of the bright truth of American life. I wrote a lot of stories on the disintegration of ordinary lives, in Texas and in my old Philadelphia memories. But when I wrote *Minding the Underworld: Clayton Eshleman and Late Postmodernism,* I had found my alter ego in the poet Eshleman, who keeps trying to run away from white Bluebonnet Margarine America in Indianapolis. He still is, perpetually. My most recent work touches on the distance we have come from bison worlds of the Great Plains and the dust of the Indian heritage. I had more bitter lessons to learn in my thirties.

The Cold War was a mandate to bankrupt the people for ten generations to come. My father thought that his work ethic and clean underwear had earned him merit pay. In truth, he was one of the ants supping on the crumbs of the federal banquet. My father had grown fat on the great public feast, with wads of hundred dollar bills going up in flames to light the federal cigars and lift the jets full of senators to their resort meeting grounds. The money was huge, a Niagara of greenbacks tumbling into the agencies and the foreign clients, and the deep channels of graft. Everyone grew sleek and round with the fat of the people's future.

My father's success occurred within a narrow dressing room of carnival mirrors, in which he appeared to himself as a regular dream boy, a winner. He put my mother on a hundred-dollar-a-month allowance to run the house, and squirreled away all his loot in the bond markets and the blue chip stocks. He looked down on me as a weak seed, someone whose leaves would never clap to the May breezes the way his did. My leaves would flutter like the plastic flags over a used car lot. He never sat down to clear his head long enough to realize he had eaten all the food in the pantry and

that the future was broke. I was heir to the crumbling American dream. Only one generation had tasted the heady liquor of prosperity, and it had come from the back pockets of the fear-driven average worker. But the illusion of success and of an unimpeded bright future to those who obeyed the rules, and followed the artificial dictates of the system, lingered on beyond the epiphany of lies and corruption.

Invisible legions of schmucks had paid for the glitter in the federal castles. The irony of our situation would not occur to us until private militias began to form in the backcountry of Michigan and Idaho, and in the broken-down landscapes of rural Texas and the South. My father hated these ignorant masses; he hated the blacks who rioted and burned down their ghettoes; he loathed the immigrants from Cuba and Haiti and Vietnam. He didn't want to have to pay for his success; he had earned it already, he thought. The masses were ungrateful for the example he set; they did not appreciate the moral principles he lived by. His impatience was growing in a ratio to America's disintegration after the plunder of fifty years.

Coming next were the bullies and thugs of Congress to hold down the public's rage as details of the banquet years became known on call-in radio shows. Newt Gingrich and his minions of right-wing Christians and patriots would unplug the social programs and leave behind a shrunken hall in which a few government scribes were visibly slaving at their desks. The public driving past the windows would see a few Bartlebys over the ledger books, with the lights turned down, and the webs growing over the idle fan blades.

It would not conceal the looting, the feverish make-believe of governing that raged for a third of the century before the echoes began to ping against the empty coffers. Now, the population is a series of tectonic social plates sliding and subducting under each other into the magma. And Gingrich and his janizaries wanted to create the impression that history doesn't exist. He wanted the American dream to dance in the eyes of young white people, and for the innocence of his own unconscious youth to sweep the land again. Now that he was pulling the levers of the federal money machine, it would be convenient to have stupidity become the public gospel. In this era of make-believe and government illusions my failures were recorded and condemned. But they were the only brine of reality I could put on my tongue.

I grew up thinking my father looked very good, a man in a tall saddle. And the boys and girls around me who seemed to put their feet into

my father's path and to go on above me, they were the children he had wanted. The rest of us either didn't care or kept straying out of the school-room to look at a real tree blowing in the wind. Failure was the point of exit from the painted paradise we were given. Merit and praise and the reward-ing of trophies, the glitter of graduation ceremonies, the splendid gifts of money and watches from admiring parents — all this was the property of a theater of illusions built on the edge of a waste land.

Failure beckoned with its secret door at the end of the garden. There it stood next to a broken shovel and the algae that had crept out of the gutter onto the brick path. If it could be opened, I would go down into its labyrinth.

At thirty-five, a man separates from the boy inside him and be-comes a dry husk. He no longer believes in anything. The boy flies away and returns as Eros in the Greek world, Cupid in the Roman myths, a harm-less angel with a bit of lust to give away. The man is alone, and whatever nature gave him has dried up into rattling seeds. His right to exist has now expired; he becomes a lingering guest in the world and his thoughts turn to religion and philosophy. Since I had turned middle-aged, I could dwell more fully on the meaning of my failure. I wanted to face it head on and go inside it.

I took a bus from Philadelphia up to Eagle's Mere, in the foothills of the Pocono Mountains, where a few thermal hotels plied a health trade back in the 1920s. The garden stood behind one of the old millionaire cot-tages there. I waited until dusk before climbing the stone wall and got down into the weedy stretches of an old maze full of topiary shrubs in the shape of chess pieces. They were strewn with wild ivy and spider webs. The moon was a sliver in the sky. A light was on in a dormer of the man-sion where a college girl read herself to sleep.

I had a lantern with me which I lit when I found cover behind a fallen beech tree. I made supper over a primus stove and ate warm beans, frankfurter buns full of honey, and drank down a thermos of scalding Nescafe. My lantern shed a weak orange glow that made the dead grass shimmer like an early frost. It was warm out, an August evening full of crickets and bat flutterings.

I wound the loose chain around my pry bar and locked the bend of the metal against the stone jamb and gave a light downward pull. The chain held. I wrapped it a second way and put the bend of the pry bar into the hook of an outcrop stone, and lifted with my shoulder. My knees ground in the pebbles and my shoe creaked. The birds fell silent as the chain burst

and rang dully. A dog in the neighboring estate let out a sleepy bark. I led the chain out of the handle and put it aside, and then tugged gently at the door, which stood fast. The rust had sealed it.

I traced the crack of the door with my lantern to determine how best to force it. A part of the metal swelled near the bottom where some other adventurer had tried it once. There I put my bar and gave a sideways heave from my waist. The door grumbled and I drew back for fear of buckling one corner of it. I tried a higher place and heaved again, and this time the catch inside an old lock bent and I felt the give.

I stared into the coils of a water hose looped over a spigot, and at a line of buckets filled with dirt. Behind them was a spiral stair leading down into the earth. I got my things and laid them inside before pulling the door to. My lantern glowed strongly now; the heat of the day came up the shaft mixed with earth smells and old sewers. My feet sent echoes down into the world below me. I had entered into the failure that America is built over. I had left behind the neon watchtowers guarding the dream world and was now in the sooty, degraded regions of the mere planet.

A dim glow began to shape the tunnel ahead; I could see the passage begin to drift down in a steady loop, as if passing the bulging roots of some powerful monument. The light was full of mutterings and unconscious dread. Step by step I made my way into the back of a giant photograph someone had lowered down on laundry cords from a sewer opening.

There, swaying in desultory winds, were the backs of the iron-workers at the foundry in Akland, their shoes muled and their feet swollen and without socks, the air venomous with sweat and exhaustion. I could see the hair lift on a slender, sway-backed boy with his lunch bucket hung on a rope from his belt loop. The man beside him was large and walrus-like, with the seat of his pants stitched up with salt water line, a fishhook jammed into the flap of his pocket. They moved to and fro, swaying in a mass, waiting for the moment in which the phosphor track would explode into a starry brilliance over America. I was moving slowly behind them, coming up in the gap of their ranks, my body like a jigsaw piece beginning to match the jagged opening. When I arrived, the photographer threw the cloth over him and held up the flashgun. A loud report made us rigid, and in the blinding that followed, my face peeled from my skull and I walked away a free man.

CURT

JOHNSON

Curt Johnson was born in 1928 in Minneapolis and lived there until his teens, when his family moved to a small town in Iowa. After high school he spent two years in the Navy as an electronics technician, then four years at the University of Iowa: BA in English, MA in American Civilization. Since 1952 he has lived in Chicago, working as an editor. He has two children.

Johnson has had 60 of his stories published, including selections in the *0. Henry Prize Stories* and *Best American Short Stories.* He has also had six novels published and six works of nonfiction, and has edited four anthologies of short fiction. Among his anthology credits is the co-editing of *Writers in Revolt: The "Anvil" Anthology,* with the late, proletariat novelist Jack Conroy. With the poet and editor Diane Kruchkow he compiled *Green Isle in the Sea,* an informal history of the vigorous activity of the small press from 1960 through 1985.

In 1998 Da Capo Press reissued my *Wicked City*, a study of Chicago's vice, crime, and corruption from 1883 to mid-century in which is demonstrated the equivalence of syndicate crime and cartel capitalism. My only book that has had even mild commercial success was *The Mafia Manager* (written in two months) published by St. Martin's Press. This guide to power in the corporate world sold 25,000 copies and was translated into 11 languages within 18 months, and was then, to the author's dismay, declared out of print.

My most recent (1997) publication is *500 Years of OBSCENE and Counting*, an inquiry into racism and its origins in the necessities of capitalism. Since 1962 I've published and edited *December* magazine and December Press publications. The most recent (1998) December Press title is Bob Connelly's *The Silents*, a definitive reference guide to 13,500 silent feature films.

Will Write for Food

Curt Johnson

In one way or another, just about everything I've ever written for myself has been conditioned by a working-class ethic I absorbed before I was 20. Before I was born, if that's possible. Let me try to explain.

My German grandparents raised four children, my mother among them. In the early years of their marriage, my grandparents farmed in southern Minnesota, both of them toiling from sunup to sundown to scratch out a living. When a child was born, my grandmother would be back in the fields three days after delivery, the newborn propped under a tree close by where she could nurse him when summoned.

Their first two sons died of diphtheria while still toddlers and my grandparents moved to Charles City, Iowa, where my grandfather worked for John Deere, and then to Minneapolis, where he was engine shop foreman at another tractor plant, Minneapolis-Moline. After the banks failed in the early '30s, my grandparents kept their savings in a Mason jar and hid it in the basement.

Their only surviving son worked at Minneapolis-Moline all of his adult life except for three years he spent overseas as a combat infantryman. Half a year after my uncle reached 65, he and other Moline plant retirees were told that the employees' pension fund (to which my uncle had contributed for 30 years) had vanished in a buyout. This used to be called theft, but corporate lawyers have disabused us of that nonsense.

My Swedish grandfather worked two jobs most of his life, days at Cargill, nights as a watchman. My Svenska grandparents raised five children and when my grandfather died, his estate consisted of a six-room wooden house and the change in his coin purse.

Most of my relatives on the Swedish side were small farmers in Minnesota and Nebraska, and my father worked summers for one or another from the time he was 12. All of those farms went under a long time ago, mostly to the banks.

Q: How is it that Swedes have such flat noses?
A: From trying to walk through stone walls.

While he was still in high school my father got a temporary job as an office boy at Ralston-Purina, working before classes and Saturdays and then full time in the summer. I was born in 1928, a year after he and my mother graduated from high school. By the time I was seven my father had been promoted to the traffic department of Purina's small Minneapolis plant. One noon when he came home for lunch there was a hushed exchange in the kitchen and a few tears from my mother, a most unusual occurrence. Because of the ongoing Depression, my father had just been busted back to office boy that morning and had had his salary cut to $7.00 a week. They had two sons by then and another child on the way.

We wore our best-condition hand-me-downs to school and were told to be glad of it. Once a year before school started, new shoes, of course, because kids' feet grow, but second-hand sneakers for gym class. Nike, Adidas, and Reebok concoctions would have been laughed at and left on the shelves, even with their price scaled down to Depression equivalents.

All of this was 65 or so years ago, you understand. I certainly didn't have a deprived childhood—there was always plenty to eat—but nobody even had any spare change. Not my relatives on the farms, not those who worked in the tractor plants or the feed mills, not even the uncle who rose in life to become a railroad section foreman. Nobody.

No, I take that back. Every so often my mother's father would take his grandkids to the movies (10¢ a child), and every so often my Swedish grandfather would pull out his coin purse and find a nickel for each of us. Little enough, but a helluva lot.

<p style="text-align:center">* * *</p>

A couple of years ago while working on a book on racism and capitalism I learned that computer whiz Bill Gates, head man of Microsoft, had a personal fortune of $18 billion. I don't begrudge him the money, of course—well, maybe a little—because I know that it is computer technology that enables administrators in far-off Washington, D. C., to conveniently transfer my Social Security benefits directly to my checking account here in Illinois. Without computers, I would have to manually open the SSA envelope each month when it arrived, laboriously endorse the government check myself, and mail it or take it to the bank personally. Still, the sheer magnitude of the sum of $18 billion staggered me.

Just think: Bill Gates could put his net worth out at a low 5.5 percent interest and be paid damn near a billion a year forever—without touching a dollar of his nest egg—such is the beauty of letting your money "work" for you.

Or he could, foolishly (since it would draw no interest), put it in a Mason jar in the basement and spend $2 million a day, every day, Saturdays and Sundays included, for the next 20 years and still have enough left to live out the rest of his life in relative comfort—between $3 billion and $4 billion, that is. Heck, I've had wives who couldn't spend $2 million a day for more than a couple of months without getting slightly manic.

<p style="text-align:center">* * *</p>

When I was about 10 years old I began picking weeds, shoveling snow, delivering show bills, like that, anything to make a dime for candy bars or comic books or a baseball game. When I was 14 I got serious about money-making and spent that and the next summer peddling fruits and vegetables and chickens and eggs door to door.

I'd take off my red baseball cap and twist it in my hands and in my most earnest, just-a-simple-countryboy manner ask the lady of the house, "Could I interest you in some fresh fruits and vegetables from Howard Lake? We also have milk-fed fryers, fresh-dressed this morning." I'd pick up a carton and lift the lid to display the tasty plucked, milk-fed, and dismembered bird.

We started selling at about 7:30 or 8:00 in the morning and worked till we sold all of the fryers, sometimes as late as 6:30. We hitchhiked home from wherever we finished. The eggs and produce came from the downtown Minneapolis commercial market, but the chickens actually were fresh-killed and dressed at Howard Lake, only the night before, not that morning.

We made a 10 percent commission on our sales and averaged about $2.00 per day, though one glorious Friday I made $7.00. (A suburban matron bought a dozen fryers for a weekend party.) Our morning routes were in the ritzier suburbs. We returned to the city in the afternoon because by then the ice on the chickens had melted and the heat of the day would start to broil them, and apartment dwellers and housewives in the poorer city neighborhoods were usually less fussy than suburbanites. But as I would helpfully point out to my customers, all you had to do was rinse the chicken in water and baking soda and the smell would go away. Usually.

Most of the other peddlers were kids like me, and they came and went, but there were two steady grownups besides our driver. One, Ralph, was a lush who claimed to be the scion of a wealthy Southern plantation family and claimed to have been seduced by the family maid when he was eight. Most of Ralph's sagacious small talk concerned his continuing sexual odyssey.

The other, Steve, was purse-lipped, hawk-nosed, frail, puritanical, and neat in dress. He was unfailingly polite and lived in a Washington Avenue flop house downtown with an invalid brother. Both Steve and Ralph were ancient—in their 40s.

One morning the police picked us all up and took us to a station house where we were made to stand in a lineup. Someone had molested a very young girl in the basement of an apartment on one of our routes. When we were released—no identification made—I got in the front seat beside Bud, our 20-year-old driver, change-maker, record-keeper, and leader, and as we sat there I heard this noise, as if someone were knocking on the floor boards. I looked at Bud and he pointed at his right leg. It was vibrating uncontrollably against the stick shift.

Steve sat on the other side of me, looking straight ahead through the windshield, calm and dignified, his hands resting on his bony knees.

That noon, over the first of his two bottles of beer for lunch, Ralph told us that obviously Steve had been the chief suspect. "You can all see that, don't you?" he asked.

Steve looked at him. "It's okay," he said. He smiled, politely. "I understand."

The next summer I was 16 and legally eligible for a real job. I got one at the Ford-Ferguson plant, two miles from my home, nine hours a day, no overtime. I started at 50¢ an hour scraping welds on tractor scoops, and by the end of the summer I was making 70¢ an hour. They had been going to hire three boys for the tasks I performed, but when they saw I could handle the work by myself, the foreman gave me first a 10¢ an hour raise, and then a month later another. All he asked was that I keep my mouth shut if the union steward ever asked me any questions.

Saturdays I'd walk five miles downtown and stuff Sunday *Tribunes* from 3:00 in the afternoon till 3:00 or 4:00 in the morning. Come home, sleep, go to a movie with my grandfather, maybe, and back to Ford-Ferguson at 7:00 on Monday morning.

I seem to have been obsessed with making money that summer. Not so. I was lonely. My best friend had, at 16, eloped with his girlfriend and left for the West. He had been working at a small filling station. He wrote me that he was reading Karl Marx. His father owned the filling station, so I guess we know who was exploiting whom. Or maybe we don't.

The next summer I got a job at a feed plant and worked there full-time summers and part-time during the week and on Saturdays through high school. When I graduated I knew everything, and was sure I would live forever. So I joined the Navy.

I have to say that boot camp came as a rude surprise. But from the distance of 50 years, and looking around me at the teenagers thronging the shopping malls today, I also have to say that there are worse things at the age of 18 than finding out you don't know anything yet and that in real life it's either shape up or ship out.

* * *

About the same time last year that the book I wrote on racism-capitalism was published, the newspapers reported that Bill Gates' fortune had doubled. He was now worth $36 billion. Mammon alone knows what Bill Gates is worth today. South America? Canada? South America and Canada? I make these guesses not entirely facetiously. In 1996, when Bill was worth only $18 billion, he was among 350 billionaires in the world whose combined net worth equaled the annual income of the poorest 45 percent of the globe's entire population. Which is what? Six billion people?

* * *

When I got out of the Navy I went back to school because I had the G.I. Bill. Yes, I was sponging off the government 50 years ago. For nine weary months of each year I would listen to lectures, read the prescribed texts, and write exams. So when summer came I wanted to do something completely different and for two summers I worked as a gandy dancer on the section, maintaining right of way for the Illinois Central, and the next two summers as a carpenter's helper, digging footings, jack-hammering concrete, framing houses, plastering dry wall, shingling roofs.

I can say, without qualification, that nothing in my life has ever equaled the satisfaction I got from the work of those summers. Maybe it was the contrast to what I did the other nine months of those years, but I think it was more than that. Of course, I was in my 20s and the working was easy, and I only did it three months a year. If you're going on 40 or 50, I imagine the work was far from easy, year in, year out.

I can also report that wearing a red baseball cap while working alongside a railroad track is discouraged.

* * *

The research for my book on racism-capitalism confirmed quite a few apprehensions I'd developed over the years. For example, the distribu-

tion of income throughout the world is criminally skewed. The 20 percent of the world's population who live in its wealthiest countries receive 82 percent of the world's total income, while the poorest 20 percent survive, when they do, on 1.4 percent. The late Mexican author and statesman, Octavio Paz explains this: "The 'advanced' nations reply very calmly that it is all a matter of 'natural economic laws' over which human beings have very little control. . . . Actually, of course, the law they are talking about is the law of the lion's share."

In our own country, which is the very richest and most powerful in the world, as we are repeatedly told, millions of people are homeless, year after year, and millions of children go to bed hungry every day. Their parents can't put food on the table for them or sufficient clothes on their backs or a decent roof over their heads. Our country's economic system excels in nothing so much as unemployment, underemployment, and poorly-paid employment, together with obscenely extravagant compensation for chief executive officers and their lieutenants.

Q: How many psychologists does it take to change a light bulb?

A: Only one, but the bulb has to want to change.

* * *

My father believed in the American Dream and he lived it. He went to work for Purina as an office boy at 17 and 30 years later he was made Vice President, Traffic, for all of Purina's 52 feed-producing plants and its other operations in the United States, Canada, and Mexico. He had an office at Checkerboard Square in St. Louis, Purina's corporate headquarters, and— not least impressive to me—occasional access to a luxury box at St. Louis Cardinals' games.

He worked more than 40 years for just one company, Ralston-Purina. All of the loyalty and energy and skills and intelligence that he had he gave to Purina. He was proud of his Vice Presidency, and we were proud of him for having been recognized as the extra-competent and exceedingly pleasant man he was. Hardwork, merit, and loyalty had been rewarded.

And then Ralston-Purina was taken over by another management and bang! He was jettisoned into early retirement. The takeover high command had malleable M.B.A.'s who were impatient to install. Being fired didn't hurt my father financially — at his level they usually throw you into the street with cushions—but it was a cruel blow to his pride and sense of self. He never commented on that, but to this day my mother has not forgiven those sons-a-bitches (not language she would ever use), and neither have I.

This all took place 30 or 35 years ago. Today Purina no longer makes feed for farm animals, which was the mainstay of its business, only cat and dog food. The price of its stock is out of sight and climbing.

<p style="text-align:center">* * *</p>

Since I graduated from college 45 years ago, I have spent my life working at white-collar jobs, and, except for my barber and relatives, I have no blue-collar friends and acquaintances. As I said, I have never had jobs in all this time as satisfying as those in my blue-collar past, brief as it was.

It isn't that the men and boys working on those crews in my youth were any nobler than those I've met since. People are people. Blue-collar people share the same virtues and flaws as their white-collar counterparts—with one notable exception: I can't recall ever working in my early years with anyone who was as mean-spirited as most of those I have met on and off the job in the past 45 years, By "mean-spirited" I intend to describe a person who is interested only in what happens to himself, as in "I've got mine, Jack. Fuck you."

Blue collars have jobs; white collars have positions and careers. Blue collars make something, or grow something, or fix something; white collars want to make money and spend it on showy possessions, and they don't much care what they have to do to accomplish that. At AT&T, at Britannica, at Scott, Foresman—to name three places I have worked—a willingness to lie and backstab was close to a prerequisite for advancement.

Blue collars make a living; white collars attempt to make a fortune. In my experience, making money and advancing their careers generally circumscribe the interests of white collars. Blue collars, on the other hand, are interested in people and their families and in living their lives in a community. They talk on and off the job about what's happening to themselves, and—often with even more intensity—to others. The women gossip, the men swap sea stories. Blue collars are interested in the ambiguities of life and its arrangements and in the puzzles and joys and sorrows of living.

Forty-five years of listening has persuaded me that white collar people are generally interested in talking about their houses, their cars, their vacations, their children's schools. (Their children are going to school to learn to manage credit cards.) White collars are interested in getting ahead, making money. They have a pretty much blanket indifference to the lives of others (except for envy), although a rich matron might, possibly, spare a few words to laughingly describe to her friends last week's road crew in the next block that spent "half its time leaning on their shovels." You will sel-

dom hear anyone who has actually done any digging scoff at a working leaning on a shovel. They know that no one can dig nonstop like a machine.

My grandparents, my aunts and uncles, my parents, the working-class people I grew up with and worked with before I went on the job market after college generally had, as I remember it, a bone-deep goodness free of calculation, and an honesty and generosity that was entirely open in spirit.

On a Saturday morning, drive leisurely through a poor section of a city. Have a cup of coffee. Take a look around. The next Saturday drive through one of the city's suburbs and do the same. I think you will feel a pulse of life in the city's poor section that is lacking in its suburb. If you don't, then I am a misguided and deluded romantic.

But wait—make the same tours of comparison on a Saturday night.

* * *

In what I've written over the past 50 years, fiction and nonfiction, I can see—now—that I have always measured my characters and their actions against the standards and values of my grandparents and my parents and the men I worked with before I put on a white collar. It's in that sense that I say a working-class ethic has conditioned almost every word I've written.

Among working-class novels I've liked in my life are Ole Rölvaag's *Giants in the Earth* and John Steinbeck's *In Dubious Battle* and *Cannery Row*. In nonfiction, Clancy Sigal's *Weekend in Dinlock* and Oscar Lewis' *Five Families* come first to mind. Very few books with the subject matter of those books are published today. You get more working-class life and atmosphere in a Walter Mosley Easy Rawlins murder mystery or an Ed McBain police procedural than in mainstream fiction, which is a pretty strange, though explainable, kettle of fish.

The formulaic best-sellers in fiction today feature heroes and heroines who have expensive meals at chic, exclusive restaurants, wear expensive clothes, own expensive houses and cars, and go to exclusive, expensive resorts in exotic vacationlands— everything expensive and out of reach of most of us. I just finished reading a prime example, *The List*, by Steve Martini. This book was a *New York Times* best-seller. It is an awkwardly written account of a novelist who writes a *NYT* best-seller. Since it was about a writer, I thought I might have some grasp of what the realities of such a story would be. I could recognize no realities in it.

In my opinion, literature is rooted in the realities of life: beans and rice, sauerkraut and franks, meat balls and gravy, pork chops and potatoes, and only once in a great while tira mi su, or profiteroles.

* * *

A last comment re Bill Gates: Personal computers are, generally, I think, little more than toys for the rich and their wannabes. Try asking a man who spends his working day running from house to house in a suburb pulling a cart and picking up garbage how much energy he has left at night to surf the Internet.

If Bill Gates wants to safeguard his fortune, he would do well—for the long-run health and vitality of the country and its economy, and thus for Microsoft sales—to urge schoolboards to take the money they're going to budget for total computerization of their classrooms and spend it on higher salaries for more teachers.

* * *

The French writer Colette once remarked, "Who said you should be happy? Do your work." The rich and the super-rich ask, "Who said we should work? Make us happy."

I have generalized about middle-class white collars of the last three or four decades, people I knew. My book about racism and capitalism, *500 Years of Obscene*, was partly about a much higher economic strata of society, the super-rich, our overclass, a minority who do not live anywhere near you and me and don't want to. These people, however, are far from indifferent to the plight of the millions of our country's poor; they endorse and encourage poverty; after all, to put it crudely, the less for you, the more for me. In their eyes, the poor are worthless.

With the author's permission, I quote my book's conclusion, conclusions I think I was starting to form back when I was seven years old:

...The overclass seems to have a deep need to hate (their fear turned inside out) and fiercely protect and add to what they have, at whatever cost to the rest of us. Compassion and cooperation do not figure in their equations, not to mention love. If they can define those who have less as unworthy, as different from themselves, they can shut their eyes to any amount of suffering and want

Racism is, has been, will continue to be a product of capitalism. The racism of slavery was, as well, of course.

All of the ugliness of racism will increasingly be used against a wider and wider spectrum of people, against everyone who has nothing by those who are increasingly approaching more closely to having everything.

The rich have their own, very destructive addiction: wealth. There is no 12-step program for this addiction, and those who have it will lie, cheat, steal, and kill for it. They do, every day. We could become a completely color-free society, and still have a small, greedy, governing overclass addicted to wealth and a huge, governed and exploited underclass— just as long as the rules in force today still obtain.

Of course I could be wrong. I think I was once. Meanwhile, inequality widens, the Dow continues to rise toward its inevitable topple, and TV continues to suck out our souls. Little enough, but a helluva lot.

Write if you get work.

JEAN

TROUNSTINE

Jean Trounstine has written about her work for *The Boston Globe Magazine, The Book Group Book, Catalyst, NADIE Journal,* and *Expanded Perspectives in Learning,* and has been featured on *The Today Show* and *Voice of America.* Her essays have appeared in journals such as *Voices West,* and her plays in prison have been the subject of over thirty news articles. All from classic texts which the women adapted themselves and put on behind bars, these plays include: *The Merchant of Venice; Lysistrata; Waiting for Lefty; The Scarlet Letter; Rapshrew* (from *The Taming of the Shrew*); *Simply Maria; The Madwomen of the Modular* (from *The Madwomen of Chaillot*); and *Arsenic and Old Lace. Changing Lives Through Literature,* a book which she co-edited, will be published by the University of Notre Dame Press in 1999.

Growing up middle class in Cincinnati, Ohio, and later, as a professor of humanities at Middlesex Community College, I never expected to find my calling working in Massachusetts' most secure prison for women. But you can't go through a pat search to enter prison without wondering what the women inside must endure every day of their lives. Schooled by those I taught, I began to understand and identify with the struggles of women behind bars, and I dedicated myself to telling their stories.

Six years ago I helped to bring an alternative sentencing program to women where offenders receive probation and a literature "sentence" instead of jail. *Changing Lives Through Literature*, a book which I co-edited, features many of the stories of working class writers that I use in this program. Through stories by authors such as Toni Morrison and Dorothy Allison, we talk about women's work, abusive relationships, families that failed, and dreams that bubble up on the pages. They are as much the teachers as I am. After twelve years of teaching writing and literature, and directing plays in prison, I have been transformed through my commitment to the working class.

NO FLUFF

Were we to answer to justice alone, none of us
would make it to heaven.
THE MERCHANT OF VENICE, Framingham Prison

Jean Trounstine

Just about the time I was bemoaning the fact that I'd never get my annual holiday cards out, a Christmas card came from Dolly, a woman who's spent twelve years in prison for second degree murder. Under a night sky, Santa and Rudolph kick up their legs and sing to the surprise of the other reindeers, *There's NO business like SNOW business like NO business I KNOW..."* Inside, above the inscription, *Wishing you the sudden inspiration of the season,* Dolly writes that she will finally see Parole in 1999, and reminds me how often she thinks about the plays we put on behind bars. It isn't that I am surprised by how strong our connection still is, even though I haven't seen her since 1995, six years after she performed the lead in *Lysistrata.* I know how important theatre was to Dolly. But I am startled that she's managed to stumble on a card about show business while in prison. There are spare supplies in the commissary at Framingham, the most secure prison for women in Massachusetts. She could have found someone inside to buy it for her, or perhaps she saved it from a package received long ago, before clothes were rationed and jewelry was taken away. Stamps no longer can be purchased for inmates by families and must come from the measly $2.00 or $3.00 a week prisoners make at jobs like microfilming or cottage cleaning. Just to get that card to me, I knew Dolly had jumped through hoops.

<center>* * *</center>

The first time Dolly came to my class in prison—I was teaching writing in the early days—she brought her knitting. There she sat, a grandmother at fifty, her hair blonde and pouffy like cotton candy, bent over a blue baby bunting for her grandchild. "I hope he's a boy," she said."It's the only color of yarn I could get." Dolly, nicknamed after Dolly Parton, had a pug nose on a face that reminded me of a racetrack bookie, pocked marked and fleshy. She was also a "sexy broad," as another classmate called her. She had a build that insisted she could hook a cow and she wrote about working on pig farms as a young girl, hauling feed. She'd been a hair-

dresser in the free world and was proud of her beautifully mauve nails which curved past the ends of her fingers.

Early on that first evening, she took me over to the window of the cramped room where we held college classes and pointed to a nest in a tree branch near the window. There were three speckled eggs. "Poor suckers," she sighed as though the eggs had been abandoned by the dead pigeon, crucified on a wire nearby. "No way to save those eggs. That area's out of bounds. No one's allowed in there. And the mama's gone." I wondered why someone who was as sharp as Dolly—she'd started a Battered Women's Group in prison, wrote poetry about lemons and insisted we set up a theatre group—had ended up with ten to fifteen.

I was never one to ask my students about their crimes—it is un-written prison code to keep convictions to yourself—but by 1988, Dolly had made it her business to get to know me, and more importantly, she wanted me to know her. She told me she'd been imprisoned unfairly for witnessing her lover kill a man. The law said she'd had a part in the mur-der, helped set him up along with George, her co-defendent. I never knew for sure what was true, and since Framingham insists, actually trains its contract employees to be distant and detached, I didn't inquire. But I al-ways suspected Dolly, a typical female inmate—poor, battered, in love with a down and out guy—had a lousy lawyer and instead of jail, should've been given probation and told to stay away from George.

Sometimes Dolly would be sitting by the window sill, before smok-ing was banned in the main institution, puffing away on a Camel, when I arrived. "You're late," she announced as I hurried in, detained by searches or other commotion at the front. "I know, I'm your captive audience," she added. "I have to wait." Those were the days when we read Tillie Olsen's "I Stand Here Ironing" and Alice Walker's "Everyday Use," stories fo-cused around single mothers who raised their kids in hard times. Dolly would greet me with photos of her granddaughter or a letter she wanted me to read. Other times, she complained about her daughter Emma, who couldn't disentangle herself from an abusive husband. "Like mother, like daughter," she'd sigh. She was always the last to leave class, worrying over a phone call that bothered her or a complaint she wanted to send to the superintendent.

She maintained that there were fewer treatment programs for women than for men, and that females were often imprisoned for longer sentences than males who committed the same crimes. At the time, I didn'tknow if she was right, but I'd listen, helping her cross her **t**'s and dot

her **i**'s so the complaints at least looked good. She'd protect other prisoners from harsh criticism if they wrote openly about their guilt or innocence, drag her friends to classes, and insist they enroll in college. Dolly was a leader.

So it wasn't out of character when she settled in to play the powerful merchant in our adaptation of the trial scene in William Shakespeare's *The Merchant of Venice.* At home with placing the scene in New York in the 1920's, she strutted and preened as Antonio, who in our version was a Mafiosa boss surrounded by his cronies. "It reminds me of bein' in Chelsea" she said, referring to the working class town she hailed from. "All the Eye-tals come out to see their friends go down in court."

She was savvy as the lead in our updated production of a Greek classic, *Lysistrata,* where a political activist convinces her compatriots to protest war. In her long billowy white dress, she urged mothers and daughters to withold sex from their men until they agreed to peace. We staged that play outside on the compound in early summer, in front of the gym's rear entrance, the aging red brick wall of the institution serving as backdrop. Trees framed the cement steps leading up to the side door of the gym, a sort of Acropolis turned steps of the White House in Washington where a modern Lysistrata and her women went to rally. We rehearsed outside in the late afternoon sun when trees were in bloom. Officers and inmates alike passed us on their way to the cottages, the prison's euphemism for barrack-like housing units where women live, four to a room. One actress tried to get me to bring in mosquito repellent, and Dolly fussed about having to carry chairs outside for the set. But obstacles then were easy to overcome. The highpoint of the play was when Dolly climbed on top of a platform, holding a megaphone in one hand and thrusting her fist into the air, entreating the audience to go the distance for peace. Dolly and the cast must have taken three curtain calls, the audience clamoring "on stage," to touch pieces of satin dresses. The chaos, controlled but enlivening, actually made me feel joyous. When I asked Dolly if she had changed as a result of the class, she replied, "I know now I can do anything."

After *Lysistrata,* Dolly was at her peak, becoming the second woman in Massachusetts to graduate from a two-year college program behind bars. She asked me to speak at her graduation, a small affair held upstairs in the series of rooms on the second floor called "Education." The large entranceway had been filled with chairs and a podium, and the event featured speeches, and even taped music like *Pomp and Circumstance.* Inmates, all dressed up in high heels and bright outfits trooped in,

single file, in a straight line. Administrators from the prison and the college made an entrance, along with a local legislator and students' family members. Teachers and prison employees sat in the front rows; prisoners in the back. It was a warm day and inmates were rustling programs or using them as fans. A baby cried a little and her mother cooed to her in hushed tones. After the superintendent and the principal spoke, handing out pink carnations to all those who'd completed G.E.D. courses, finished a college class or succeeded in certificate programs like gardening or computers, the star of the day stood up.

Dolly moved to the podium in her black robe, white-blonde hair in a twist, lips red. Her eyes were clear, almost radiant, a collar sticking out above her robe. I watched Dolly's hands, adjusting the graduation cap so the tassle didn't hang in her face. Women broke into applause, and a few "Go girls" could be heard as Dolly began her valedictory speech, telling how she grew up *in a single parent home, and lived in poverty...My biggest dream was to be a hairdresser. I had thought of college but I knew it was out of reach, a dream to be dreamed, but not touched.* She went on to say that when she was sentenced to MCI Framingham, she lost all self-esteem, but after achieving her degree, she was proud of herself: she had surpassed her dreams. The stories we read, the writing we'd done, all of it echoed in Dolly's speech. We all rose. The superintendent shook her hand and handed her a framed certificate while everyone else clapped. Even though, at the time, I couldn't shake the feeling that all the pomp and circumstance was self-congratulatory, Dolly was given a party, cake and soda, and even photo opportunities with her family. She pulled me aside to get away from the hoopla. Dolly, smoking a Camel; me hunched against a window for air; we reminisced like schoolgirls.

Six years later, by 1994, college graduations in prison were gone and many other celebrations had ceased to exist as the country had changed its tune about crime and punishment. This new "No Fluff" policy brought more prison construction nationwide with fewer preventative services. While women at Framingham were herded in and out of overcrowded spaces, recreation and treatment programs dwindled. The inmate newspaper staff was having a hard time getting approval for its current edition and hadn't printed an issue for months. Framingham's Education Department, which had never bothered much with the college program, still chugged along in its second floor corner of the old brick building, serving those who hadn't finished high school and non-English speakers. As one teacher described, "Censorship's everywhere nowadays." Instructors were scrutinized

for what videos they showed, for every word put on paper, and for the content of classes. "Inmates aren't supposed to look happy," she added. "We've been told to make sure they don't smile too much at the public events we put on."

Many states were responding to the "get tough" attitude with new sentencing laws, insisting that criminals serve more time in more secure facilities. Dolly became one of the casualties. In 1994, Dolly was living at Lancaster Prison, a pre-release facility to which, because of good behavior during her years at Framingham, she had been transferred in the summer of 1989. At Lancaster, she tasted freedom—worked at an outside job, was permitted trailer visits with her family, took classes with a four year institution, and lived without locks. I went to visit Dolly there, to help her get her feet on the ground. She'd lost weight and wore her hair cropped short and a tweed jacket over bluejeans, a "spiffy look" I told her. We sat together in the visiting room, a smoky couch-filled space with soda and candy machines, and looked at paralegal brochures. We yakked about old times and she asked questions about all "the girls." She complained about her heart condition, "an old wound," and worried about her daughter, but mostly we tried to buoy her spirits. "The world doesn't want people like me talking to kids," she remarked when I asked how she liked being in Lancaster's Outreach Program which toured local schools discussing rehabilitation. "I'm not a fighter anymore, Jean. I just don't have the juice." I tried to reassure her that wasn't true. But she told me, I was a voice of the past. "The climate's turned mean. You better watch your back."

Late that year, Congress responded to the crackdown mentality with a major Crime Bill including no federal Pell grants for prisoners after June 1995. This meant inmates would be denied college classes, since Pells supported higher education in prison, and since most states had no intention of kicking in funds, in spite of statistics showing education reduced recidivism. Although I had taught behind bars for nine years, I realized my classes would be cut along with the community college contract. I planned to hook up next with Boston University, a private school which operated without Pells, in order to continue putting on plays.

Just when I was feeling hopeful, I ran into Dolly in the hallway at Framingham. "What are you doing here?" I exclaimed to the worry etched on her face. I was shocked by her frail body, skin sagging in pockets under her eyes, the blotchy cheeks.

"They brought us back, anyone on a murder charge. The state says we have to finish our sentence *here*. 'Truth in sentencing,' they call it. Jee-sus."

She shook her head. I knew that the country's "tough on crime" policy was in full swing but I hadn't believed Massachusetts would succumb. Dolly told me about new policies, where offenders on a murder charge, having spent years in pre-release, were being yanked back to more secure facilities, often in the middle of the night. The majority of prisoners faced frequent lockdowns, cell searches at midnight, and fewer visits. While college classes were on the way out, already gone were arts and crafts, the bonsai tree program that had allowed prisoners to learn gardening, and most contracted social services like HIV support groups. "You're holding on by a string," she added, "just like me."

"I'm sorry," I mumbled, inept, wishing for words. I glanced up, as Dolly sank into a sigh. "Shattered," I thought to myself. Lysistrata was barely visible and certainly not the woman I had brought to my college the year before, as part of Lancaster's Outreach Program. Then, she had stepped up to the podium in a crowd of two hundred to retell her story of domestic violence, emphasizing how George, at one time, had beaten her up. She had been strong, triumphant, someone who had weathered despair. Looking at her now, I saw the battered woman. Dolly had not fared well in the system; punishment had all but crushed her spirit.

Dolly rubbed a sneaker into the floor. "Damn roach." She began to spell out her recent family problems, but was interrupted by an officer. The guard beckoned her back to a line of women, all in bluejeans and faded workshirts, a far cry from the old days of bright red dashikis, flouncy skirts and hats. Reluctantly, Dolly rejoined them. "Come see me when you can," I called to her. Looking over her shoulder at me, she disappeared into a sea of blue.

Dolly came to see me frequently that winter and spring. She was often loaded down with Kleenex, wheezing, and hoarse. She barely glanced at the Zora Neale Hurston book that I was reading with my class, *Their Eyes Were Watching God,* or asked about the writing we were doing based on reconstructing Janie's trial scene. Instead, Dolly would go on about her daughter Emma who had been brutally beaten by her husband, and although Emma had finally left him, was still "pining for that loser." She'd brag about her grandchildren in the same breath. "Darlene's grown so tall, Emma can hardly find clothes to fit her. Darlene still talks about that damn father of hers, how he fed her slaw and steak on a bun before he left. She keeps saying, 'Mama, I miss that slaw.'"

Dolly's tone was far from jovial. She seemed sad and still in shock from having been hauled back to Framingham. Her short hair was thinner

and had fallen out in places. There were patchy red spots, almost like bruises on her neck and cheeks, and the rest of her skin was leathery and colorless. "I'm afraid I will die in here," she said over and over. I'd nod, wishing I could tell her she wouldn't. We'd sit for a few minutes, after she came up from an early dinner, at the same table she had written essays at years before. Afternoon count would be complete and the halls relatively silent. She'd brighten when I'd ask her to tell anecdotes from pre-release, and she'd go on about the time she got to stay overnight in the trailer with her grandkids, or brag about how she had intended to earn her Paralegal degree by mail, if they hadn't "lugged" her back to Framingham. "I hate that damn Bette St. Clair," she'd announce about Framingham's recently appointed head of treatment, a tiny iron fisted maiden whose colorful suits and petite stature seemed mismatched with chain of command. "Don't kid yourself," Dolly cautioned, whispering animatedly across a table. "Control is her middle name." But most of the time, at our meetings, Dolly sat sullen, occasionally staring out the window.

One night, Dolly arrived with a letter. Lilacs flourished across the yard and their scent wafted through the open window. "It's from my lawyer. She's trying to get my sentence commuted. Will you help me?"

I looked at the envelope. It bore an official looking stamp. "How did this happen?"

"There's no other way out for me Jean. Valarie, that's my lawyer, says that I might not get the medical treatment I need unless the Governor realizes prison is killing me and gives me a pardon."

"What do you want me to do?"

"Nothing illegal," Dolly joked. And then more seriously, as she pulled her chair closer to mine. "Just call her. She'll tell you what to do." She handed me the letter. Her knuckles looked old, bruised. "I would've had her send it to you, but I couldn't find your address at the college."

Although I knew Dolly often exaggerated, and that the prison wouldn't want me involved in her life, I believed whatever her crime, she'd had enough punishment. After a certain point, incarceration stops paying off for women like Dolly and for the community they're eventually going back to. Plus, Dolly wasn't getting any healthier in prison. I'd heard about her medical mishandling from the day she'd gone to get a breast exam in handcuffs. That had been a disaster. She'd spent hours in a glass room, the kind you can see into but you can't see out of, and she was strip searched twice. "I'm never going for a breast exam again," she told our class, "even if I have to die of cancer in this hellhole." I opened the envelope and read:

This letter is to request that you write a letter of recommendation for Dolly Harrigan. We are in the process of requesting that Governor Weld commute her sentence. This letter should indicate the following: how long you've known her, how you met, what kind of person you think she is, what you base those beliefs on, and why you believe Dolly deserves to have her sentence commuted. The letter should be addressed to Governor William F. Weld and mailed back to me at this office.

"Of course I'll write for you," I said, stuffing the letter back in its envelope. Thinking of the requests for letters of recommendation from my college students, I asked, "How much time do I have?"

"Years," Dolly replied. "Years."

* * *

That spring, teaching at Framingham was as troublesome as Dolly's return to lock-up. I realized there was not one of my twenty students who knew me from past years. Along side new policies, new head of treatment and new school principal, my history had no meaning. I frequently clashed with the administration over classroom curricula. "I heard you used an essay about racial issues," the principal might say, calling me on the phone at my office. "Don't do a play about domestic violence. It's not appropriate for prisoners." My favorite was, "It would be better to avoid conflict at all cost." The interest in education seemed long gone.

The last time I saw Dolly was in 1995, the morning of our final performance of *Arsenic and Old Lace*. *Arsenic*, the eighth play I'd put on at Framingham, and a play considered an "old chestnut" in theatre lore, had taken a new turn in prison. Bette insisted her position was, "It must seem more like a class project than a play." I had agreed to censorship in spite of my better judgment, and cut out large chunks of the script, paring a three act play down to half its size. The cast wanted to keep in all the cops, always a hit with our audience, although I had told the costume company to make sure they looked like the Keystone variety. "And no real badges," I warned, remembering how years ago, I'd been forced to wait an hour while the front desk debated whether or not I could bring in a policeman's uniform. But *Arsenic's* humor, featuring two maiden aunts, pillars of the community, who render "charities" by poisoning twelve men before the curtain rises, was particularly dark in a women's prison setting. Taking a piece of literature and looking at it through the eyes of Corrections is a strange task.

We were no longer allowed to invite families, nor any outside guests. No crowds of two hundred would sit cheering in the yard or in the prison gymnasium, the gym floor having buckled with rain from roof leaks. We received approval to videotape, and to hold two performances, but some of our technical needs had been nixed. "No-go on storing the sound set-up inside," I'd been told. "They say it's 'dangerous.'" Although I wondered, to whom and why, I was not wasting energy on small matters. Just getting to do a play in this climate was enough.

Bobby pins had to be counted; wigs were not allowed; scars were okayed if put on with sticky paper; but glue was a negative. Basic make-up supplies were fine, but mustaches and hair color had to be removed before Count. Renting costumes was okayed, but with eleven cast members, we figured on at least a hundred pieces, including hats, ties, shoes, and jewelry. The costume company had to put each costume in a plastic bag with no pins; with Bette in charge, every item was inventoried and, every outfit, pat searched. As for props, I was savvy enough to realize no glass, no metal objects, and no sharp edges, so I tried to shape my lists accordingly. During *Lysistrata,* we had been permitted an old empty wine bottle for the actresses to use in the famous oath scene, but now, to avoid trouble, I had written "canteen" instead of "flask," on the prop list.

So when Dolly entered the Modular, an out-of-commission unit, and our newest theatre space, I was pacing at the front of the stage, reminding the prisoners seated on blue exercise mats not to rest their legs on our speaker cables, taped loosely to the floor. But mostly, I was worrying about whether we'd pass inspection in this year of toughness. After all, I was hanging on by a thread. When Dolly waved at me warmly, and took a seat in the last row of chairs, I felt enormous comfort seeing her and waved back. It was somehow a mixed blessing, her being in the audience eight years after *Merchant.* I tried to imagine what she must be feeling, having starred in plays years before, having graduated from college behind bars, beset with personal and legal problems, and then shipped back without warning to Framingham. "We are really something" Dolly had said the night of our first production. She'd been the first to enter the gym where actresses made-up before the show. She waved her black pencil in the air and then, carefully, drew dark brows over her own. "You look like Jackie Gleason," one of the others exclaimed. Heads turned to see. "Oh my God," sputtered another. "You do." "Watch out," Dolly said jokingly, "or I'll give you eyebrows." She placed cue cards in her pants pocket. "We might

not look nervous Jean, but we are," she reminded me. She put a red hanky in her suit pocket, a fedora upon her head and moments later, sauntered into the gym as Antonio. The audience heckled and cheered, while Dolly, like a slick politician, waved to her constituency.

I wish I could say Dolly's presence led to a great epiphany, some deeper understanding of what it meant for a woman to spend all that time in a locked environment and then after some freedom, to be locked up again, a woman who had been, in every sense of the word, one of the shining lights behind bars. But it wasn't so at the time. I just felt sad, watching Dolly peruse the *Arsenic* program, and nostalgic for what my students called "the old days." I missed the community that Dolly had been a part of, had helped to create. As Billie Holliday belted a song out of the speakers and more women drifted into the performance space, I looked around the large white room that seemed like an empty army barracks. It was a lonely road, this prison business, and I wondered if Dolly would make it without losing more of her heart.

A friend of a cast member yelled over at me, standing by the set she had designed. One of the recreation officers was snapping her photo, near the backdrop, a painted sheet complete with pictures of the aunts, 40's style radio, bookcase, and window filled with leafy tree. We had turned over an empty cabinet in the Modular, inventing a window seat, and borrowed a red couch from the Parenting Room in the main institution, dragging it across the compound to our stage. The designer was cheery, all smiles, and I waved at her. But her enthusiasm couldn't make up for the fact that few in the audience, beside Dolly, knew our history, had been around, had heard of, or been friends with the women who acted in the eight plays put on at Framingham. As officials drifted into the room and took their seats, waiting for the play to begin, I turned towards the audience. Dolly looked up and our eyes met.

* * *

The first letter was sent the day after my last class the following fall. It had been predictable, an epilogue to the action. Sending videotapes of the play to families without permission was the issue they finally snagged me on. Signed by the superintendent, the letter contained no surprises. *This letter shall serve as notification that your authorization to enter the facility will not be renewed following your completion of the current Fall, 1995 semester.* It went on to state their position on what Boston University had called "a technicality," in light of my nine years of work. In one fell

I often wonder if I had stayed in prison if I could have done more for Dolly. It was a year after I left Farmingham that the second letter arrived. It was from Dolly's lawyer. *As you most likely already heard the Advisory Board for Pardons has unanimously determined that Dolly's request for a hearing be denied at this time.... Dolly thanks you from the bottom of her heart for caring enough about her to assist her in her petition by putting your feelings down on paper.* I cried when I got that letter.

In my office at home, next to my writing desk, I have a picture Dolly created, bought at a prison art show five years ago for $25.00 It is a portrait of a woman, half her face covered by bars, a fractured vine growing out of her head. Only one side of the woman has a face; the other side is annihilated. This is what prison has done to Dolly.

But her voice echoes like bells, ringing loud, soft, sometimes tinny and shrill, above the din that surrounds our criminal justice system. Dolly is still at Framingham and she still sends me cards.

Note: The names have been changed to protect privacy, and the point of view here does not necessarily represent Framingham Women's Prison.

ARTHUR L.

CLEMENTS

Arthur L. Clements teaches at Binghamton University, where he has received both the Chancellor's and the University Awards for Excellence in Teaching. His book publications include: criticism, *The Mystical Poetry of Thomas Traherne* and *Poetry of Contemplation*; and poetry, *Dream of Flying*, and *Common Blessings*, which won an ALTA award for translation and publication in a bilingual edition, *Benedizion Comuni*.

I lived in my Italian grandparents' home and grew up in a busy, working-class, and ethnically diverse neighborhood of Brooklyn during the Great Depression and the Second Great War. (Nothing small about that era!) My grandfather, the first one up in the morning and the last home at night, worked long hours six days a week in a small barbershop in mid-town Manhattan. On Sundays, he tuned our radio to Italian opera, cut the hair of family members, tended to his vegetable garden and fig trees, and gently presided over our extended family during dinner. Before going to work, he frequently left loving notes for my grandmother that began "Cara mia Lisa." My grandmother, who died when I was ten years old, was also a gentle, loving, hard-working person, though somewhat sickly. I remember her scrubbing clothes in a large tub in our basement, cooking sauce, sausages, and meatballs in an iron pot for the next day's meal, preparing St. Joseph Day's pastries, sitting by the living room window in the evening to watch for my grandfather's return from work, and smiling a lot. As I detail in my essay, from them and other family members I learned Old-World and working-class values and habits, as from them and my mother, who died when I was six, I acquired a love of reading, writing, teaching.

My Mother, Randall Jarrell, and Me

"We owe so much to others and acknowledge so little."
Henry Miller

Arthur L. Clements

In 1967, at one of many faculty parties given at Binghamton University for visiting poets, I happened to speak with a friend of Randall Jarrell. When that friend learned I had been a writing student of Jarrell's at Princeton while Jarrell was resident poet there in 1951-52, she mentioned that Jarrell, who in 1965 was killed by a car as he walked near a highway and was thought by some to have committed suicide, was unhappy the year he spent at Princeton and she wondered whether I had any ideas why. Though I myself had often been very unhappy at Princeton, I was surprised by the question, all the more so because Jarrell had appeared that year to be cheerful, and I said no, I didn't know why he was unhappy. Over the years, partly with regard to that unanswered question, from time to time I have thought about my having been a student of Jarrell's at a pivotal period in my own life. I have reread the diary I kept that year and reread his poetry, I have read important books relating to him, particularly Mary Jarrell's edition of *Randall Jarrell's Letters* and William Pritchard's biography, *Randall Jarrell: A Literary Life*, and I have reflected on the influence of another writer on my early life, my mother, whose diary and copy of *Legends of King Arthur and His Court* with her signed name, Mena Clements, came into my hands on the death of her sister, my Aunt Clara. I'm uncertain that I yet have a satisfactory answer to the question about Jarrell that has led me to further reflection, but I believe I have discerned certain patterns in what has been a process of self-discovery. Life often imitates art in the sense that archetypes and myths of literature provide patterns by which we may come to a better understanding of our lives, patterns that sometimes mirror the patterns already in our lives so that we can see them face to face and more clearly. This process of understanding has given me more answers about myself, who I am and why I became a teacher and writer, answers that relate to my mother, to her working-class family, and to Randall Jarrell.

Randall Jarrell was born in Nashville, Tennessee, the first child of Owen Jarrell, a photographer from a rural working-class family, and Anna Campbell Jarrell. After he was one year old, his family went west, moved about considerably, and settled when he was six in Long Beach, California, the golden land. Working-class people typically seek the better life, but "better life" has a double meaning: a better economic life or a better cultural life, and often the phrase means both. The family struggled financially, his parents separating a few years later. Except for a year spent with his grandparents in Hollywood, Jarrell thereafter grew up in Nashville, active in dramatics and journalism in high school, resentful that as a youth he had to work several jobs to help with family finances when he'd rather be reading in the local library, pursuing the better cultural life. Through the generosity of an uncle he attended Vanderbilt University, where he was befriended by his teachers John Crowe Ransom and Robert Penn Warren, who recognized his brilliance and encouraged his writing poetry. Enlisting in 1942 in the U.S. Army, Jarrell served as an instructor of aviators and came back to tell about the horrors of the Good War in his second and third books of poetry, *Little Friend, Little Friend* (1945) and *Losses* (1948). By the time he arrived at Princeton in September 1951, he was well known as a poet and critic but still poor, especially because of his generous divorce settlement with his first wife, a settlement that included half his Princeton salary. In addition to teaching, he therefore had to work hard writing criticism and reviews, which paid, but left little time for his poetry.

In September 1951, I returned to Princeton for my sophomore year from a very different direction then Jarrell's, despite similarities in our working class backgrounds, but the year I spent in Creative Writing with him gave my life new direction and purpose. I was coming from the home of my immigrant Italian grandparents, Elisa Cacchione and Leopold Clemente; as a newly arrived young man in America under melting pot pressures and prejudices, my grandfather had changed his name from Clemente to Clements. By working hard, my grandparents managed to buy a new house in Brooklyn, a largely rural borough in the early twentieth century, and made many sacrifices to raise their family, struggling all the more through the Great Depression.

The oldest of five children, my mother grew up in a traditional Italian/American working-class family, "working class" being a phrase that often, somewhat euphemistically, means poor, hard-working, and under social, cultural, as well as economic pressures and prejudices. As a child and

young woman, my mother read widely, especially ancient and medieval history and literature. An idealist and romantic, she, like Miniver Cheevy, "dreamed of Thebes and Camelot." The world of her reading became the real stuff of her imagination, her real life; she preferred, as Jarrell did, reading and writing, the better cultural life. Some of the plays she wrote were based on the legends of King Arthur and all were performed under her direction for family and neighbors. In an elaborate antiquarian script, she hand-printed all the playbills. My mother's dreaming and writing became her way to rise out of oppressive immigrant working-class status and environment at a time when women had limited choices.

The diary she kept during the magical year of her engagement to my father, Arthur (Americanized from Arturo) De Lalla, mentions him in one way or another on every page. Evidently obsessed by her own knight-in-shining-armor, she seemed especially delighted that he shared the same name as one of her favorite medieval heros. She named me as much after that legendary king as after my father, as she had named my sister, four years older than I, after "Elaine the fair, Elaine the lovable, Elaine the lily maid of Astolat." I imagine my mother as an impressionable adolescent reading from the *Legends of King Arthur and His Court*, as she later read to me. From her reading she would have learned the values and ideals of Chivalry : honor, courtesy, generosity, gentleness, gallantry, and self-sacrifice, values and ideals consistent with her Old-World, Catholic, working-class family. An old story (archetype and myth), so in this spirit I imagine she must have awaited the coming of her knight.

Although my mother had thought herself most blessed to meet the man of her imagination and gladly gave him her heart and hand in marriage, the idylls of this King Arthur and Queen Philomena did not long remain idyllic. My father has been described as a man of prodigious desires, who gambled, drank, and charmed pretty women. Because he gambled away the rent money, our immediate struggling family was literally unsettled, like the young Jarrell's family, by frequent moves to different apartments or to my grandparents' home. And there were other more serious consequences of my father's misbehavior. I imagine that, having read and absorbed the legends, my mother had responded to my father as Elaine did when she first "watched the handsome face of Lancelot worshipfully....And from that moment she loved him 'with that love which was her doom.' " My Aunt Clara told me my mother wanted to heal and transform my hurt and troubled father, much as Elaine had nursed the wounded Lancelot to health and life, and in accord with chivalric, Christian, and working-class ideals of self-

sacrifice. But my father apparently was incorrigible. I imagine, too, that my mother's final feelings were like the rejected Elaine's in her "Song of Love and Death," as expressed by Tennyson:

> Sweet is true love tho' given in vain, in vain;
> And sweet is death who puts an end to pain;
> I know not which is sweeter, no, not I.
>
> I fain would follow love, if that could be;
> I needs must follow death, who calls for me;
> Call and I follow, I follow! Let me die.

Not unlike Elaine, who died for lack of Lancelot's love, my mother, on June 21, the summer solstice day of most light, in 1938, lay her head in a gas oven and committed suicide. For most of my life, I could not say to anyone, much less write, that sentence. Although suicide is the one unforgivable sin according to the Catholic Church, Graham Greene and his provocative *Brighton Rock* notwithstanding, there never was for me a question of forgiveness, only a child's bewilderment and profound sadness that have persisted along with my efforts to understand. The time of most understanding came in the year I studied writing with Randall Jarrell, a time that changed my life, although it has taken me many years fully to realize the lessons learned and implicit in that special year, to see the patterns more fully and clearly.

If, according to one interpretation of the myth of the Fortunate Fall, we all lose Eden as we grow up out of childhood, I came out of my childhood with two great losses: Eden and my mother. As Yeats wrote, "Man is in love and loves what vanishes." No wonder (and how fortunate) that I should have been profoundly affected and influenced by Randall Jarrell, whose major themes are childhood, loneliness, loss, and the deep desire for change, transformation. "Self-transformation," wrote Rilke, whom Jarrell admired and translated, "is precisely what life is." And the work of art always tells us "You must change your life." The Greek term "metaphor," the heart of poetry, is perfectly translated by the Latin term "transformation." The sensitive, tormented, gifted artists, precisely those likely to be driven by the world's cruelties to attempt suicide, most keenly desire transformation.

After my mother died and her family banished my prodigal, roving, unfaithful father, my maternal grandparents legally adopted my sister and

me, changing our last name from De Lalla to Clements (a name that had itself years previously been changed but one that still means clemency, mercy, compassion). My grandparents' home, converted some years before my mother's death to a two-family house, was not only the gathering place on special occasions of our extended family but also, on the second floor apartment, the permanent home of my mother's younger married brother, my Uncle Johnny, one of several "fathers" to me. If my mother represented the cultural better life desired by our working-class family and left me a legacy of idealism and the love of story-telling, literature, and writing, my Uncle Johnny represented the practical and economic better life and by his help and encouragement enabled me (as an uncle had enabled Jarrell to attend Vanderbilt) to go to Princeton and thereby, eventually, study with Jarrell.

My uncle was one of my early, enduring, best teachers. He taught me working-class ideals and values, such as ambition, discipline, and long hard work as well as such practical skills as do-it-yourself home repairs. He taught me to pitch a baseball and throw a football, to swing a bat and to play basketball, actually coaching me both outside our home and on the playing field and gym. And he encouraged me to attend his alma mater, Brooklyn Technical High School, one of New York City's best schools, and to become an engineer, in effect to complete his own unrealized dreams. Engineering was presented as an effective, vocational way to rise out of our difficult working-class (also meaning "poor") circumstances, and I knew what that and hard work meant because of my many part-time and summer jobs for minimal wages. But also knowing that my mother wrote and remembering poems and stories she told or read to me encouraged me to write and to enroll for two years of creative writing courses while pursuing my pre-engineering program in high school, though writing, it was understood, was not a likely way to earn a living. By nature and nurture, by presumably inherited parental traits and gifts and by working-class family influence and guidance, I seemed destined to be divided between the idealistic and the practical, between the cultural better life and the economic better life, eventually to have to choose.

This choice was clarified by my early years at Princeton. In the 1950s, Princeton students were predominantly white, Protestant, prep school boys from wealthy families. Under the University's policy of diversifying this homogenous student body, scholarships were given to working-class public school students, like myself, especially those who excelled athletically as well as academically. Even with a full-tuition scholarship, I still

needed several jobs to support myself through college. As a freshman thinking I wanted to be an engineer, I was placed in advanced Math, Physics and Chemistry classes. But it didn't take long for my thinking to start to change. In the labs, I spilled sulphuric acid on my varsity sweater, looked into the microscope and saw my eyelashes, and realized I wasn't really meant for engineering, my mother's writer's blood too thick in my veins. Besides, I became seduced by Humanities courses and the alluring Platonic trinity: Beauty, Truth, Goodness. In my first freshman semester I elected a Philosophy course, and in the second, having maintained excellent grades, I was allowed to enroll in a large upperclass Modern Literature course, the only freshman in the course. That course was pivotal. Professor Thomas Riggs, my preceptor, encouraged me to submit my term paper on T.S. Eliot's "The Wasteland" for the English Essay Prize. The prize money was more than I earned in two months from my several jobs. Receiving the award confirmed my growing inclination to switch out of engineering: as my official Princeton transcript reads, "Mr. Clements changed from a candidate for the B.S.E. degree to a candidate for the A.B. degree as of June 1951." I was by now considering a return to my mother's love, writing.

Impressed and delighted, my family took my winning the essay prize as a sure sign of my future success in leaving behind our working-class circumstances. I took special pleasure in the delight and approval of my grandfather, who had been my real father. True American that this hard-working Italian had become, he labored all his life and at the age of 86 died on Independence Day, July 4, 1951, just weeks after I received the prize check and two months before I started study with Randall Jarrell.

A few days before I returned to Princeton for my sophomore year, my long absent biological father suddenly showed up briefly in my life with his blonde girlfriend and gave me a Royal portable typewriter, about which I wrote in my diary for September 17, 1951: "A beauty, real beauty.... A symbol of my search for a spiritual father—a search for values.... A Royal way to start my literary career." About my first Creative Writing conference with Jarrell, September 27, I wrote that he impresses me as "riotously witty, intelligent, and somewhat gay" (a word I meant in the sense of Yeats' "Lear and Hamlet are gay," not of course in the current sense), and that I "should learn much. Feel as if I have already from first conference." New father figure that Jarrell may have been for me and tough-minded (but fair) critic that he was, he exhibited some of the same qualities I associated with my mother: exquisite sensitivity, intelligence, gentleness, kindness, courtesy, and a bright shining appearance (a cheerfulness that overlay a deeper sad-

ness, as I was to learn only many years later). He was critical of the five poems I submitted for our first conference and I immediately understood that all his bright intelligence and wit would be directed toward a serious and honest discussion of my work and that he would give me not ego-stroking but valuable advice and help.

I still have the black loose-leaf binder with the poems I wrote that year, along with a folder of short stories. On many of these poems I noted some of the remarks and suggestions for revisions that Jarrell made during our weekly hour-long conferences. He was particularly critical of a very long poem I wrote much in the style of Eliot's "The Wasteland." It is not surprising I attempted such a poem, having written an award-winning essay on Eliot's poem, but in our conference I learned more, I think, about the nature of good poetry and about how to write and not to write poetry than I did studying poetry for a semester in a literature course. Merciless though he was in regard to my overly imitative attempt, Jarrell also cited numerous lines for their quality and effectiveness.

As well as meeting once a week for an individual conference, Jarrell's students also met once a week for a group discussion of poems in *Reading Poems* (Oxford, 1941) and fiction in *Short Novels of the Masters* (Rinehart, 1948), both treasured books that I still have at hand. My signed and dated (9/21/51) copy of the *Short Novels* has many more marginal notes in it than my *Reading Poems* because in the Fall 1963 this wonderful collection of short novels was one of the required texts at Syracuse University in freshman English, a section of which I taught as a young Instructor. The fact that as an Instructor I taught this same book that I studied as a student in Jarrell's class aptly symbolizes the influence Jarrell had on me to become a college teacher, poet, and critic.

At our weekly small group meetings or precepts, as they were called at Princeton, we five or six students were noticeably more quiet than students generally were in precepts other than Jarrell's. I think a main reason for our shyness was that his brilliance somewhat intimidated and awed us. Although students in precepts were supposed to do most of the talking and normally did so, while the preceptor occasionally simply guided us, we were so quiet and unresponsive that on more than one occasion Jarrell took to asking each of us around the seminar table to comment on the poems or short novel under discussion. It should also be said to our credit that we were smart and serious enough as students to want to hear what he had to say. And so our reticence effectively required Jarrell to do much of the talking. Part of my diary entry for November 8th, 1951, for

example, reads: "Mr. Jarrell practically lectured on Tolstoy and his 'The Death of Ivan Ilych' in precept, but it was very enlightening. He knows so much. I feel very despondent when comparing how little I know." When I taught this story in the Fall 1963, I recalled some of what Jarrell had said about it and I felt that as a consequence I taught two of my best classes that term. As the saying goes, "A teacher affects eternity; you never know where his influence stops."

One particular aspect of Jarrell's brilliance that amazed me was the great speed and yet deep insightfulness with which he read. He would typically read quickly the poems I presented to him each week yet he commented on them at length and with extraordinary critical acumen. His father had been a photographer, and he seemed to have a photographic mind. Near the end of one of our conferences, after we discussed my poems, I mentioned that I had written an essay on Whitman for my American Literature course and he responded that he had just written an essay on Whitman and would like to read my essay. Glancing at my watch, I saw that only a few minutes remained till the end of the hour and said there wasn't time. He said, yes there was, I gave him my essay, he read it in what seemed a flash and commented on it with his characteristic critical perceptiveness. His own essay was of course his famous "Some Lines from Whitman," originally published under a different title in the *Kenyon Review* at a time when Whitman was ill-regarded by academic critics. In an essay on Jarrell's criticism that Leslie Fiedler published in the 1967 memorial volume *Randall Jarrell: 1914-1965*, edited by Lowell, Taylor, and Warren, Fiedler writes that because of Jarrell, "With Whitman we have come to feel at home once again, forgetting that only a couple of decades ago he had been declared officially dead by...Tate and Blackmur and Yvor Winters and all the small fry they spawned" (66-67). Jarrell's essay on Whitman, variously reprinted, is required reading for my students whenever I teach Whitman, which teaching, with thanks to Jarrell, I frequently do.

In that same American Literature course, we students also read *Moby Dick* (my diary entry for October 31 remarks "what a beautiful and intricate book it is!") and, led by one or another of our professors, we argued mainly about whether the whale symbolized good or evil and whether or not Melville was an atheist. There was a good amount of critical hairsplitting in literature courses, where students were of course required to write criticism; few professors encouraged creative work. Jarrell noted all of this in his December 1951 letter to Elizabeth Bishop: "I'm going to write a piece à la 'The Obscurity of the Poet' called 'The Age of Criticism'"....

The boys who write poetry and stories here say they're a small minority now, most students never think of writing anything but criticism. Two professors lead a great war, with many impassioned adherents among the students, about whether Melville was a complete Atheist...." (*Letters,* 298). "The Age of Criticism," completed while Jarrell was at Princeton, argued perceptively and persuasively that we lived in an Alexandrian age concerned more for criticism than for the literature it is supposed to help us appreciate (how much more sadly true, and therefore prescient, Jarrell's argument has become in recent decades). I recall discussing in one of our conferences in the Spring semester Jarrell's review of a critical book on Eliot, a subject I was naturally interested in. Wondering whether I should read the book after all, I asked him if the book was really as bad as he suggested. He smiled his delightful smile at me and said it was worse! Though Jarrell took issue with much of the criticism practiced in his day, he was himself one of the best critics of his time, as were other poets (such as Jonson, Coleridge, Arnold, and Eliot) in their times. He thus provided an ideal role model for the aspiring writer with much interest and some ability in both poetry and criticism. By his own dual accomplishments, as well as by his teaching, Jarrell demonstrated that we students could do it all, writing, criticism, and teaching, and, perhaps, do it all well.

Near the end of the Spring semester, I took to one of my conferences with Jarrell my much reread copy of his *The Seven-League Crutches*, which he signed "For Arthur Clements," and he wrote out his four-line poem, "Another War" (entitled "A War" in *The Complete Poems*). I always felt that he saw deeply within me, perhaps knew me better than I knew myself, and this poem confirmed my feeling. I and other students felt vulnerable and threatened by the then raging Korean War. But the poem said much more to me, and I particularly believed that Jarrell saw into and understood my terrible loneliness. Entry after entry in my diary remarks on this feeling, "I am alone, really alone." After all, I had recently lost my grandfather and my biological father had appeared and disappeared again; unlike the previous year, I was now rooming alone, and studying long hours alone; my high school sweetheart had married another, and I felt very lonely in an all-male college (I had told Jarrell that his wonderful translation of Corbière's "The Contrary Poet," a poem about a lonely poet and his lost love, was one of my favorite poems in *The Seven League Crutches*, and he of course had read my poems of love and loss); and, under financial pressures, I had managed to be excused from eating in the University Din-

ing Halls (awful food compared to my Italian family's fare) so I could save some money by eating spare meals of bread, beans, and coffee heated on a hot plate in my room alone. Living in a single room on the top floor of an all-male dormitory, I *was* The Contrary Poet in his lonely tower, and sometimes I thought I heard "the rats in the garrett...dancing farandoles! / The roof slates rattle down like castanets!" And often I felt, "Ah, but wouldn't I retail my skin to Satan / If he'd only tempt me with a little ghost —You." Jarrell had written, as Corbière had before him, a poem about — me! And so I began to understand that Art gives self-knowledge, and I wanted to live my examined life in this process of self-discovery.

I didn't then know that Jarrell, whose poetry excels at poignantly expressing feelings of solitude, loneliness, and loss, often felt that year at Princeton, like me, lonely and unhappy. Since he invariably appeared cheerful, I must assume he "prepare[d] a face to meet the faces that you meet." About that line in our preceptorial discussion of "Prufrock," Jarrell remarked that a lesser poet would have written "To prepare a mask to meet the masks that you meet", and, with memory of him, I repeat his comment when teaching "Prufrock" to my students. Only years later did I learn he was going through a divorce from his first wife and was separated by a continent from his beloved Mary von Schrader in California, whom he married in November, 1952, and to whom from Princeton he wrote at different times: "I lead a queer lonely life in Princeton...there's nothing better than an acquaintance or two—no good friend...." and "Believe me, I haven't been gay or funny without you. I often was in the fall, in a sort of desperate way. I missed you so much and was so lonesome" (*Letters,* 295, 314). Yes, underneath his bright countenance of cheerfulness, wit and humor, Jarrell had, as his poetry expresses, profound knowledge and experience of daily loneliness as well as of the horror and desperation with which ordinary life as well as war could confront any human being, and of a child's and a man's sense of loss. And so he was keenly insightful and deeply sympathetic toward others, as my diary entry for December 12, 1951, suggests.

The pages in my diary for November 30 to December 11 are blank because, despite my feeling happier at the beginning of the Fall term compared to the previous year, a growing and recurring despondency of some weeks, including "contemplation of suicide" (October 21), culminated in my visiting Dr. Melville of the Counseling Service at Princeton, with the terribly ironic result that the psychologist made me feel more depressed. My diary for December 12 reads: "The reason I have made no entries lately is be-

cause Dr. Melville had made me feel inferior and defeated. But today Mr. Jarrell said he liked my poetry, it was some of the best I've done, and I'm developing well as a poet. To hell, then, with Dr. Melville—I don't need his demoralizing psychoanalysis. I'm going to be a poet!" If Dr. Melville kept me from writing, Jarrell enabled me to write. If Jarrell saw into my distress and spoke kindly and sympathetically, I believe he also spoke, as he always did in his criticism, sincerely and honestly. He not only helped at a crucial time to give my bewildered young life direction and purpose but also, in that sense as well as a more literal sense, he helped to save my life.

For the rest of the academic year, my weekly visits with Jarrell when we discussed my writing and his weekly precepts remained the most instructive and uplifting events of my difficult sophomore year. Jarrell, so exquisitely intelligent, actually encouraged my writing and was gentle and kind (in the chivalric, Old-World way of my mother) as well as clear and firm in his helpful criticism of it. As a result, I signed up for another year of Creative Writing (with, as it turned out, Saul Bellow), continued to write and to publish regularly in the college literary magazine, and enjoyed in my senior year a reputation as "the campus poet." After my stint in the Army near the end of the Korean War, I went on to graduate work in English Literature and thereafter remained in academia as a teacher of Renaissance and Modern Literature and Creative Writing.

Robert Lowell reports that Jarrell "once said, 'If I were a rich man, I would pay money for the privilege of being able to teach.' Probably there was no better teacher of literature in the country..." (*Randall Jarrell: 1914-1965*, 105). As a former student of Jarrell's, I could not more wholeheartedly agree, with both statements. And for me, too, there was no better teacher of life. By helping and confirming me in my choice of becoming a teacher and writer rather than an engineer, Jarrell actually enabled me to accommodate both sides of my working-class heritage, both mother and uncle, so to speak. One could say that I rose out of constraining working-class circumstances by seeking first the kingdom of heaven, the good literary, cultural life of teaching, reading, writing, and that all the other things of the economic life have been added unto me, in sufficient measure, uniting love and need. As Rumi writes, "let the beauty we love be what we do." William Pritchard has observed that Jarrell "was most himself when reading, writing, and teaching"(6). Like teacher, like student. Those days I teach, read, write are my most satisfying and happy days, the days I am most myself, the days I am most transformed.

WORKING THINGS OUT

ESSENTIAL ANALYSES

BRUCE WILL

SPRINGSTEEN PERCY

Will Percy is a writer and attorney born and raised in New Orleans, Louisiana. He is a writer and activist, and the nephew of novelist Walker Percy. His work has been published in *DoubleTake, Why, Harper's,* and *Playboy* magazines. He is currently working on a book about the politics and law of environmental racism in Louisianna.

<div align="center">* * *</div>

Bruce Springsteen was born in the U.S.A. in 1949 to a working-class family in Freehold, New Jersey. A bright but rebellious student, he fell in love with rock and roll music by watching Elvis Presley on the *Ed Sullivan Show*. Despite his father's disapproval, he joined his first band, the Castiles, in 1965. For a time he studied at Ocean County Community College and contributed poems to the school's literary magazine, then began playing in different bands in Asbury Park, along the Jersey shore.

Following an abortive trip in 1972 to join his family who had relocated in the San Francisco area, he returned to the East Coast where he signed with manager Mike Appel (reputedly on the hood of a car in a dark parking lot). Under contract with Columbia Records, he released a debut album *Greetings from Asbury Park, New Jersey* in 1973, which earned him early acclaim as the "New Dylan." His active recording and performing career soon earned him the praise of critic Jon Landau: "I saw rock and roll's future and its name is Bruce Springsteen." 1975 brought the release of *Born to Run* with its urban lyricism and his wall of sound production.

In the two follow-up albums, *Darkness at the Edge of Town* (1975) and *The River* (1980) Springsteen developed a new intimacy with his material and audience by treating themes of youthful idealism and disillusionment with an emotional realism. This vein was further explored in his 1982 acoustic recording of *Nebraska* in which he speaks of forgotten American lives in an intimate and plan-speaking voice. Working with the E Street Band in 1984, he released *Born in the U.S.A.* which became an American rock anthem.

The personal strain and failure of his marriage to actress-model Julianne Phillips was treated in his *Tunnel of Love* (1987), followed by a six week rock tour to raise monies in support of Amnesty International's work for human rights. A romance with backup singer Patti Scialfa led to their marriage in 1991 and their three children.

In many ways Bruce Springsteen has become synonymous with America, giving voice to its forgotten people and expressing a heartfelt belief in its lost values of compassion. His powerful single "The Streets of Philadelphia" treated the disease of AIDS and has been followed by his acclaimed *The Ghost of Tom Joad* (1995). In the line of folk singer Woody Guthrie and novelist John Steinbeck, Springsteen identifies with and gives voice to working-class people everywhere and exposes the travesty of an American Dream gone sour. His musical vision and goals are clear, "People deserve . . . truth. They deserve honesty. The best music, you can seek some shelter in it momentarily, but it's essentially there to provide you something to face the world with."

Rock and Read

Will Percy Interviews Bruce Springsteen

In the fall of 1997, Will Percy, nephew of novelist Walker Percy, conducted the following interview with singer and songwriter Bruce Springsteen. They met on a farm in central New Jersey, not far from the small town where Springsteen grew up and near the Jersey Shore clubs where he first made his mark as a musician in the 1970's. The two explored the importance of working-class culture and books in Springsteen's life, including his fondness of Walker Percy's essays in *The Message in the Bottle* and his deep ties to working class life and art. [This interview first appeared in the spring 1998 issue of *Doubletake* magazine.]

Will Percy: When did books start influencing your songwriting and music? I remember as early as 1978, when I saw you in concert, you mentioned Ron Kovic's *Born on the Fourth of July*, and you dedicated a song to him.

Bruce Springsteen: I picked up that book in a drugstore in Arizona while I was driving across the country with a friend of mine. We stopped somewhere outside of Phoenix, and there was a copy of the paperback in the rack. So I bought the book and I read it between Phoenix and Los Angeles, where I stayed in this little motel. There was a guy in a wheelchair by the poolside every day, two or three days in a row, and I guess he recognized me, and he finally came up to be and said, "Hey, I'm Ron Kovic"—it was really very strange—and I said, "Oh, Ron Kovic, gee, that's good." I thought I'd met him before somewhere. And he said, "No, I wrote a book called *Born on the Fourth of July*." And I said, "You wouldn't believe this. I just bought your book in a drugstore in Arizona and I just read it. It's incredible." Real, real powerful book. And we talked a little bit and he got me interested in doing something for the vets. He took me to a vet center in Venice, and I met a bunch of guys along with this guy Bobby Muller who was one of the guys who started VVA, Vietnam Veterans of America.

I go through periods where I read, and I get a lot out of what I read, and that reading has affected my work since the late seventies. Films and novels and books, more so than music, are what have really been driving me since then. Your uncle once wrote that "American novels are about everything," and I was interested in writing about "everything" in some

fashion in my music: how it felt to be alive now, a citizen of this country in this particular place and time and what that meant, and what your possibilities were if you were born and alive now, what you could do, what you were capable of doing. Those were ideas that interested me.

The really important reading that I did began in my late twenties, with authors like Flannery O'Connor. There was something in those stories of hers that I felt captured a certain part of the American character that I was interested in writing about. They were a big, big revelation. She got to the heart of some part of meanness that she never spelled out, because if she spelled it out you wouldn't be getting it. It was always at the core of every one of her stories—the way that she'd left that hole there, that hole that's inside of everybody. There was some dark thing—a component of spirituality—that I sensed in her stories, and that set me off exploring characters of my own. She knew original sin— knew how to give it the flesh of a story. She had talent and she had ideas, and the one served the other.

I think I'd come out of a period of my own writing where I'd been writing big, sometimes operatic, and occasionally rhetorical things. I was interested in finding another way to write about those subjects, about people, another way to address what was going on around me and in the country— a more scaled-down, more personal, more restrained way of getting some of my ideas across. So right prior to the record *Nebraska* [1982], I was deep into O'Connor. And then, later on, that led me to your uncle's books, and Bobbie Ann Mason's novels—I like her work.

I've also gotten a lot out of Robert Frank's photography in *The Americans*. I was twenty-four when I first saw the book—I think a friend had given me a copy—and the tone of the pictures, how he gave us a look at different kinds of people, got to me in some way. I've always wished I could write songs the way he takes pictures. I think I've got half a dozen copies of that book stashed around the house, and I pull one out once in a while to get a fresh look at the photographs.

WP: I find it interesting that you're influenced a lot by movies—you said you're more influenced by movies and books than music. In the liner notes of *The Ghost of Tom Joad* you credited both the John Ford film and the book *The Grapes of Wrath* by Steinbeck.
BS: I came by the film before I really came by the book. I'd read the book in high school, along with *Of Mice and Men* and a few others, and then I read it again after I saw the movie. But I didn't grow up in a community of ideas—a place where you can sit down and talk about books, and how you read through them, and how they affect you. For a year, I went to a local

college a few miles up the road from here, but I didn't really get much out of that particular place. I think I'm more a product of pop culture: films and records, films and records, films and records, especially early on. And then later, more novels and reading.

WP: Where did you draw your musical influences in your earlier writing as compared with this last album?

BS: Up until the late seventies, when I started to write songs that had to do with class issues, I was influenced more by the music like the Animals' "We Gotta Get Out of This Place" or "It's My Life (And I'll Do What I Want)"—sort of class-conscious pop records that I'd listen to—and I'd say to myself: "That's my life, that's my life!" They said something to me about my own experience of exclusion. I think that's been a theme that's run through much of my writing: the politics of exclusion. My characters aren't really antiheroes. Maybe that makes them old-fashioned in some way. They're interested in being included, and they're trying to figure out what's in their way.

I'd been really involved with country music right prior to the album *Darkness on the Edge of Town* [1978], and that had a lot of effect on my writing because I think country is a very class-conscious music. And then that interest slowly led me into Woody Guthrie and folk music. Guthrie was one of the few songwriters at the time who was aware of the political implications of the music he was writing— a real part of his consciousness. He set out intentionally to address a wide variety of issues, to have some effect, to have some impact, to be writing as a way to have some impact on things: playing his part in the way things are moving and things change.

I was always trying to shoot for the moon. I had some lofty ideas about using my own music, to give people something to think about— to think about the world, and what's right and wrong. I'd been affected that way by records, and I wanted my own music and writing to extend themselves in that way.

WP: I notice that you talk about "writing" and not "songwriting." Do you sit down and write lyrics and then look for music?

BS: When I write rock music, music with the whole band, it would sometimes start out purely musically, and then I'd find my way to some lyrics. I haven't written like that in a while. In much of my recent writing, the lyrics have preceded the music, though the music is always in the back of my

mind. In most of the recent songs, I tell violent stories very quietly. You're hearing characters' thoughts—what they're thinking after all the events that have shaped their situation have transpired. So I try to get that internal sound, like that feeling at night when you're in bed and staring at the ceiling, reflective in some fashion. I wanted the songs to have the kind of intimacy that took you inside yourself and then back out into the world.

I'll use music as a way of defining and coloring the characters, conveying the characters' rhythm of speech and pace. The music acts as a very still surface, and the lyrics create a violent emotional life over it, or under it, and I let those elements bang up against each other.

Music can seem incidental, but it ends up being very important. It allows you to suggest the passage of time in just a couple of quiet beats. Years can go by in a few bars, whereas a writer will have to come up with a clever way of saying, "And then years went by. . . ." Thank God I don't have to do any of that! Songwriting allows you to cheat tremendously. You can present an entire life in a few minutes. And then hopefully, at the end, you reveal something about yourself and your audience and the person in the song. It has a little in common with short-story writing in that it's character-driven. The characters are confronting the questions that everyone is trying to sort out for themselves, their moral issues, the way those issues rear their heads in the outside world.

WP: While your previous albums might all come from personal experience— from the people and places you grew up with in New Jersey and elsewhere—you seem to have started writing more about other people and topics now, Mexican immigrants, for instance, in songs like "Sinaloa Cowboys." With that song, I remember you said in concert that it started out when you met a couple of Mexican brothers in the desert once when you were traveling.

BS: There's no single place where any of the songs come from, of course. True, I drew a lot of my earlier material from my experience growing up, my father's experience, the experience of my immediate family and town. But there was a point in the mid-eighties when I felt like I'd said pretty much all I knew how to say about all that. I couldn't continue writing about those same things without either becoming a stereotype of myself or by twisting those themes around too much. So I spent the next ten years or so writing about men and women—their intimate personal lives. I was being introspective but not autobiographical. It wasn't until I felt like I had a stable life in that area that I was driven to write more outwardly—about social issues.

A song like "Sinaloa Cowboys" came from a lot of places. I'd met a guy in the Arizona desert when I happened to be on a trip with some friends of mine, and he had a younger brother who died in a motorcycle accident. There's something about conversations with people—people you've met once and you'll never see again—that always stays with me. And I lived for quite awhile in Los Angeles, and border reporting and immigration issues are always in the paper there. I've traveled down to the border a number of times.

WP: Why would you travel down to the border?
BS: With my dad, I'd take trips to Mexico a few years back. We'd take these extended road trips where we'd basically drive aimlessly. The border wasn't something I was consciously thinking about, it was just one of those places that all of a sudden starts meaning something to you. I'm always looking for ways to tell a particular story, and I just felt the connection, I can't explain what it was exactly—a connection to some of the things I'd written about in the past.

I don't think you sit down and write anything that isn't personal in some way. In the end, all your work is a result of your own psychology and experience. I never really write with a particular ideology in mind. As a writer, you're searching for ways to present different moral questions— to yourself because you're not sure how you will respond, and to your audience. That's what you get paid for—from what I can tell. Part of what we call entertainment should be "food for thought." That's what I was interested in doing since I was very young, how we live in the world and how we ought to live in the world. I think politics are implicit. I'm not interested in writing rhetoric or ideology. I think it was Walt Whitman who said, "The poet's job is to know the soul." You strive for that, assist your audience in finding and knowing theirs. That's always at the core of what you're writing, of what drives your music.

It's all really in you uncle's essay "The Man on the Train," about the "wandering spirit" and modern man—all that's happened since the Industrial Revolution when people were uprooted and set out on the road into towns where they'd never been before, leaving families, leaving traditions that were hundreds of years old. In a funny way, you can even trace that story in Chuck Berry's "Johnny B. Goode." I think that we're all trying to find what passes for a home, or *creating* a home of some sort, while we're constantly being uprooted by technology, by factories being shut down.

I remember when my parents moved out to California—I was about eighteen. My folks decided that they were going to leave New Jersey, but they had no idea really where to go. I had a girlfriend at the time and she was sort of a hippie. She was the only person we knew who'd ever been to California. She'd been to Sausalito and suggested they go there. You can just imagine—Sausalito in the late Sixties! So they went to Sausalito, three thousand miles across the country, and they probably had only three grand that they'd saved and that had to get them a place to live, and they had to go and find work. So they got to Sausalito and realized this wasn't it. My mother said they went to a gas station and she asked the guy there, "Where do people like us live?"— that's a question that sounds like the title of a Raymond Carver story! And the guy told her, "Oh, you live on the peninsula." And that was what they did. They drove down south of San Francisco and they've been there ever since. My father was forty-two at the time— it's funny to think that he was probably seven or eight years younger than I am now. It was a big trip, took a lot of nerve, a lot of courage, having grown up in my little town in New Jersey.

But that story leads back to those same questions: how do you create the kind of home you want to live in, how do you create the kind of society you want to live in, what part do you play in doing that? To me, those things are all connected, but those connections are hard to make. The pace of the modern world, industrialization, post-industrialization, have all made human connection very difficult to maintain and sustain. To bring that modern situation alive—how we live now, our hang-ups and choices— that's what music and film and art are about— that's the service you're providing, that's the function you're providing as an artist. That's what keeps me interested in writing.

What we call "art" has to do with social policy—and it has to do with how you and your wife or you and your lover are getting along on any given day. I was interested in my music covering all those bases. And how do I do that? I do that by telling stories, through characters' voices—hopefully stories about inclusion. The stories in *The Ghost of Tom Joad* were an extension of those ideas: stories about brothers, lovers, movement, exclusion—political exclusion, social exclusion—and also the responsibility of these individuals—making bad choices, or choices they've been backed up against the wall to make.

The way all those intersect is what interests me. The way the social issues and the personal issues cross over one another. To me, that's how people live. These things cross over our lives daily. People get tangled

up in them, don't know how to address them, get lost in them. My work is a map, for whatever it's worth—for both my audience and for myself—and it's the only thing of value along with, hopefully, a well-lived life that we leave to the people we care about. I was lucky that I stumbled onto this opportunity early in my life. I think that the only thing that was uncommon was that I found a language that I was able to express those ideas with. Other people all the time struggle to find the language or don't find the language—the language of the soul—or explode into violence or indifference or numbness, just numbed out in front of TV. "The Language"—that's what William Carlos Williams kept saying, the language of live people, not dead people!

If I'm overgeneralizing, just stop me. I'm not sure if I am or not, but in some fashion that's my intent, to establish a commonality by revealing our inner common humanity, by telling good stories about a lot of different kinds of people. The songs on the last album connected me up with my past, with what I'd written about in my past, and they also connected me up with what I felt was the future of my writing.

WP: Do you think your last album [*The Ghost of Tom Joad*], which wasn't a pop or rock-n-roll record, had the same impact on the larger public that other records of yours had?

BS: I've made records that I knew would find a smaller audience than others that I've made. I suppose the larger question is, How do you get that type of work to be heard—despite the noise of modern society and the media, two hundred television channels? Today, people are swamped with a lot of junk, so the outlets and the avenues for any halfway introspective work tend to be marginalized. The last record might have been heard occasionally on the radio, but not very much. It's a paradox for an artist—if you go into your work with the idea of having some effect upon society, when, by the choice of the particular media, it's marginalized from the beginning. I don't know of any answer, except the hope that somehow you do get heard— and there are some publishing houses and television channels and music channels that are interested in presenting that kind of work.

I think you have to feel like there's a lot of different ways to reach people, help them think about what's really important in this one-and-only life we live. There's pop culture—that's the shotgun approach, where you throw it out and it gets interpreted in different ways and some people pick up on it. And then there's a more intimate, focused approach like I tried on *Tom Joad.* I got a lot of correspondence about the last album from a lot of

different people—writers, teachers, those who have an impact in shaping other people's lives.

WP: Do you think pop culture can still have a positive effect?
BS: Well, it's a funny thing. When punk rock music hit in the late 1970's, it wasn't played on the radio, and nobody thought, Oh yeah, that'll be popular in 1992 for two generations of kids. But the music dug in, and now it has a tremendous impact on the music and culture of the nineties. It was powerful, profound, music and it was going to find a way to make itself heard eventually. So I think there's a lot of different ways of achieving the kind of impact that most writers and film-makers, photographers, musicians want their work to have. It's not always something that happens right away— the "Big Bang"!

With the exception of certain moments in the history of popular culture, it's difficult to tell what has an impact anymore, and particularly now when there're so many alternatives. Now, we have the fifth Batman movie! I think about the part in the essay "The Man on the Train" where your uncle talks about alienation. He says the truly alienated man isn't the guy who's despairing and trying to find his place in the world. It's the guy who just finished his twentieth Erle Stanley Gardner Perry Mason novel. *That* is the lonely man! *That* is the alienated man! So you could say, similarly, the guy who just saw the fifth Batman picture, *he's* the alienated man. But as much as anyone, I still like to go out on a Saturday night and buy the popcorn and watch things explode, but when that becomes such a major part of the choices that you have, when you have *sixteen* cinemas and fourteen of them are playing almost exactly the same picture, you feel that something's going wrong here. And if you live outside a major metropolitan area, maybe you're lucky if there's a theater in town that's playing films that fall *slightly* outside of those choices.

There's an illusion of choice that's out there, but it's an *illusion*, it's not *real* choice. I think that's true in the political arena and in pop culture, and I guess there's a certain condescension and cynicism that goes along with it—the assumption that people aren't ready for something new and different.

WP: Do you think that the culture of celebrity is a cause of some of those problems? You seem to have escaped some of the problems that go along with being a celebrity.

BS: I don't know, it's the old story—a lot of it is how you play your role. My music was in some sense inclusive and pretty personal, maybe even friendly. I've enjoyed the trappings from time to time, but I think I like a certain type of freedom. Of course, I enjoy my work being recognized, and when you get up on stage in front of twenty thousand people and you shake your butt all around, you're asking for some sort of trouble. I hope I've kept my balance. I enjoy my privacy.

I don't think the fascination with celebrities will ever really go away. An intellectual would say that people in the Industrial Age left their farms and their towns, so they couldn't gossip with their neighbors over the fence anymore—and all of a sudden there was a rise of a celebrity culture so we could have some people in common that we could talk about.

The substantive moral concern might be that we live in a country where the *only* story might be who's succeeding and who's number one, and what are you doing with it. It sure does become a problem if a certain part of your life as a writer—your "celebrity," or whatever you want to call it—can blur and obscure the story that you're interested in telling. I've felt that and seen that at certain times. One of the most common questions I was asked on the last tour, even by very intelligent reviewers was, "Why are you writing these songs? What are you complaining about? You've done great." That's where your uncle's essay "Notes on a Novel about the End of the World" was very helpful to me and my writing. Your uncle addresses the story behind those same comments: "The material is so depressing. The songs are so down." He explains the moral and human purpose of writing by using that analogy of the canary that goes down into the mine with the miners: when the canary starts squawking and squawking and finally keels over, the miners figure it's time to come up and think things over a little bit. That's the writer—the twentieth-century writer is the canary for the larger society.

Maybe a lot of us use the idea of "celebrity" to maintain the notion that everything is alright, that there's always *someone* making their million the next day. As a celebrity, you don't worry about your bills, you have an enormous freedom to write and to do what you want. You can live with it well. But if your work is involved in trying to show where the country is hurting and where people are hurting, your own success is used to knock down or undercut the questions you ask your audience. It's tricky, because American society has a very strict idea of what success is and what failure is. We're *all* "born in the U.S.A." and some part of you carries that with you. But it's ironic if "celebrity" is used to reassure lots of people, barely

making it, that "Look, someone's *really* making it, making it big, so everything is alright, just lose yourself and all your troubles in that big-time success!"

WP: Do you think you're through making music videos?

BS: I don't know. I probably am. There's nobody waiting with bated breath out there for my next video right now. I've never been much of a video artist. I was "prevideo," and I think I remain "prevideo," though maybe I'm "postvideo" now.

Music videos have had an enormous impact on the way that you receive visual images on television and in the theaters—and it sped up the entire way the music world worked, for better or for worse. When I started, you had a band, you toured two or three, four years, you did a thousand shows or five hundred shows, that's how you built your audience, and then maybe you had a hit record. I feel sorry for some of these talented young bands that come up: they have made a hit record, a video or two, and then it's over. I think it might have the music world more fickle. In some ways, it may be more expedient for some of the young acts, but I think it's harder also, because you don't have the time to build a long-standing relationship with your audience.

There was something about developing an audience slowly—you'd draw an audience that stood with you over a long period of time, and it got involved with the questions you were asking and the issues you were bringing up. It's an audience who you shared a history with. I saw the work that I was doing as my life's work. I thought I'd be playing music my whole life and writing my whole life, and I wanted to be a part of my audience's ongoing life. The way you do that is the same way your audience lives its life—you do it by attempting to answer the questions that both you and they have asked, sometimes with new questions. You find where those questions lead you to—your actions in the world. You take it out of the aesthetic and you hopefully bring it into your practical, everyday life, the moral or ethical.

"Man on the Train" helped me think about these things in some fashion, where your uncle dissects the old Western movie heroes. We have our mythic hero, Gary Cooper, who is capable of pure action, where it's either all or nothing, and he looks like he's walking over that abyss of anxiety, and he won't fail. Whereas the moviegoer, the person watching the movies, is not capable of that. There's no real abyss under Gary Cooper, but there *is* one under the guy watching the film! Bringing people out

over that abyss, helping them and myself to realize where we all "are," helping my audience answer the questions that are there—that's what I'm interested in doing with my own work.

That's what I try to accomplish at night in a show. Presenting ideas, asking questions, trying to bring people closer to characters in the songs, closer to themselves—so that they take those ideas, those questions—fundamental moral questions about the way we live and the way we behave toward one another—and then move those questions from the aesthetic into the practical, into some sort of action, whether it's action in the community, or action in the way you treat your wife, or your kid, or speak to the guy who works with you. That is what can be done, and *is* done, through film and music and photography and painting. Those are real changes I think you can make in people's lives and that I've had made in my life through novels and films and records and people who meant something to me. Isn't that what your uncle meant by "existentialist reflection"?

And there's a lot of different ways that gets done. You don't have to be doing work that's directly socially conscious. You could make an argument that one of the most socially conscious artists in the second half of this century was Elvis Presley, even if he probably didn't start out with any set of political ideas that he wanted to accomplish. He said, "I'm all shook up and want to shake you up," and that's what happened. He had an enormous impact on the way that people lived, how they responded to themselves, to their own physicality, to the integration of their own nature. I think that he was one of the people, in his own way, who led to the sixties and the Civil Rights movement. He began getting us "all shook up," this poor white kid from Mississippi who connected with black folks through their music, which he made his own and then gave to others. So pop culture is a funny thing—you can affect people in a lot of different ways.

WP: Did you always try to affect the audience like that? When you first started out, when you were young?

BS: We were trying to excite people, we were trying to make people feel alive. The core of rock music was cathartic. There was some fundamental catharsis that occurred in "Louie, Louie." That lives on, that pursuit. Its very nature was to get people "in touch" with themselves and with each other in some fashion. So initially you were just trying to excite people, and make them happy, alert them to themselves, and do the same for yourself. It's a way of combating your own indifference, your own tendency to slip into alienation and isolation. That's also in "Man on the Train": we

can't be alienated *together*. If we're all alienated together, we're really not alienated.

That's a lot of what music did for me—it provided me with a community, filled with people, and brothers and sisters whom I didn't know, but whom I knew were out there. We had this enormous thing in common, this "thing" that initially felt like a secret. Music always provided that home for me, a home where my spirit could wander. It performed the function that all art and film and good human relations performed—it provided me with the kind of "home" always described by those philosophers your uncle loved.

There are very real communities that were built up around that notion—the very real community of your local club on Saturday night. The importance of bar bands all across America is that they nourish and inspire that community. So there are the very real communities of people and characters, whether it's in Asbury Park or a million different towns across the land. And then there is the community that it was enabling you to imagine, but that you haven't seen yet. You don't even know it exists, but you feel that, because of what you heard or experienced, it *could* exist.

That was a very powerful idea because it drew you outward in search of that community—a community of ideas and values. I think as you get older and develop a political point of view, it expands out into those worlds, the worlds of others, all over America, and you realize it's just an extension of that thing that you felt in a bar on Saturday night in Asbury Park when it was a hundred and fifty people in the room.

What do you try to provide people? What do parents try to provide their children? You're suppose to be providing a hopeful presence, a decent presence, in you children's lives and your neighbors' lives. That's what I would want my children to grow up with and then to provide when they become adults. It's a big part of what you can do with a song, and pictures and words. It's real and its results are physical and tangible. And if you follow its implications, it leads you both inward and outward. Some days we climb inside, and some days maybe we run out. A good day is a balance of those sort of things. When rock music was working at its best, it was doing all of those things—looking inward and reaching out to others.

To get back to where we started, it can be difficult to build those kinds of connections, to build and sustain those kinds of communities, when you're picked up and thrown away so quickly—that cult of celebrity. At your best, your most honest, your least glitzy, you shared a common history, and you attempted both to ask questions and answer them in concert

with your audience. *In concert*. The word "concert"—people working together—that's the idea. That's what I've tried to do as I go along with my work. I'm thankful that I have a dedicated, faithful audience that's followed along with me a good part of the way. It's one of my life's great blessings—having that companionship and being able to rely on that companionship. You know, "companionship" means breaking bread with your brothers and sisters, your fellow human beings—the most important thing in the world! It's sustained my family and me and my band throughout my life.

WP: Do you think you've extended your audience to include some of the kinds of people that you're writing about now: Mexican immigrants, homeless people? Do you feel that you're doing something for those people with your music?

BS: There's a difference between an emotional connection with them, like I think I do have, and a more physical, tangible impact. There was a point in the mid-eighties where I wanted to turn my music into some kind of activity and action, so that there was a practical impact on the communities that I passed through while I traveled around the country. On this last tour, I would meet a lot of people who are out there on the front line—activists, legal advocates, social workers—and the people that they're involved with. It varied from town to town, but we'd usually wok with an organization that's providing immediate care for people in distress, and then also we'd find an organization that's trying to have some impact on local policy. It helped me get a sense of what was going on in those towns, and the circumstances that surround the people that I'm imagining in my songs, in the imagined community I create with my music.

I'm sure I've gotten a lot more out of my music than I've put in, but those meetings and conversations keep me connected so that I remember the actual people that I write about. But I wouldn't call myself an activist. I'm more of a concerned citizen. I think I'd say that I'm up to my knees in it, but I'm not up to my ass!

I guess I'm—rock bottom—a concerned, even aroused observer, sort of like the main character of Ralph Ellison's *Invisible Man*. Not that I'm invisible! But Ellison's character doesn't directly take on the world. He wants to see the world change, but he's mainly a witness, a witness to a lot of blindness. I recently heard two teachers one black and one white, talking about that novel, and it sure got to them; it's what Ellison wanted it to be, it's a great American story—and in a way we're all part of it.

EDWINA

PENDARVIS

Edwina (Eddy) Pendarvis teaches at Marshall University in Huntington, West Virginia. Every year in addition to her regular course load, she teaches an English composition course for college credit to students at a local high school. Her poems and articles have been published in *Antietam Review, Appalachian Journal, Bone & Flesh, Now & Then, Phoebe, Small Pond, Wind Magazine, Zone 3*, and other journals. Her poetry collection, *Joy Ride*, is published in *Human Landscapes* (Bottom Dog Press, 1997).

I was born in eastern Kentucky and spent my childhood in small coal towns there and in southern West Virginia. During my teen-age and early adult years I lived in Florida, where I failed unspectacularly at several jobs. A brief stint as a curb hop ended because I didn't yell the orders loud enough. I also failed as a lingerie model (too shy) and as a telemarketer (not persistent enough). My only job success, as a kindergarten aide, seemed insignificant, given my resolve never to become a teacher. With the help of a National Defense Education Act Loan—which could be repaid through teaching—I went to college, majoring in English. Having hated elementary school and high school, I was surprised to find I enjoyed college. The English major allowed me to get credit for doing what I loved to do anyway: read novel, stories, and poems.

After graduating reluctantly, I tried to get a job as a reporter, a proof-reader, even an advertising-copy writer, but couldn't get any job that drew much on my major except, of course, teaching. After teaching junior high and high school English for a few years and finding it more fun than Id expected, I had to leave my job because a Florida law required teachers who were pregnant to take a leave or quit as soon as their pregnancy became obvious. Here was an excuse to go back to school.

Two children, two degrees, and many years later, I am surprized to realize I've taught more of my life than not.

"Rescue Me"

Edwina Pendarvis

Today, the temperature in Dallas, Texas, is 112 degrees. It's been in the triple digits, the radio says, for 24 days now. Eighteen people have died from the heat. South Dallas—mostly Hispanic and African-American, all poor—is hit the hardest. I hear this news only a day or two after my sister has sent me a science section of the *New York Times* reporting the twentieth century to be the hottest of the past six centuries in which weather has been systematically recorded. The warming trend, according to the *Times*, seems due to the greenhouse effect, the accumulated pollution of industrialized nations.

As the earth's air and water are being polluted, mountaintops chopped off, forests destroyed, and temperatures forced upward, all for profit, what do I do with my leisure time? Like many other people, I spend too much time with what are essentially fairy tales. I read romantic nineteenth-century novels, like Bronte's *Wuthering Heights*, and twentieth-century science fiction, like Gibson's *Count Zero*; and I watch innumerable action movies featuring sensational escapes from mortal danger. With all I know about the disastrous effects greed for inordinate profits has had on working-class people, I do little to try to rescue myself, my family, and my friends from the even worse privations the future seems to hold. What little I do, though, is grounded in another kind of literature, one that doesn't feature fantastic notions of rescue from existential fears.

Fairy tales, updated and mass-produced, reinforce my tendency to look for rescue by magic and, not only to look for impossible rescue—but rescue from the wrong things. It takes powerful antidotes, like the poems of Lucille Clifton, author of *Two-Headed Woman, Good Woman: Poems and a Memoir, Quilting,* and *The Book of Light*, to help me focus my energy to write and take an active part in working-class struggles to effect my own rescue. I think I'd spend even more of my leisure time on fairy tales if it weren't for such counterbalancing literary influences as the writings of Clifton and others who write about working-class lives.

While I'm confessing to marked escapist tendencies, I may as well admit that my earliest literary influence was comic books, or "funny" books. Escapist as they were, though, some funny books of the early 1950's coun-

tered *some* of the sexist, reactionary conventions of the popular fairy tales children of the time read, listened to, and watched at the movies. Fairy tales idealized wealth, nobility, and beauty as outward signs of an inner grace possessed only by a fortunate few; funny books helped to form my taste for a more democratic literature.

Funny books meant a lot to me, as they probably did to working-class children across the country at the time. They were the first books I can remember reading on my own. Like a lot of kids, I read them before I could read—I read the pictures. My friends and I bought them and traded with each other after we'd read them. All the children I knew had stacks of comic books. In fact, these neighborhood stacks were our lending library; I never saw a public library in any of the small coal towns my family lived in. We seldom read adventure comics featuring larger-than-life figures like Superman or Wonder Woman—maybe they were too hard for most of us to read. We liked the humorous exploits of more humble characters. The glossy covers and newsprint pages depicting the adventures of Little Lulu, Tubby, Woody Woodpecker, Goofy, and Donald Duck gave me my first independent experience of literary pleasure. From the time I was five years old until I was nine or ten, I read many more funny books than fairy tales. Though I see the influence of both in my writing, I think funny books contributed more to the egalitarian basis of my work.

Cinderella and Snow White, whether in rags or in finery, were *too* beautiful and good. Worse, fairy tales confounded these two qualities so you couldn't have one without the other. My friends and I thought our freckles and bony knees precluded beauty and thus ruled out goodness as well. Since fairy-tale heroines seemed to have *only* beauty and goodness to draw on as they faced danger, we knew that in comparison we weren't really up to the task of facing life's dangers. It didn't take such beauty and virtue to measure up in funny books.

One reason it didn't was that life was safer. In funny books authority was only a dimly felt presence. A mother or father might be depicted only as a pair of feet in high-heels or house slippers, with the rest of the figure always out of the frame. Adults were mostly benign or ineffective. Even if they nagged or yelled, they weren't much heeded—think of Sylvester's grandmotherly owner fussing about the cat's tireless efforts to catch and eat Tweety bird; or Dennis the Menace's neighbor, Mr. Wilson, having an apoplectic, but harmless, fit of temper over one of Dennis's innocent insults to his dignity.

Funny books got some of their humor from lampooning the evil authority figures of fairy tales. Witch Hazel's niece, Little Itch, and the Big Bad Wolf's son, Li'l Bad Wolf, consistently disobeyed their elders, undermining their authority. Little Itch out-witched her aunt, and the littlewolf refused to be bad, repeatedly foiling his father's wicked (but not very wicked) plots. This was a strong contrast to traditional fairy tales, in which children's fate at the hands of a malevolent authority was circumvented only by rescue by a benevolent authority—often royalty, in the form of a prince, a *handsome* prince. In funny books, children's lives didn't depend on perfect goodness or beauty, and the plot was moved forward by a set of humble characters who were roughly equal in power—a community of peers.

Little Lulu was a working-class Snow White: not the daughter of a king, her hair only *almost* black as coal, her skin not quite as white as snow, only her dress was blood red—suggesting she could hold her own. Alone or with her friend and rival, Tubby, she set out confidently, making her way in their world with optimistic equanimity. Little Lulu and other comic-book children didn't wait for rescue. They met their problems with cunning and high spirits, the qualities that leftist literary critic Walter Benjamin admired in heroes and heroines of folk tales.

The funny books I read often used magic—talking animals, for example—but the plots didn't usually *depend* on magic. In contrast, fairy tales, which appeal to existential fears shared by almost everyone, depend on "faery" or magic. Magic is the means and end of fairy-tale plots. Unnatural evil sets them moving and (unnatural) living happily ever after is their point. Although our modern fairy tales usually dispense with beneficent animals, fairy godmothers, witches, and magic spells, they still often depend on astounding evil—Hannibal Lecter, for example, in the popular movie, *Silence of the Lambs*—to get the plot going; and extraordinary beauty (*Pretty Woman*), astounding goodness (even angels, as in the movie *Michael*), great determination (Sigourney Weaver's character in *Aliens I, II,* and *III*), exceptional skill (Rambo's survival tactics), or ingenious devices (James Bond's espionage gadgets) to resolve conflict.

Much of the appeal of these contemporary fairy tales may be to the irrational part of the mind which seeks constant reassurance that someone more powerful than we are will come to save us from death and gratify all of our needs forever. Repeated vicarious escapes from death and myriad promises of undying love help satisfy my desire for this kind of unrealistic

reassurance, but when I'm looking for literature to pull me out of Never-Never Land, one of the authors I turn to most often is Lucille Clifton.

Well aware of human limitations and the unlikelihood of a *deus ex machina* ending to human predicaments, Clifton writes modestly and with humor. She consistently refuses the temptation to magnify her own importance. In the ending lines of one of her most famous poems, "admonitions," she takes away the mystique of genius and its implied authority over others with these lines about herself:

> children
> when they ask you
> why is your mama so funny
> say
> she is a poet
> she don't have no sense

These lines, which implicitly democratize the poetic urge, are from her collection, *Good Woman: Poems and a Memoir*. *Good* woman—big-hipped and imperfect in terms of mainstream standards of beauty, but nevertheless a good woman. Thus she counters fairy-tale notions equating conventional outward beauty with inward grace. In her collection, *Quilting*, a single stanza about the famous African-American singer Lena Horne, shows that Clifton knows something about the politics of who is considered beautiful in this culture and why:

> people talk about beautiful
> and look at lizabeth taylor
> lena just stand there smilin
> a tricky smile

Clifton, an African-American woman born into a working-class family in Depew, New York, in 1936, emphasizes race more than class, but she doesn't exclude class. Her poems precisely delineate her sense of community with African-Americans and with other people who are having a hard time materially and emotionally because of social forces unfairly aligned against them. Lucille Clifton stands by those people in her writing. In these opening lines from "admonitions," she pledges her loyalty to African-American brothers and sisters:

What you pawn
I will redeem
what you steal
I will conceal

my private silence to
your public guilt
is all I got

Of course her poem belies her claim. She uses public words to give witness to their suffering and to commend their struggle. Clifton's body of work suggests who the worst thieves are. Most thieves are just petty thieves. The thieves we should be most concerned about steal people's lives and means of livelihood legally. Collectively, they—or rather, we, to the extent that we join in and acquiesce to such thievery—steal rivers, mountaintops, and even the weather. She testifies to these outrages and to the achievements of such widely defamed working-class figures as Malcolm X, Huey Newton, Bobby Seale, and Angela Davis. Her work is not escapist—it looks at the real working-class world and expects no magical rescue from authority.

The form of her poetry itself subverts authority. Clifton's poetry is spare. She seems to *want* people to understand; there's nothing coy, obscurant, or pedantic about her writing. She shows her seriousness of purpose by refusing to take standard grammatical conventions seriously. There are many different grammars in English, and Clifton selects her grammar carefully for her own aesthetic and egalitarian ends.

Instead of removing themselves from their political and economic context, Clifton and other working-class writers speak out against the disproportionate authority of wealth. They don't name lack of virtue as the singular cause of people's misfortune. Instead they publicly name social oppression as a primary cause of poverty. They understand that the United States is not really a meritocracy of the good and beautiful, and their writing makes it clear that rewards do not always—or even often—accompany hard work. Their stories show that good and beautiful people can work hard all their lives and stay poor. And maybe of even greater importance, their work gives testimony to ordinary working-class men and women who heroically oppose the authority of national and international institutions of greed. Reading the poetry of Lucille Clifton, Phillip Levine, Thomas

McGrath, Amiri Baraka, Carolyn Forche, and many (but still too few) others who share their disenchantment with the political and economic status quo helps me to write out of a sense of comradeship with other working-class people. I think my strongest political efforts, written and otherwise, are inspired by this literature, in which the faery rescue is exchanged for the real possibility of struggle.

And Texas? A cool rain is coming down here in the southern mountains of West Virginia, and an old motown favorite, "Rescue Me," just came on the radio. Fontella Bass's hopeful lyrics fill the room. Nice. But, as I write, the heat is still holding in Texas.

KAREN

KOVACIK

Karen Kovacik lives in Indianapolis, Indiana. She finished a dissertation in 1997 on contemporary women poets from working-class backgrounds. She is currently teaching creative writing and literature at Indiana University-Purdue University in Indianapolis. Her first book of poetry, *Beyond the Velvet Curtain*, will appear in 1999 from Kent State University Press.

I was born in East Chicago, Indiana, in 1959. As a small child, I wanted to be a baker's lady when I grew up because I loved the smell of bread and cake. By the age of 9, I was certain I wanted to be a teacher and a writer. One of the formative experiences of my writing life was meeting Tillie Olsen when I was 19. I had already read her *Tell Me a Riddle* and *Silences* (and had wept over them both many times) when I found out she was coming to my Indiana University dorm and that I could sign up to have dinner with her. At table, she inspired us with stories from her teaching life, telling us how nervous her MIT students became when she asked them to switch the gender of the pronouns in a passage of prose using the generic She. After dinner, she hugged me and told me that she looked forward to seeing my writing in print someday.

I published my first poems at 22 in the *Bellingham Review*. For a couple of years after college, I worked as a writer and graphic artist for Indiana University before heading to Poland with me then-husband to make art and translate contemporary Polish poetry. My two years in Poland made me allergic to any mention of social class for quite some time. The antidote to this allergy only arrived years later when I was in the Ph. D. program at Ohio State University and became interested in contemporary women poets from working-class backgrounds.

Thirteen Ways of Looking at a
Working-Class Background

Karen Kovacik

1

 "To generalize about war is like generalizing about peace," writes Tim O'Brien in "How to Tell a True War Story." "Almost everything is true. Almost nothing is true" (87-88). I feel this way about telling the story of my life. Class, America's "dirty little secret," has complicated my story, and although I wish, at times, I were an "organic intellectual" or that I descended from a committed line of union organizers, the truth is that my family of origin is working-class Republican. When I sit down to write, I become a shortwave radio jammed with the voices of my anti-Communist father, the ironists of Central Europe (Milan Kundera, Witold Gombrowicz, Sándor Csoóri), all the poets I've ever read, the language of the Catholic mass, my grandfather speaking Polish, my sister telling me to check with her before I write about her, my ex-husband editing my word choices, and my significant other insisting on praxis. When I read my work aloud, I can hear Kundera pronounce a piece "too sentimental" or my parents say, "But that's not how it really happened!"

 The voices multiplied when I started a Ph.D in English at Ohio State in 1992. Foucault was all the rage then, and the language of high theory all but jammed my already staticky radio. It led me to the dead end of my first dissertation, an analysis of how Marianne Moore, Elizabeth Bishop, Adrienne Rich, and Jorie Graham used metaphors and languages of science in their poetry in order to position themselves within or against a patriarchal literary establishment. Only when I happened upon a second and final topic, a study of contemporary women poets from working-class backgrounds, did some of the static dissipate, and I found myself trying to reconnect the academic part of my life with poetry-writing and my working-class family.

2

 "Curriculum Vita," which is an important poem in my series on class, work, and family, depicts the life of my maternal grandfather. Before World War I, Antoni Szymonik emigrated from the impoverished Galicia region of southern Poland—at that time still part of the Austro-Hungarian empire—to the industrial landscape of East Chicago, Indiana:

Curriculum Vita

Antoni Szymonik, born 1887, subject of Franz-Joseph, was favored by storks, played in the beets and poppies, drank from the Vistula, tormented mutts on short chains, experienced snow without shoes, hunger without relief, was educated through the second grade, talked his mother into selling a pasture for his passage, huddled in steerage until his clothes turned to rags, arrived in New York coughing blood, yet with his name intact. ¶ Settled in the Indiana Harbor, learned to make cleanser at the soap factory, glued corrugated cardboard in the box factory, then tried the cement factory, but the thick white dust burned his lungs. ¶ In 1920, returned home to fight the Russians. ¶ Resettled in the Harbor, built engines at Blaw-Knox, lived in a basement, washed down salt tablets with Pepsi, breakfasted on blood sausage and bacon, outlived one wife, beat the second. ¶ Fathered two children who couldn't stand each other, drank boilermakers, walked miles through streets named for trees (Alder, Butternut, Catalpa), bought a house next to a railyard, and the freights lurchedthrough his dreams. ¶ Read a newsletter called *Weteran*, learned to tell Polak jokes, dared strangers to punch him in the gut with a pool cue, drank bacon grease to clear his lungs, referred to one granddaughter as "the Jewess," showed her the veins behind his zipper, excelled at jigsaw puzzles, suspected the Mexicans next door of stealing his aspirin. ¶ Died of a stroke in 1974 while watching *Bonanza* beside a statue of the Blessed Virgin.
(14)

3

Years before writing "Curriculum Vita," I had been struck by Polish poet Wislawa Szymborska's "Zyciorys" ["Résumé"]: "Of your loves, mention only the marital, / of your children, only those who were born." Szymborska was referring to life under Stalinism, during which Polish citizens were expected to fill out regular questionnaires supplied by the bureaucracy, and she illustrates movingly the gap between public and private

revelations. When I began "Curriculum Vita," I was applying for academic jobs and had stacked up copies of my own C.V. next to my desk. The chasm between the official and the unofficial seemed of earthquake proportions. Neither of my parents have college degrees, and my grandparents received only a rudimentary formal education because of immigration, poverty, and long workdays. The crisp, laser-printed sheets of my résumé, neatly stapled, betrayed no sign of the ambivalence I felt on the cusp of earning my doctorate. As I was busy sketching a version of my life in endless job letters, it occurred to me to ask what my dead grandpa, for many years a machinist, would think of his harried granddaughter, a pillow at her back, "working" at writing. Instead, I trained my newly class-sensitive lens on him.

4

When I have read "Curriculum Vita" aloud to university audiences, some people have been audibly uncomfortable. More than one person asked me if this was really a poem. A couple of men laughed out loud at the line about wife-beating; I gave them a stern look before continuing with the reading. Some people have requested copies of the poem because it reminded them of a member of their own families. But many listeners have found the poem hateful and have wondered why I wrote it. To them, I reply that my grandpa was no marshmallow, so a syrupy love poem wouldn't work. He was the sort of tough guy, who, if he appreciated poetry at all, would gravitate toward a verbal pool cue. Still, to avoid sentimentality is not to relinquish tenderness. Three phrases catch in my throat when I'm performing the poem aloud: "the thick white dust burned his lungs," "[he] walked miles through streets named for trees," and "the freights lurched through his dreams." These sentences suggest his vulnerability, his ordinary desire for peace and health, which forty years in the machine shop, the swigging of countless boilermakers, and hundreds of Polish jokes did not manage to extinguish.

5

I wouldn't have written this poem had I not been working on my dissertation at the same time. At 36, I was finally old enough to begin understanding how class had an impact on my life. Certainly, I was no red-diaper baby. My family sat around the TV in the Seventies, watching "The Price Is Right." My father praised the wonders of supply and demand by

pointing out how the gas stations on Kennedy Avenue lowered or raised their prices based on the availability of crude oil. Once, in fourth grade, when I asked my dad, a lab technician at Kaiser Chemicals who had been twice laid off, what class we belonged to, he looked down at his plate and hesitated before admitting, "I guess we're lower-middle."

Yet I come from a line of people who've made their living by tending sheep, rolling steel, bleeding grease from pipes, and sweeping office floors. And as a first-generation college student, although part of me wanted to fit into the privileged, self-satisfied world of Butler University in Indianapolis, with its formal dances, walnut paneling, and windows swagged with thick gold pleats, another part, equally insistent, felt above or outside it, and after two years, I transferred to a public school. By the time I got to dissertating at Ohio State, I had learned not to be shocked by fellow students who owned horses or whose parents collected Chagalls. I felt most in touch with my working-class roots when I perceived colleagues' scorn towards people who worked with their hands. The anger that seized me at such moments made my body shake.

6

The dissertation on women working-class poets made me reconsider everything, including the snobbery of Butler, the friends and family who worked in the steel mills, my wholesale disdain for the communist party in Poland, where I had lived from 1985-87. My reading took me beyond the safe confines of the *MLA Bibliography* into labor history, ethnographies of waitresses and secretaries, and sociological studies of higher education and upward mobility. It was as if I had stumbled onto a cache of treasure.

It was a relief to encounter poets who didn't rattle on about the crew of painters they had hired to redo the beach house, poets who not only saw the maid, but also depicted what it felt like to clean up rich people's messes, cook their meals, care for their children. A favorite poem that I included in the dissertation, one which influenced my writing of "Curriculum Vita," was Thylias Moss's "She's Florida Missouri But She Was Born in Valhermosa and Lives in Ohio," a tribute to the poet's mother, Florida Missouri Gaiter Brasier, who was born in Valhermosa Springs, Alabama, and participated in the Northern Migration of southern Blacks. For Mrs. Brasier, like many African-American women of her generation, the move north meant a lifetime of employment in domestic service. It is Moss's

genius that she is able to describe the demeaning nature of the work, while representing her mother as larger than life:

> My mother's named for places, not Sandusky
> that has wild hair soliciting the moon like blue-black
> clouds touring. Not Lorain with ways too benevolent
> for lay life. Ashtabula comes closer, southern,
> evangelical and accented. . .
>
> She's Florida Missouri, a railroad, sturdy boxcars
> without life of their own, filled and refilled with
> what no one can carry. (100)

From the beginning, the poem mixes language play with an inquiry into the serious business of naming. Although Moss doesn't explicitly mention the legacy of slavery, her poem calls attention to how important naming is, particularly because African slaves were named or renamed at the whim of white owners. And in the Jim Crow era, as the racial caste system persisted, African-Americans were expected to address whites by titles, and in return, were called by their first names. Thus, in a poem about domestic service, an occupation rife with inequality, naming becomes central: Mrs. Brasier, named for two southern states, takes on mythic status, dwarfing the Ohio towns where she works. Proud of her mother's strength and angry at some of the menial duties Mrs. Brasier was asked to perform as a domestic, Moss concludes the poem with a riff on another Ohio place name, a suburb southeast of Cleveland:

> You just can't call somebody Ravenna who's going
> to have to wash another woman's bras and panties, who's
> going to wear elbow-length dishwater to formal gigs,
> who's going to have to work with her hands, folding and
> shuffling them in prayer. (100)

Even though Mrs. Brasier has "to wash another woman's bras and panties" and wears "elbow-length dishwater" rather than elegant evening gloves, she comes off dignified and alive. There is something subversive in that final image of Mrs. Brasier working with her hands and, at the same time, "folding and shuffling them in prayer." Although the word "shuffling" has

connotations of servility, it also suggests a changing of the order, as in the shuffling of a deck of cards.

7

In her essay "Writing with Class," novelist Valerie Miner cites working-class writer, Stan Weir, on the anguish that results when images of one's class, work, and culture are scarce. Says Weir: "I once read . . . about a Spanish prisoner who said that one of the worst tortures was not having a mirror. After a while she began to think she had become deformed. That's what happens to labor. There is no mirror in the media about what we do"(29). In a country like ours that denies its class system, the poets in my dissertation— including Thylias Moss, Jan Beatty, Patricia Dobler, Ana Castillo, and Gloria Anzaldúa—have all made the choice to "come out" as working-class, to provide the mirrors that make people of the working classes more visible. They—and increasingly I—are defying the "co-ercians to pass" that Tillie Olsen describes in *Silences:* the pressures "to write with the attitude of and / or in the manner of the dominant" (287).

8

Some of the most memorable instances of refusing to pass for middle-class occur in poems about schooling, and no wonder: as Janet Zandy has written, "Working-class children wherever they grow up—unless at least one parent has had access to a formal education—will not be able to move from the language of home to the language of school without disruption" (5). Thus, Ana Castillo's "Red Wagons" offers a parody of white, middle-class primers—Dick and Jane—from the perspective of a Chicana, working-class child. And Patricia Dobler's "Field Trip to the Mill" is written from the point of view of a nun in steel country, who fears for the fourth graders clinging to her, among the catwalks and cauldrons, "as she watches them learn their future"(3).

Another instance of the "disruptions" that Zandy has described can be found in Jan Beatty's "As If That's All There Is," a poem about a working-class woman's anger at the hypocrisy she encounters in graduate school:

> Don't ask me to ponder the shape
> of an old oak bench, or why
> in the sixteenth century things were
> as they were, as if that's all there is.

I'm not so impressed with your studies
as I watch you talk to a guy in the bar
and miss the essence of the conversation.

You are an oak table, your careful words
a testament to someone's craftsmanship.
You hear only what you're about to say next.

I know you'd call essence a naïve concept,
and laud the freeing nature of social construction,
but I'm not convinced that's all there is,
as I watch you not tip the waiter, stepping in front
of someone to make a point about ancient Greece. (26)

The academic in the bar is violating what for the speaker are important codes of conduct: tipping the waiter, acknowledging the contributing "craftsmanship" of others, maintaining consistency between word and deed. If Beatty is essentializing class here, she is doing so to shift the terms of the debate, much as she would by yelling "Hey!" to get the attention of unruly or insolent customers when waitressing. (Beatty put herself through grad school at Pittsburgh by waiting tables.) Because colleges and universities have traditionally been strongholds of privilege, instances of class bias and condescending ways in which academics speak about workers or behave toward them—frequently go unchallenged.[1] By saying, in effect, "In my community your 'studies' do not count as knowledge, and your behavior is unspeakably rude," Beatty is asserting a belief system and way of knowing that skewers such privilege.

9

A final example of the refusal to "write in the manner of the dominant" can be found in Gloria Anzaldúa's powerful, multivocal poem, "El Sonavabitche." In 1972, Anzaldúa was selected by the state of Texas to work as a summer high school teacher for children of migrant families in Muncie, Indiana. Her poem, drawing on that autobiographical experience, identifies a common ruse among employers of undocumented workers: on payday, the employer makes an anonymous call to Immigration, and the workers are arrested or dispersed before they can be paid. The poem's main speaker, like Anzaldúa, has been a teacher and an advocate for mi-

grant workers' rights. Seeing migrants bent over tomato plants in a field, she flashes back to the frightening memory of immigration police "thumping fists on doors, / [their] metallic voices yelling Halt!" A Chicano acquaintance sympathetic to the undocumented workers describes their all-too-typical trip from Texas to Indiana—a closed pickup for thirteen people, no food or bathroom stops, one person suffocated on the way.

The "sonavabitche" is presented to us mostly through his lines of spoken dialogue and through creepy descriptions of him by the main narrator, who finds him lizard-like, with "lidded" eyes, his pupils like "pinpricks." His speech, peppered with racial slurs, mispronunciations, and grammatical errors, functions as the sort of self-indicting "exposé quotation" one might expect from a satirical documentary. The "sonavabitche" offers the activist a drink, pretends to be ignorant of any complicity with Immigration, and comes on to her with a crude pickup line: "Well what can I do you for?"

Throughout the interview, the activist forces herself to talk tough, even though she reveals nervousness in asides to the reader. This is their final showdown:

> Whoa there, sinorita,
> wets work for whatever you give them. . .
> Two weeks wages, I say,
> the words swelling in my throat. . . .
>
> You can't do this,
> I haven't broken no law,
> his lidded eyes darken, I step back.
> I'm leaving in two minutes and I want cash
> the whole amount right here in my purse. . .
> No hoarseness, no trembling. . . .
>
> Yeah, but who's to say you won't abscond with it?
> If I ever hear that you got illegals on your land
> even a single one, I'm going to come here
> in broad daylight and have you
> hung by your balls.

Anzaldúa dramatizes an activist for workers' rights finding a voice of assertion against a boss who has tried to use her class, race, and gender against

her. The activist's challenge is successful: the "sonavabitche" hands over the wages, and the collusion between the law and the exploiter is temporarily disrupted. Anzaldúa's poem is representative of the dissident poetry that James Scully describes in *Line Break:* that which "talks back, that would act as part of the world, not simply a mirror of it" (5). It "breaks silences: speaking for, or at best with, the silenced" (5).

10

Not surprisingly, the poems I've cited here "teach" well. I don't want my students, many the first in their families to get a university education, to experience what I did in my introductory poetry class in 1977— being told that the work we were reading was important but having no clue how to relate it to my own life. Back then, all of the poems we read in English class were by white males from élite backgrounds, with the exception of Emily Dickinson's most insipid lyric, "If I could stop one heart from breaking," and Marianne Moore's "Poetry." While canonical poetry is also of use in the classroom, it is no longer news that we need to address and to supplement the canon's glaring gaps. I continue to share Stevens' "Thirteen Ways of Looking at a Blackbird"—one of my favorites when I was a freshman because of its oblique angles and sudden swerves—but I follow it up with Raymond R. Patterson's deft and moving "Twenty-Six Ways of Looking at a Blackman." Hunger, racism, gender inequities, homophobia: I want my students to know that poetry can speak to these silences even as they acquire the literacies of simile, meter, and line.

11

As I admitted earlier, I was no red-diaper baby. The protest songs I now play for my students I learned in the last four years at rallies and in the classroom. The labor history I now know I primarily acquired when working on my dissertation. My father attributes my interest in workers'rights to my having been brainwashed by the university forces of "political correctness." But when I think about my academic training, especially the dissertation, I see now that it largely helped me to reframe knowledge I already had. When I was three years old, my father was laid off from Standard Oil. When I was fifteen, he was laid off again from Kaiser Chemicals. Both grandfathers and assorted uncles and aunts have suffered from inadequate safety provisions, unfair labor practices, and the lack of a strong union. Seven relatives have died of different kinds of cancer, I'm convinced, because of insufficient regulation of industry in our home county.

As I revise my life, I see my father doing the same. At 70, he softens his memories of growing up during the Depression. It wasn't *that* bad, he repeats as if trying to convince himself as well as me. "We never went hungry," he says, though sometimes admits that they had nothing to eat but lettuce soup. He is making a familiar ideological point: today's poor get too many handouts. Back then, he emphasizes, people didn't complain. So what if his family of five plus a boarder or two all crammed into a one-bedroom apartment? Or because a steel mill, concrete manu-facturer, and coke plants surrounded their flat, his family had to sponge the grime from their wallpaper every season?

I draw different conclusions from his stories. Rather than welfare "reform" and increased privatization, I want guaranteed housing, educa-tion, and health care for all, a strengthened OSHA and EPA, plus time enough to reflect, be lazy, relax. I want my poetry and teaching to be more than lines on my vita. I want connections with a broader world, while not losing the link to my family.

12

"Being a college professor must be like rolling off a log," my father says. "You only have to be in class a couple of hours a week, you get the summers off, plus you get sabbaticals." After 30 years in the workforce, Dad was entitled to four precious weeks of vacation a year— a lot compared to what many working-class and poor Americans get, but still not enough. He would wake up at six and not arrive home till after six-thirty in the evening. In the winters, this meant rarely seeing the sun. Most of the time, he struggled numbly from week to week, waking early, staying late, doing projects around the house on his weekends off. There wasn't much time to think, though he read whenever he could. "Working with your mind," he says, "now that has to be something."

13

In "I Stand Here Ironing," Tillie Olsen, the first working-class writer I ever read, assumes the voice of a mother who's preoccupied with the conditions that have stunted her adolescent daughter's potential: "She has much to her, and probably little will come of it. She is a child of her age, of depression, of war, of fear." But then, in part to reassure herself, and in part to place this individual story in a broader context, the mother adds, "So all that is in her will not bloom—but in how many does it?

There is still enough to live by" (20-21). These sentences were etched in my mind in 1978 when I read Olsen's story for the first time. It has taken me years to grow into her words and to begin to understand the stuntings, emotional and material, in my own family, in me, and in American class politics. But Olsen's words have also made me less obsessed with origins, less preoccupied with creating a tidy life-story in which each element leads inevitably to the next, as it typically does on a résumé or vita. From improbable sources and despite limitations, I am summoning the will to agitate, grow, and change.

[1] Of course, not "all" academics treat working-class people rudely, and there are working-class people who embody contradictions between belief and practice. But I have plenty of anecdotal evidence of class condescension that I have gathered simply because, as a Ph.D candidate, I was presumed by my colleagues to share their privilege. At an academic conference in Louisville, for example, a colleague who does work on gang narratives and her academic husband expressed dismay at the small working-class houses in an urban neighborhood—similar to the ones in my community while I was growing up. And I once got into a bitter argument with a Dartmouth-educated roommate over the men who were re-roofing our apartment building. It was a June day in Columbus, Ohio—an unseasonable 100 degrees—and she complained because their pounding was "disturbing" her reading for general exams. Furthermore, she described the men as "lazy" because they took over two weeks to complete the job.

Wendy Luttrell's *Schoolsmart and Motherwise* (Routledge, 1997) provides another lens through which to view Beatty's poem: Beatty, in Luttrell's terms, is contrasting "schoolwise" intelligence with a "commonsense" shrewdness about people, derived in part from a consciousness of class difference.

See also my chapbook, *Nixon and I* (Kent State University Press, 1998), in which "Curriculum Vita" first appeared, and my forthcoming *Beyond the Velvet Curtain* (Kent State, 1999). My dissertation, *"Poetry Should Ride the Bus": Women Working-Class Poets and the Rhetorics of Community* is available from Ohio State via interlibrary loan or on microfilm from UMI.

Works Cited

Anzaldúa, Gloria. *Borderlands / La Frontera: The New Mestiza.* San
 Francisco: Spinster's / Aunt Lute, 1987.
Beatty, Jan. *Mad River.* Pittsburgh: University of Pittsburgh Press, 1996.
Castillo, Ana. *My Father Was a Toltec.* New York: Norton, 1995.
Dobler, Patricia. *Talking to Strangers.* Madison: University of Wisconsin
 Press, 1986.
Llewellyn, Chris.*Fragments from the Fire.* Viking Press, 1987; rpt.
 Bottom Dog Press, 1995.
Luttrell, Wendy. *Schoolsmart and Motherwise: Working-Class
 Women's Identity and Schooling.* New York and London:
Routledge, 1997.
Moss, Thylias. *Small Congregations: New and Selected Poems.* New
 York: Ecco, 1993.
O'Brien, Tim. *The Things They Carried.* New York: Penguin, 1991.
Olsen, Tillie. "I Stand Here Ironing." *Tell Me a Riddle.* New York: Dell
 Publishing, 1961.
_____. *Silences.* New York: Dell Publishing, 1978.
Patterson, Raymond. "Twenty-Six Ways of Looking at a Blackman." In
 Every Shut Eye Ain't Asleep: An Anthology of African-
American Poetry. Ed. Michael S. Harper. New York: Viking,
1993.
Scully, James. *Line Break: Poetry as Social Practice.* Seattle: Bay
 Press, 1981.
Zandy, Janet. "Introduction." *Liberating Memory: Our Work and Our
 Working-Class Consciousness.* New Brunswick: Rutgers
 University Press, 1995.

HELEN

RUGGIERI

Helen Ruggieri teaches in the writing program at the University of Pitts-
burgh, Bradford, Pennsylvania. She also works as a poet in the schools
through the Alternative Literary Programs. She has a Masters of Fine Arts
from Penn State where she won an Academy of American Poets Prize. Her
essays, memoirs, and prose works have appeared in *Boston Review, Potomac
Review, Snowy Egret, Mother Earth News, The Diarist's Journal, Humor-
ous Vein, Belles Lettres,* and others. She is completing a book of memoir.

My parents were born in Scotland and came to this country to escape the life they were born to. So I grew up hearing all the usual stuff—you're so lucky, you don't know what it is to be hungry, yatta yatta. Of course, I was lucky. Not only did I have more than enough to eat, I was cousin to a writer who wrote several novels about rural Scotland and the poverty of class and spirit that existed there between the two world wars. And I was fascinated by how James Leslie Mitchell who wrote under the name of Lewis Grassic Gibbon made this so clear to me. He is not well known out of Scotland, but without his example I don't think I'd have come to do what I do. A rough paraphrase of one of his statements might sum up my feelings—*I like to remember I'm a peasant, but good manners make me reluctant to boast of it.*

The Ghost of Ernest Hemingway Follows Me Everywhere

Helen Ruggieri

The ghost of Ernest Hemingway follows me everywhere. He picked me up years ago when I was at sea. Perhaps we shared a cabin, perhaps he caught me on deck, at the movies, in the library. Perhaps it was something I wanted from him, but it was a long time in making itself known. It began in 1949 aboard the luxury liner Ile de France somewhere in the North Atlantic between New York and Southampton. I'll try to make it clear, but you know how ghosts are, all mist and temperature changes. Hang on. Be brave.

I'm not a devoted fan or an aficionado. I am the bull, one tracked, clumsy. He is the matador, agile, showoff. I am the fish safe in my element; he is the fisher man pulling me into the air where I choke. Shooting a lion in the shadows of Kilamanjaro? I am one of the bearers toting a canvas six man tent on my head.

Perhaps we were like opposites, my iron filings and his magnetic personality. I cling. Though I want to think I am the one to shake him off. He is so suave, sophisticated, charming, trailing me like the hungry shadow who is everything left over, everything I'm not. We all might want to be our nots, but we screw it up. We be what we are given, usually.

The family history abounds with ghostly little examples of my givens. We have a knack, a way, a predilection. Just before the first world war when motor cars were becoming more common, the local laird was driving down the two ruts that passed for a road and walking along ahead was the whitehaired, bent old relative, trudging along, head forward. The laird honked. The old man kept walking paying no attention as if he were deaf. The laird fumed along behind, afraid to turn off into the fields, soggy with rain. When my sweet old kissing cousin got to his turn off, he looked back, lifted his cap, and then turned to his way.

You use what you have. He had old age. The story goes into the family history. This is how we are and how it works. We think we're smarter than our social betters. We don't want to ape them. When you come from this tribe, you have a sweet sort of patience. You wait your

time. If it comes, good. If not, no big deal. The laird probably didn't even give it a thought, didn't catch the whiff of so there, ha ha that made the old man's day.

We're subtle. We take satisfaction in our own knowing, in passing the tale along.

I asked my father who drove an ambulance in the first world war if he'd ever run into an fellow driver called Ernest Hemingway. He thought about it for a minute and then launched into his favorite story about driving the headless corpse of a general across the dark roads of Belgium cratered by bombs, golden threads of mustard gas floating like rags in the wind. I was 18, he'd say, and they stuck me with this duty because I was a private. Only privates ferried dead generals through no man's land to be returned home for burial. The privates were buried elsewhere. Certainly not home. Privileges for the privileged.

Did he talk to you? Were you afraid? I demanded.

No, he said. I was more afraid of what was out there in the dark, machine guns, land mines. I thought about a poem I'd had to memorize "if you can keep your head when all about you / are losing theirs. . . ." Something like that. It made me laugh. I thought it was the funniest thing I'd ever heard. I looked at him in a sort of stunned recognition and then we both began to laugh. That's genes for you.

I had an uncle who was always telling stories about World War II. He was dropped behind enemy lines into Yugoslavia, usually, and the officer in charge was a Major, Somerset Maugham or Evelyn Waugh, usually. The story was that they were stalking the target (I can't remember what) and darkness fell. They came to the home of a peasant family and the Major (Maugham or Waugh) ordered them out so he could sleep in the one bed. That part was always the same. Only the country and the name of the major changed. He personally had to persuade the peasants not to knife the major while he slept by pointing out it would probably ruin the bed-clothes.

But to get back to Ernest Hemingway and how he found me or was it how I found him waiting until relativity was proven, we go so fast, time runs backwards.

The Twenties were the peak of transatlantic travel aboard luxury liners, and between the wars the Ile de France was the queen of the sea. Hemingway and a friend were bound for Paris traveling cabin class. They snuck into the first class dining room for dinner. This was a dining room, seating 700, designed by Pierre Patout (creator of 'Joy') of Pyrrehean marble

in three shades of gray. It was the art deco marvel of the French Line. Hemingway watched Marlena Dietrich walk down the grand staircase into the ornate dining room aglimmer with Louis Quatorze chairs and white linen. She was about to join a table but as she would make thirteen, she hesitated. Hemingway took command of the situation in his perfectly fitted borrowed white dinner jacket. Bowing low over her hand, he offered himself as the fourteenth guest. Only the movies and fantasy could do that scene justice. Don't you hate it! This is where we met though I'm not born yet. That's okay, I'll wait.

I'm the first person in my family to graduate from college (or even attend). I'm a first generation American, my parents children of tenant farmers, butchers, shoemakers, tavern keepers. What Hemingway grew up knowing first hand, I grew up knowing from watching the movies, on the outside, looking in. I was peasant, too canny to brag about it, the end line of those story tellers, ruled, not ruling, armed with infirmity, memory, wit.

In 1949 after the Ile de France had been restored for Atlantic traffic, I was traveling with my parents for a visit home to Scotland. I snuck into the first class bar over the stern. I was waiting for my father who liked to drink up there because you could look out the windows at the wake of the ship trailing behind. I couldn't stand the vibrations at the stern-end of the ship. It made me ill stabilizers or not. I went out and threw up in the tiny gutters available for such purposes to keep passengers with queasy stomachs from having to vomit into the wind. I was twelve, paralyzed with embarrassment when the kindly steward offered to take me back to my cabin (did he know I was out of my class?). I didn't want to say. After my father had a few drinks in him, nothing would prevail upon him to leave unless it was to go to another watering hole. I staggered back alone through staircases, passageways, decks and various hallways until I found myself back in my own class. No one bothered me, no one noticed me, the invisible seasick brat you would not invite to your table under any circumstances. A quality I share with ghosts—invisibility.

It was the end of an era. The age of the big liners was coming to an end. Within ten years two-thirds of tourists would fly to Europe, impatient with the five days of the big ships, wanting the most of Europe time allowed. Perhaps they didn't have time to pack the twenty or so pieces of luggage (at the least) you'd have to take to be able to make the de rigueur four times per day clothing changes. That's how the other class lived. Our

trunks were filled with canned hams and sugar, things impossible for the poor old folks at home to come by, still on rationing.

We were going 'home' to those hills between the rivers Don and Dee; we didn't need dinner jackets. Already my parents were worried the relatives would think we were putting on airs by bringing our own car, a big, two-tone blue 98 Oldsmobile with Hydromatic drive—a stunner among the mini Morrises.

My parents had originally come to this country on the Normandie to get away from the serfdom of being stuck in the position you are born in. Nothing so boring as being cast in your role before you're even born. My father thought he could do better. He did. On the way my parents developed a soft spot for French ships. My mother also had a horror of being below the water line and the Ile de France cabin was high above the water line and amidship.

There were three classes. Steerage was banished, replaced by Tourist. I imagined them as the peons down there sleeping on pallets in the hold of the ship, partitioned by moth eaten blankets from other family groups, spreading scarlet fever and other assorted plagues. We were Cabin class, a buffer between the cheapest fare and First Class. Second Class if you will. It was 1949, the reconditioned Ile de France was making its maiden voyage after ferrying troops during World War II.

On board the Ile de France, my ears, my eyes, my stomach and I were intent on keeping balance, treading deep waters of despair about being trapped on this rolling menace. Class has nothing to do with sea sickness, though some say it's an inherited disorder. But in the movies where I'd seen the glamorous ones make the crossing, no one got seasick or if they did it was the comic relief. That was not what I saw as my role though the ghost laughed heartily. Of course, he had no stomach for it.

One miracle drug the war produced was dramamine which prevented motion sickness. I was finally able to keep some down and achieve a shaky harmony with my surroundings.

So drugged, I could enjoy the many entertainments on board the Ile de France. I tried them all to keep myself from thinking about my stomach troubles. In the playroom there were daily Punch and Judy shows, a sort of demented activity where wooden puppets scream and beat at one another, sometimes armed and sometimes not. Since they were in French, the humor and story line escaped me. I was quite fond of an electric rocking exercise horse in the gym but the attendant in his whites kept shoo-

ing me away. I swam in the salt water pool complete with tides. Some
afternoons there was horse racing. Wooden ponies complete with jockeys
were moved forward by the stewards after some pretty woman had been
chosen to draw lots. There was shuffleboard but you needed a partner and
I was always a loner, not one you'd grab to make up a fourth. I was work-
ing through every leisure activity that filled the time between meals.

The meals. Alors. We ate at the first sitting at 6 p.m. because we
didn't have to dress which is to say we wore clothes, but not borrowed
dinner jackets and slinky long dresses. My mother, father and I walked
down a long windowless corridor to the dining room. The smell of food
trapped below decks made my stomach churn and we hadn't even been
seated yet.

We would walk to our table near the kitchen doors which would
bounce open every time one of the white jacketed waiters emerged holding
the oval trays above their shoulders. Perhaps this is where I learned pa-
tience, waiting for the meal to be over. Alors for saying this but I can't
stand the way the French eat. My mother plunked everything on the table
and you ate what you wanted, when, deciding on your own portions.

The Ile de France waiter would bring an enormous dinner menu and
place it before you. It did you absolutely no good, because it was in French.
My father would inquire about the translations with the waiter and order
for us. Daddy had been in France during the first war and knew some
French, as far as I could tell, mostly the lyrics, inky dinky parle vous. The
waiter began by bringing a plate of dishwater clear soup with three noodles.
They called it consomme and so you do. Eat it up now, my mother would
nag. That was just like home.

The waiter takes it away. You sit. He brings three pieces of asparagus
with a dollop of yellow melting over it; eat your vegetables, now, Helen.
You sigh, you drag your fork around in it. He takes the plate away. "The
mademoiselle does not favor aspergere," he would ask in that solicitous
tone waiters are taught in waitschool. You give him that fake smile which
you hope he interprets as "I don't appreciate your fake concern. I will steal
your tip."

He brings a plate of fish with many dangerous bones in it. Then
meat covered by some gelatinous, opaque sauce that might be gravy. You
scrape it off to see what's beneath. You still can't recognize it. You nibble
at it. "Do you want me to cut your meat," my mother asks?

"Moooother," I say, horrified. The fried potatoes are tasty. He
takes the plates away. Can we go yet? Non. There's desert which looks

like a picture in *Ladies Home Companion* but tastes like Timothy grass with sugar sprinkled over it. Your delight disintegrates. "You're not eating your dessert? my father asks. Are you still sick?"

Finally, fruit that appears to have been waxed (we've gotten the same basket at every meal since we embarked) is placed on the table. Now? Finally, you leave. Two hours shot. And you had to get dressed up or at least put a dress on, one of your new ones, a royal Stewart plaid skirt that swings out in a big circle. It's eight o'clock, the second sitting is beginning to gather in the corridor in their well-fitted costumes.

All I want is a nice cold glass of fresh milk—not canned milk for godsake, no one with any taste would drink canned milk. Marlena Dietrich does not put in an appearance.

The crossing is, essentially, five days of nothing but eating. There's breakfast, and at ten, bouillon or coffee or chocolate, and then lunch and then tea and dinner, finally, followed by post evening libations and bedtime snacks. To a person prone to seasickness, this is not the best of holidays. At tea they served petit fours—beautifully iced tiny cakes decorated with little pink flowers and green leaves on a chocolate ground. They were so gorgeous I could not resist. But once you bit in, what a disappointment. They tasted like stale bread dipped in bitter chocolate; the icing was so sweet it hurt your fillings. And what looked good on the outside to tempt you involved a price to pay further down the digestive line. I have never been able to focus attention on petit fours without an overwhelming feeling of despair and disgust.

I huddled in a deck chair under a plaid robe, reading boring leatherbound French novels translated into English which I picked up from the ship's tiny library. I was twelve reading about poor Emma Bovary. I struggled on to the end. I went through Zola, and lesser Balzac. There are many odd people in the world and apparently, many of them lived in France, I decided. They were usually sad and given to compulsions, but went well with sea sickness and gave me other lives to think about, not my own which had been tilted away from home where rank was determined by who was toughest or who talked toughest to this off kilter world where toughness seemed grossly out of place. Top rank went to the most civilized or those who appeared to be the most civilized and civilization was determined by clothes and manners.

It was like living in a movie set. Unfortunately, no script was provided. One watched. One acted out a part that didn't quite fit and seemed essentially, phony. The ghost circled me snickering though to every-

one else I thought I was invisible.

Every afternoon there were French movies in black and white without subtitles showing erratic behavior of people who apparently were 'in love.' They seemed sad about it or possessed by it. Other movies were about starving children being bombed or French soldiers running from battles. There were no cowboy movies. Comedies seemed out of favor. No Marlena films. *Les Parents terribles* had a wonderful title though I couldn't figure out what was going on. *The Bicycle Thieves* was all agony and society. They were not movies you would send your children to, but they seemed to fit with the novels, a terrible world out there in France. Lucky American.

Children were few on board the Ile de France. In the playroom tots played with blocks or dolls, things well beneath the dignity of a twelve year old. I did meet a companion and we began playing checkers with chess pieces because I didn't know how to play chess. Tom, an English boy about two years younger than I, was convinced that I personally knew cowboys because I was an American. "Do you ride horses?" he wanted to know. "Of course," I boasted. In fact, yes, I had several times ridden horses or at least been up on their backs since riding seemed to imply control. That didn't mean I kept them in my garage as Tom seemed to interpret my admission. I think he wanted to marry me, but could not quite forgive me for not knowing how to play chess. He was somebody to pal around with even if it was embarrassing to be seen with someone wearing short pants.

The days dragged along as they do in child time. But finally, my moment comes. The ghost brushes by, whispers softly to me, my face flushes, my embarrassment is total. I have been revealed, exposed. My invisibility is stripped away. Now the ghost will have his way with me, nag me to decide, to choose, say, "See! I told you so."

I was standing on a wide, open stairway that curved down into the cabin class bar. I was probably sent by my mother to get my father. A woman came up behind and said "pardonemwah" as she swished around me.

She was wearing a long dress of some silky material in a mustard yellow, big shoulders and draped skirt, very sophisticated, I thought. Her hair was swept up in what they called a French twist, and she reeked of powder and perfume and all those female things I was still too young to have.

"Huh!" I said, startled.

"American. Can't you tell," she laughed to her escort. She said it lightly with a modulated lilt as if it were a witticism, as if I didn't speak English. Oh, Marlena.

We don't know who we are until someone tells us, Ernest whispered. Come with me, cara mia, we'll run before the bulls at Pamplona. The blue fish are running in Baja. The train is in the station. "Decide."

I know this is the crossroads. One of us will chose and one will be buried under it. The doppelganger will drop over the side, disappear in the dark water. But the child in me needs years to process the data. One life. So much of it wasted trying to understand things. There is a ceremony at carnivale in Frontera in the Canary Islands called Los Carneros—the festival of the sheep. The older children dress up in sheep's clothing and chase the younger ones. In sheep's clothing you can do what you want. A good hairdo, an expensive dress—hah! You can scare anyone.

However, standing there, my Marlena whisking by me in her mustard colored dress, I don't know the ghost's name yet. I have not read any modern American novels. Hemingway is not in the ship's library. I am thinking Emma Bovary is an absolute idiot, without wisdom or anger. When I read Hemingway's women I see they have a small part, they cook or look pretty. The bull or the fish have more character being what they are.

Years go by. I open a book about the Ile de France out of nostalgia, curiosity. I imagine him spotting Marlena in her mustard yellow dress as she makes her entrance. I feel his lips brush the back of my hand. I recognize his touch, the wanting, the denial. I slam the book shut on him but it does no good.

This is the crossroads. Make your choice. I already have, I know. But out there in the dark waters he is calling, dye your hair, lose ten pounds, write about love, make the men more manly, make the women more like Emma Bovary, no one wants to read this stuff. It's too lower class, too intellectual, too ironic. Fix yourself up. Decide. Have a petit four.

I think at the time I have a lot to learn—how to speak French through my nose, how to play chess, how to drink canned milk without gagging. The ghost nods, adds to the list skiing, hunting, bridge, baccarat, the tango, and on and on.

The years slide under the hull. I learn other things—parsing and driving, kung fu, the difference between sarcasm and irony and several kinds of that. Ernie, if you knew what I'd seen, fire storms off Orion, how a bat dives for a cricket, the way the cricket evades attack, the difference

between English lavender and French. You'd never kiss my hand, too bad for you.

I could tell you about the time my father drove the headless corpse of the general across Belgium, about when we lived in the Bronx and at night you could hear the lions roar and my mother was afraid. I meant to ask what cabin you had on the Ile de France and if you slept with Marlena, if you played chess in the game room in the gray North Atlantic afternoons. Sometimes I want him to kiss my hand, but I'm tired of waiting around for it. If he won't forgive me for being what I am, I'll have to forgive myself for not having the patience to play chess, for pronouncing French as if I grew up in Scranton among the children of immigrants. I could practice, but I have other things to do, my sheepskin is at the cleaners, the laird is steaming. I'm trying to keep a straight face. My horse is down yonder in the corral, I say, gesturing over my shoulder. The bobby pins are dropping out of my yellow hair, my hair spray has given up the ghost. Ernie, Ernie, kiss my hand before you disappear forever, before the earth moves and we are wrenched apart (did I get that right?).

I want, I want, but I won't. I can't. Perhaps I'll forgive you for being who you are. Perhaps you'll agree I'm amusing, if difficult. It was easier for you to slide from class to class. I didn't have enough room to pack all that might be needed. I decided to stay where I was. No big deal, mon ami, I never looked good in yellow. I wanted to be an expatriate here and I was and I am. My subjects are here and me, class and gender, role models and writers. We immigrant's children have a way to go, and all the excuses we need signed and dated.

A woman once told me her ancestors came over on the Mayflower. "Religious fanatics?" I asked lightly.

"Huh!" she says. I lift my cap, turn to my way. All of us are Ernest some of the time. The rest of the time we stick with our genes.

SCOTT
RUSSELL
SANDERS

Scott Sanders was born in Memphis, Tennessee, in 1945. His father came from a family of cotton farmers in Mississippi, his mother from an immigrant doctor's family in Chicago. He spent his early childhood in Tennessee and his school years in Ohio. He studied physics and English at Brown University, graduating first in his class in 1967. With the aid of a Marshall Scholarship and a Danforth Fellowship, he pursued graduate work at Cambridge University, where he completed his Ph.D. in English in 1971.

Since 1971he has been teaching at Indiana University where he is Distinguished Professor of English and director of the Wells Scholars Program. He spent a year as writer-in-residence at Phillips Exeter Academy, and another year as visiting scholar at the Massachusetts Institute of Technology. He has received fellowships for writing from the National Endowment for the Arts, the Indiana Arts Commission, the Lilly Endowment, and the Guggenheim Foundation.

In his writing he is especially concerned with our relationship to nature, issues of social justice, the character of community, and the impact of science on our lives. His hobbies include hiking, carpentry, gardening, and travel. He and his wife Ruth, a biochemist, have reared two children in their hometown of Bloomington, Indiana.

His fiction and essays have appeared widely, in places such as *Audubon, Harper's, Orion, North American Review, Georgia Review, Ohio Review, Kenyon Review, Parabola,* and *Utne Reader.* He has served as literary editor of The Cambridge Review, as fiction editor of The *Minnesota Review,* and as a columnist on new fiction for the *Chicago Sun-Times.* He is a contributing editor for *The North American Review* and an editorial adviser for *Orion.*

He has published sixteen books, including eight works of fiction: *Wilderness Plots* (1983), *Fetching the Dead* (1984), *Wonders Hidden* (1984), *Terrarium*(1985), *Hear the Wind Blow* (1985), *Bad Man Ballad* (1986), *The Engineer of Beasts* (1988), and *The Invisible Company* (1989). His books of personal nonfiction include *The Paradise of Bombs* (1987), which won the Associated Writing Programs Award for Creative Nonfiction, *In Limestone Country* (1991), and *Secrets of the Universe* (1993). His *Staying Put* (1993), a celebration of the sense of place, won the 1994 Ohioana Book Award in Nonfiction. Writing from the Center(1995), a personal account of the quest for a meaningful and moral life, won the 1996 Great Lakes Book Award. His latest book, *Hunting for Hope,* appeared from Beacon Press in September 1998. His storybooks for children include *Aurora Means Dawn* (1989), *Warm as Wool* (1992), *Here Comes the Mystery Man* (1993), *The Floating House* (1995), *A Place Called Freedom* (1997), and *Meeting Trees* (1997).

For his collected work in nonfiction, he was honored in 1995 with a Lannan Literary Award. His work has also been selected for *The Best American Essays*, the *Kenyon Review* Award for Literary Excellence, the PEN Syndicated Fiction Award, and the Gamma Award; it has been honored by the American Library Association and the National Council of Teachers of English; it has been twice nominated for the National Magazine Award; and it has been performed on National Public Radio. His work is much anthologized.

Writing from the Center

Scott Russell Sanders

In Kenya, a man hungry for sweetness walks into a clearing and blows a few notes on a whistle. Soon a bird flutters at the edge of the clearing, chatters loudly, then flies a short distance into the woods. The man follows, carrying an ax. When the man draws near to where the bird has perched, it flies again, and the man follows. And so they move into the forest, on wing and foot, until they come to a tree the bird has chosen. If the man walks too far, the bird circles back, circles back, until at last the man discovers the right tree. He chops a hole in the hollow trunk and lifts out the dripping combs, gathering honey for tongues back home. The bird eats what the man leaves behind, honey and bee larvae and wax. So bird and man serve each other, one pointing the way and one uncovering the sweetness.

The bird belongs to a cluster of species called honey guides. The man belongs to a tribe that has known for generations how to summon, how to follow, and how to honor these helpers. No one can say how the cooperation came about, whether birds taught humans or humans taught birds, but it has lasted as long as the tribe's memory. Seek in a proper manner, these people know, and you will be reliably led.

For a writer, the search is more chancy. You cannot be sure what clearing to enter, what notes to whistle. Moved by nameless hungers, armed with words instead of an ax, you slip into the forest, avoiding the trails because so many others have trampled them, following a bird that refuses to show itself, a bird that may be leading you astray, a wild goose instead of a honey guide. You may never find the hollow tree, may wander lost for weeks or years, forgetting why you set out. And even if you do find the tree, it may be filled with bitterness rather than sweetness, and the bees may rush out and sting you. Still you wander the woods. What lures you? How do you know when you have found the hidden food that will satisfy your hunger? And if in a rare hour you find the source, how do you speak of it, how by mere words can you drag the slippery essence into light?

Setting aside metaphor briefly—only briefly, because metaphors are the elusive birds that lead me on—let me say as plainly as I can what I am seeking. I would like to know where authentic writing comes from; I would like to know the source of those lines that are worth keeping, the

writing that brings some clarity and beauty into the confusion of our lives. I know all too well the sources of phony, forgettable writing—mimicry, trickery, exhibitionism, habit, reflex, fashion, whimsy, conceit.

But already in my plain statement there is a wrinkle, for who is to judge which lines are phony and which are authentic? The writer, to begin with, and then the reader. If you hope to write well, and not merely transcribe whatever drifts through your head, you must distinguish the honest from the dishonest, the deep from the shallow, by testing each line against all that you have read or thought, all that you have lived through. The reader never sees more than a tiny portion of what the writer could have passed along—and a good thing, too. Of the sentences that come to me, I throw away a hundred for every one I keep, and perhaps I should throw away a thousand; I wait for a sentence that utterly convinces me, then I wait for another and another, each one building upon all that went before and preparing for all that follow, until, if I am patient and fervent and lucky enough, the lines add up to something durable and whole. My business here is to say what I have come to understand, through my own practice, about the source and conditions for such writing.

* * *

In America, during the past century or so, we have expected worthy writing to come from the margins—of the psyche, of the community, of the continent. We have expected the writer to be a misfit, an outsider, a stranger in strange lands, uprooted, lonely and lorn. We have often taken moodiness, madness, or suicide to be evidence of genius. We have celebrated the avant garde, as though writers were soldiers. We have praised the cutting edge, the experimental, the new, as though literature were a kind of technology. We have assumed that talent would either be born on the coasts or be drawn to them, toward the shining Atlantic or Pacific, away from the dark interior.

Literature may come from the edge, of course; but to believe that it comes only from the edge is a damaging myth, an especially beguiling one for young writers who are insecure about their background and eager for sophistication. In my own first attempts at writing I blundered far enough toward the edge to lose my way. I was born in the Mississippi Valley and reared in the Ohio Valley, deep in that dark interior from which writers are supposed to emigrate. In the 1960's I left the Midwest to attend college in New England, then left America to attend graduate school in Old England. When I began writing earnestly I was living in Cambridge, and I had the

impression that true art could only be made far from the numbing influence of one's home ground, in exile and rebellion. Didn't Eliot, Pound, Hemingway, Fitzgerald, Stein, and Baldwin leave the United States for Europe? Didn't Joyce and Beckett leave Ireland? Didn't Conrad leave Poland and Nabokov leave Russia? Didn't Lawrence shake the dust of England from his heels and roam the world?

Reasons for quitting America were not hard to find: the Vietnam War, the nuclear arms race, riots in the cities, squalor in the countryside, the cult of money and power, the blight of advertising, the idiocy of television, the assault on air and water and soil. England and Europe were just as tainted, I soon realized, but their ills were not my responsibility. I could live abroad without feeling called upon to join in the work of healing. And wasn't that the ideal writer's stance, as Joyce taught by word and example, to stand aloof from the human fray, paring one's fingernails, disentangled, free?

During my four years at Cambridge I wrote steadily and badly, in tortured sentences, about expatriates and drifters. In bleak times I thought of suicide—who hasn't?—and in genial times I struck poses. I learned the poses from biographies of writers who had scorned their home places, had leapt from bridges or boats, had breathed gas in rented kitchens, had taken to drink or drugs or dalliance, abandoning spouses and children, betraying friends, consuming self and others for the sake of the work, as though the poems or novels or plays were so many precious lumps of charcoal left from the burning of a forest. My posing never gave way to serious action, because I had no stomach for alcohol or betrayal. I knew that writers are supposed to be eccentric, but I could not force myself to go very far off-center. I could not persuade myself that anyone else should suffer for the sake of my writing. As it turned out, I could not even bear exile.

When I finished my degree I applied for a teaching position at a university in the south of England, and to my surprise I was offered the job. Teaching jobs were so scarce, the officials expected me to say yes on the spot, as I had every intention of doing; but when, at the end of a wearisome day of interviews, the chancellor smiled behind his rimless spectacles and put the choice before me, to stay there and make a career in England, I trembled and said no. For all my dismay over America, for all my infatuation with literary exile, I could not become an expatriate. The gravity of home was too strong.

On the train ride back to Cambridge, shaken by my decision, I began remembering the neighbors from my country childhood who had

lost jobs, the discouraged men, the bruised women, the hungry kids begging food at school, patches on their clothes, rain leaking through the roofs of their shacks, hurt leaking from their voices. Instead of fretting over my own future, I sat on the train making notes about those faces, recovering those voices, recalling stories from the Ohio Valley, describing people and places I thought I had left forever, and in that way, ambushed by memory, I finally wrote a few lines worth keeping.

<p style="text-align:center">* * *</p>

Those four years in England were also the opening years of a marriage that seemed a wonder and blessing to me, as filled with trials and revelations as any trek to the Pole. Ruth and I had known one another since before we were old enough to drive. We had courted chiefly through the mail, exchanging hundreds of letters. The desire to impress her on the page with my flair and affection had given me the first powerful incentive to write well. It seemed miraculous that she had become my wife, my companion in daily discoveries, my fellow traveler. We looked forward to having children, buying a small house with a bit of garden out back, sharing work and neighbors, settling down. The country of marriage, as Wendell Berry calls it, was more vivid to me in those years than any country defined by maps.

So I was troubled when I came across Flaubert's advice to a friend: "Stay always as you are, don't get married, don't have children, get as little emotionally involved as possible, give the least hold to the enemy. I've seen what they call happiness at close quarters and I looked at its underside; to wish to possess it is a dangerous mania." I could not imagine being more deeply involved with another person, waking and sleeping, than I was with Ruth, nor could I believe that made her the enemy of my art. And yet Flaubert's warning was echoed by Turgenev: "It is not a good thing for an artist to marry. As the ancients used to say, if you serve a Muse, you must serve her and no one else. An unhappy marriage may perhaps contribute to the development of talent, but a happy one is no good at all."

If those two crusty old bachelors were the only ones who thought that writers should be loners, I could simply have ignored what they had to say. But Flaubert and Turgenev were voicing the dogma of a sizable denomination in the Church of Literature, a sect whose members are mostly but not exclusively male. The dogma holds that if you are to be a serious writer, a writer for the ages, a writer to be reckoned with in the hall of fame, then you must sacrifice everyone and everything else to your work.

Resist all other claims on your mind, your emotions, your loyalties. Love art with all your heart. Stand apart.

A writer need not be single in order to believe in the virtues of detachment. Emerson, for example, though very much the paterfamilias, confided to his journal that "the writer ought not to be married, ought not to have a family. I think the Roman Church with its celibate clergy & its monastic cells was right. If he must marry, perhaps he should be regarded happiest who has a shrew for a wife, a sharp-tongued notable dame who can & will assume the total economy of the house."

Here the terms of the choice are clearly masculine: the writer should become either a monk, entirely devoted to the word, or else a literary prince, waited on hand and foot by the sort of helpmate whom Conrad, alluding to his own wife, called "a silent, watchful, tireless affection." The writer's wife need not be silent, Emerson suggests, so long as she not be lovable. Let her be a shrew, but a good manager. Then while the uncaptivating mistress runs the house, the master may compose in solitude, emerging only to deliver manuscripts or to pat the children on the head.

For all the masculine tinge of those pronouncements on marriage, there is more than male arrogance behind the yearning for detachment. Some female writers have imagined themselves as nuns, in the manner of Emily Dickinson; many have remained single, as did Jane Austen, Willa Cather, and Flannery O'Connor; others, including Kate Chopin and Isak Dinesen, have come into their own as writers only after the end of marriage; and a few at least of the married ones have turned husbands and children into acolytes. Women have had to tug harder and longer to open doors into rooms of their own; but the desire for such a room, for the uncluttered space of mind, for the freedom to pursue one's imaginings without restraint from any other soul, is neither male nor female.

In "Silences," a much-quoted statement about the conditions for writing, Tillie Olsen argues that "substantial creative work" can be produced only when "writing is one's profession, practiced habitually, in freed, protected, undistracted time as needed, when it is needed. Where the claims of creation cannot be primary, the results are atrophy; unfinished work; minor effort and accomplishment; silences." It would be hard for any writer who has tried juggling job and marriage and art to disagree with Olsen; and yet her argument begins to sound ominous when she sums it up by quoting Kafka: "Evil is whatever distracts." The patients of Chekhov or William Carlos Williams must have been distracting, and likewise the death-camp

mates of Primo Levi, the friends of Nadine Gordimer suffering from apartheid, the students of Theodore Roethke and Denise Levertov, the war comrades of Tim O'Brien, the enslaved ancestors of Toni Morrison, the husbands or wives of other writers, the grandparents, the daily news, the hummingbird at the feeder, the violet in the grass, the rising moon, the great worrisome world with its needs and splendors. If whatever distracts is evil, then we are back to Flaubert's advice, that the writer should flee as from an enemy anyone or anything that makes an emotional claim.

Marriage means—in the usual course of things—children, in-laws, neighbors, mortgages, insurance, furniture, quarrels: it means being snarled in the world, being *answerable*. What writer, embroiled in family and household and job, has never dreamed of stealing away into seclusion? What writer of either sex has not sometimes yearned, as Emerson phrased it, "to be released from every species of public or private responsibility"? No bills to pay, dishes to wash, deadlines to meet, no oil or diapers to change, no ringing phones or barking dogs, no letters to answer or drains to unclog, no one and nothing to contend with except the work at hand. Arts colonies thrive because they offer just such a release, however temporarily. If anyone out there has labored at writing without ever craving such freedom, please will your brain to science, so that we might discover the secret of your serenity.

Of course it is easier to make books if you are single, childless, and looked after by servants, especially if you also enjoy a private income. Yet Flaubert, Turgenev, Emerson, Olsen, and other advocates of the unencumbered life argue not merely that such a life will be easier but also that the fruits will be finer. They are saying that books made in splendid isolation will be superior to those made in the midst of family. If the family is afflicted with happiness, so much the worse, for joy will lull you to dullness. Do not go gentle into that delight, the champions of detachment warn us. Do not become entangled. Love nothing except your work, lest you confuse the Muse. Be single-minded, ruthless, aloof.

There is a seductive purity in that vision of the writing life, as there is in any life consecrated to a single labor. Yet for anyone who, in spite of Flaubert's caveat, cannot help being "emotionally involved," for anyone who relishes the moil of marriage, it is also a limiting vision. Thoroughly wedded to Ruth, I have never desired to become Ruth-less, neither during those Cambridge years nor at any time since. Nor would I, having become a father, choose to be childless, even though my mind and mood

sway in the most distracting sympathy with the movements of my children.

Instead of regarding marriage as a hindrance, I have come to see it as the arena where I wrestle with concerns that are as old as our species. That is what Gary Snyder means, I believe, when he speaks in *The Real Work* of family as "the Practice Hall." From his time in Zen monasteries and fire towers, Snyder understands the virtues of solitude; but he also understands the virtues of companionship. "I have a certain resistance," he explains, "to artificially created territories to do practice in, when we don't realize how much territory for practice we have right at hand always." The goal of the writer's practice is the same as anyone else's: to seek understanding of who and where and what we are, to come fully awake. If you are well married, sharing a life and not merely a bed or a bank account, then family may become your territory for doing the real work—spiritual as well as practical—of being human.

<p style="text-align:center">* * *</p>

When I said no to the offer of a teaching post in England, it was a married man's decision, for Ruth had even less of a desire than I did to become an expatriate. As a scientist, she had never succumbed to the Romantic notion that creativity flourishes only on the margins, in wandering and exile. Nor did she see any reason why a person could not make discoveries in the middle of the country as well as on the coasts. So when I was offered jobs back in America beside the shining Atlantic and Pacific, Ruth persuaded me to turn them down in favor of one in her home state of Indiana, in Bloomington, where she had studied chemistry. Southern Indiana was in the Ohio Valley, she pointed out, so the people and houses and churches and landscape would remind me of the places where I had first paid attention to the world.

As soon as we unpacked our bags in Bloomington, I set out to explore the neighborhood, to learn its ways and wildflowers, to hike the trails, drive the back roads, listen and watch. I bought Geological Survey maps and traced the contour lines. I sat in on trials at the courthouse. At the farmer's market I found out what to plant in our yard. On street corners, park benches, and parlor sofas I heard local tales and songs. I read graffiti in the alleyways, gravestones in the cemeteries, gravels in the creekbeds. In dirt and rocks, in museums and books, I studied the history of my region, beginning with the ancient oceans, on through periods of mountain-building and glaciation, through ten thousand years of civilization by native people, centuries of European exploration and settlement,

the clearing of forests, homesteading, farming, manufacturing, the spread of canals and railroads and highways, the rise of cities, right up to my own tumultuous time. In all these explorations, I was not following a literary strategy, I was following my nose—or, to invoke a more elegant organ, my heart. Weary of travel, I was glad to give up being a visitor and ready to become an inhabitant. I wished to make my new home ground the ground of my imagination.

The impulse to marry a place, like the impulse to marry a person, runs against the grain of much writerly advice. In *The Triggering Town*, to choose an influential example, Richard Hugo urges us to avoid writing about our own neighborhoods, and to write instead about strange towns, where we feel no "emotional investment," where we are constrained by "no trivial concerns such as loyalty to truth, a nagging consideration had [we] stayed home." As an outsider, a sort of literary tourist, you need be faithful only to your words. "You owe reality nothing," Hugo insists, "and the truth about your feelings everything." Surely that is an odd disjunction, to set feelings against reality, as if the writer's imagination were sealed inside a floating bubble. Hugo does acknowledge that "after a long time and a lot of writing, you may be able to go back armed to places of real personal significance." But by that time you may well have been confirmed in the role of literary tourist, one who wanders in search of material, as the strip miner hunts for coal or the timber cruiser hunts for board feet.

Whitman envisioned the American land as a patchwork of neighborhoods, but also as an expanse to be overcome. In our view of the continent, there has always been this tension between an attachment to place and a yearning to conquer distances. Our frenzied building of roads, our restless mobility, our taste for the standardized fare of franchises are all expressions of this anxiety about wide open spaces. The net effect of Whitman's rhetoric, if not his biography, was to glamorize the mover at the expense of the settler. Much of our literature is the work of earnest pilgrims, idle drifters, travelers who write from a distance about places they have abandoned, or nomads who write about no place at all.

I am more attracted by the examples of American writers who, sometimes after periods of wandering, have settled down and rooted their art in a chosen place: most famously Thoreau, of course, in Concord; Faulkner in his patch of Mississippi, Eudora Welty in hers; William Carlos Williams in Rutherford, New Jersey; Flannery O'Connor in Milledgeville, Georgia; Grace Paley in New York City; Wendell Berry on his farm beside the Kentucky River; Ursula Le Guin amidst the rain and rhododendrons of

western Oregon; Gary Snyder in the Sierra foothills of northern California; Mary Oliver on Cape Cod. Each of these writers possesses a "locus of the imagination"—to borrow a phrase from the Dakota poet Thomas McGrath—and each one has engaged in a lover's quarrel with his or her place, seeing it critically in light of knowledge about other places and other possibilities.

Even though her white skin has at times made her feel unwelcome as well as guilty in her homeland, Nadine Gordimer has chosen to stay in South Africa, to use her intelligence and imagination in the struggle for a free society. "One thing is clear," Gordimer insists, "ours is a period when few can claim the absolute value of a writer without reference to a context of responsibilities." It is striking, how directly she contradicts Emerson's desire "to be released from every species of public or private responsibility." In an age of totalitarian politics and coercive mass media, those responsibilities include giving voice to the silent, upholding the integrity and precision of language, speaking truth to power.

By chance and necessity, Pablo Neruda lived in a good many countries, and yet, according to his *Memoirs*, he never let go of his native land, and the land never let go of him. When his period of foreign service and political exile was over, he returned to Chile:

> I believe a man should live in his own country and I think
> the deracination of human beings leads to frustration, in one
> way or another obstructing the light of the soul. I can
> live only in my own country. I cannot live without having
> my feet and my hands on it and my ear against it, without
> feeling the movement of its waters and its shadows, without
> feeling my roots reach down into its soil for maternal
> nourishment.

For writers who are firmly in place, the metaphor of roots is inescapable. "Nothing can grow unless it taps into the soil," William Carlos Williams tells us in his *Autobiography*. To put down roots does not mean, however, that one can no longer budge. Our legs were made for walking, as the heartbreak songs proclaim. But instead of walking away from our messes and confusions, as Americans have traditionally done, instead of rambling forever toward pay dirt or sunset, aimless as tumbleweed, we need to move in loops, out and back again, exploring our home ground, as owls or foxes or indigenous people explore the territory they use for hunting, gathering, mating, and play.

The writer who is steadfast rather than footloose risks being dismissed as regional or quaint. What could be more backward than staying put in a culture that rushes about? How can you see the big picture from a small place? I find the beginnings of an answer in the word *stead* itself, which derives from an Indo-European word meaning to stand. To be steadfast is to stand by someone or something, out of a conviction that what you are committed to is worth loving and defending. A homestead is a place where one makes a stand. A farmstead in the Midwest is typically a huddle of sheds and barns and silos around a house, with trees for shade in summer and for windbreak in winter, surrounded by hundreds of acres of pastures or cultivated fields, like a tiny human island in a fertile sea. Whenever I see those farmsteads, I sense the smothering isolation, but I also sense the gathered purpose.

Knowledge of how one's region fits into larger patterns is the surest defense against parochialism. "Being regional, being in place, has its own sort of bias," Gary Snyder concedes, "but it cannot be too inflated because it is rooted in the inviolable processes of the natural world." We need to recover the ancient sense of homeland as an area defined not by armies and flags, not by religion or race, but by nature and geography and by the history of human dwelling there, a habitat shared with other creatures, known intimately, carried in mind as a living presence.

The effort to know and care for and speak from your home ground is a choice about living as well as writing. In that effort you are collaborating with everyone else who keeps track, everyone who works for the good of the community and the land. None of us is likely to fulfill the grand ambition of Joyce's young artist, Stephen Dedalus, to forge in the smithy of our souls the conscience of our race; but we might help form the conscience of a *place*, and that seems to me ambition enough for a lifetime's labor. Trees tap into the soil, drawing nourishment and returning fertility. Capturing sunlight, breaking down stone, dropping a mulch of leaves, replenishing the air, trees improve the conditions for other species and for the saplings that will replace them. So might writers, through works of imagination, give back to the places that feed them a more abundant life.

* * *

By choosing to settle in the Midwest, far from the mythical cutting edge and the actual publishing houses, I made another unfashionable decision. Every young writer I knew in my wandering years wished to live in London or Paris, New York or Boston, San Francisco or Los Angeles. My

friends asked me what on earth I would do way out there in Indiana. Whom would I talk with? How would I keep my mind alive? Did Hoosiers give a hoot about literature? Booth Tarkington had left Indiana to seek fame and fortune elsewhere, and so had Theodore Dreiser, Kenneth Rexroth, and Kurt Vonnegut. But what writer of consequence had ever *moved* there? At age twenty-five, a writer of no consequence whatsoever, I could not answer those questions.

I found little support for my decision in books. The most celebrated literature about the Midwest has been written by those who left—Mark Twain, Willa Cather, Sherwood Anderson, Sinclair Lewis, Ernest Hemingway, Wright Morris, Toni Morrison—and who made a case for their leaving. You can read variations on the case in *Adventures of Huckleberry Finn, Main Street* or *Winesburg, Ohio*, in *My Antonia* or *Sula*: the Midwest is a realm of rich soils and pinch-penny souls, a country of raw farms and small towns and grubby industrial cities, populated by gossips and boosters and Bible-thumpers who are hostile to ideas, conformist, moralistic, utilitarian, and perpetually behind the times.

There is enough truth in this portrait for it to be commonly mistaken for the whole truth. Midwesterners themselves often accept the grim account, apologizing for living where they do, expecting culture to arrive from far away, like tropical fruit, and looking askance at anyone who makes art in their own neighborhood. If you were any good, they say to the writers in their midst, wouldn't you be somewhere else? Wouldn't you be living within a taxi-ride of the talk show studios? Wouldn't you be rubbing elbows with literary movers and shakers in those glitzy settings where folks move and shake? No offense, now, but if you were serious, wouldn't you abandon this homely country for someplace more inspiring?

Midwesterners buy the same environmental calendars that other Americans buy, we browse through the same books of landscape photographs, watch the same dazzling wilderness expeditions on film, and from all of those images we learn that real nature, like real culture, is somewhere else. Real nature means the sort of thing you see on posters—mountains and old growth forests, painted deserts, buttes, hot springs, volcanoes, glaciers, rocky coasts and white-water streams—and for scenery like that you have to drive a long, long way. The Midwest does not often show up on posters. It is a modest, subtle, working landscape. Yet even in this country of prairies and glacial plains and wooded hills, wildness wells up everywhere, in the midst of towns, inside closed rooms, within our own bodies.

No matter where we live, the energy of creation flows in each of us, every second. We can feel it in heartbeat and dream and desire; we can sense it in everything that grows, from bacteria to beech trees, from babies to butter-flies.

Since well before the Civil War—when Audubon began sketching birds along the Ohio River and Sam Clemens opened his eyes and ears to life on the Mississippi—the Midwest has been feeding the imaginations of writers. It has begun feeding their bellies in a more dependable way during the past few decades, as universities and arts councils have become pa-trons of the arts. Only recently, however, in fits and starts, here and there, has the Midwest begun to nourish its writers with a sense of purpose, a sense of doing work that matters in a region that matters.

Many readers still welcome reports from the interior of other con-tinents—the secret depths of the Himalayas, the heart of Africa, the Aus-tralian outback, the Amazon jungle, the Russian steppes—while neglect-ing reports from the interior of our own continent. The pundits who define literary fashion may continue to think of the Midwest, if they think of it at all, as the blank space over which one must tediously fly on the way to somewhere important. The blank spaces are not on the land, however, they are in our minds. Life struggles and blossoms and mutates here as it does everywhere. We will never know the whole truth, about this region or any other, but we could use a much fuller account of the Midwest than we have yet received.

If we imagine North America as Turtle Island, to borrow a meta-phor from the old people, then out in the Midwest we are on the hump of the shell. Every bit of the shell deserves our attention. Some parts have been intricately carved and painted, filmed and photographed, rendered in prose and poetry, while many other parts have scarcely been noticed. The writer's work is to notice, record, and remember, to inscribe the shell with stories. The surest way of convincing your neighbors that they, too, live in a place that matters is to give them honest and skillful writing about your mutual home.

<div align="center">* * *</div>

To be sure, worthy books have been written in exile, in isolation, on the margins of continents, in the precincts of madness. There is much to be said for writing from the edge, and it has been said over and over. In our infatuation with edges, we have scorned the center, a word that carries for me spiritual and psychological as well as geographical meanings. I am

suspicious of theories about the writing life that urge us to abandon the common in favor of the exotic, the local in favor of the distant. The truth about our existence is to be found not in some remote place or extreme condition but right-here and right-now; we already dwell in the place worth seeking. I write from within a family, a community, and a landscape, concentric rings of duty and possibility. I refuse to separate my search for a way of writing from my search for a way of living.

Whatever the orthodoxy may be in the larger society, among artists there is a widespread belief that fidelity to anything besides art is foolish. Listen long enough to writers, and you will hear many of them chant, along with Yeats,

> The intellect of man is forced to choose
> Perfection of the life, or of the work,
> And if it take the second must refuse
> A heavenly mansion, raging in the dark.

But the choice seems false to me. One's work grows out of one's entire life, including—if those are the choices you have made—the pleasures and struggles of marriage, of fatherhood or motherhood, of householding and citizenship. Yes, in order to work you must withdraw, if only into the room of imagination. But you carry into that private space every scrap of your experience, however acquired.

The Romantic image of the writer as an isolated genius, inventing worlds from scratch, legislating for humankind—an image that seems to rule over much of what passes for "creative writing" in universities—also seems to me a dangerous illusion. We are the servants, not the masters, of words. Language arises from the long human effort to make sense of things, and therefore even the simplest sentence binds us to our fellows, to history, and, by what it designates and celebrates, to the earth.

* * *

Early in my explorations of Bloomington I came across a limestone marker half buried in the lawn of the courthouse square and bearing the words, CENTER OF POPULATION USA 1910 CENSUS. When I read the inscription, I visualized a slab in the shape of the United States, with all the citizens of 1910 represented by stick figures, each figure in its appropriate spot, the whole array balancing on a point beneath my town. With the migration of Americans toward the setting sun, the imaginary point has

kept moving westward. For a brief spell, however, the citizens of Bloomington could imagine they were living at the center of something, if only of a census map. The limestone marker was a pitch for importance, akin to all those claims one sees on license plates and billboards, naming this village a gateway, naming that state the heart of it all.

According to the historian of religion, Mircea Eliade, humans have always and everywhere imagined their town, their tribe, their temple, their sacred mountain as the center of the world, "the point at which the Creation began." So we have Mecca, Golgotha, Mount Olympus, the holy centers where profane and sacred meet. The very name of Babylon means "gate of the gods." The Lakota people can show you their sacred mountain in the Black Hills. The Hopi believe their ancestors emerged from an earlier, fallen world into the present one through a hole in their homeland, and that hole remains the source of all things. Depending on the gods we worship, those of us who descend from more recent immigrants to America locate our holy centers in Hollywood or Times Square, on Wall Street, Bourbon Street, or Pennsylvania Avenue, on the peak of Mt. Katahdin or the bottom of the Grand Canyon, on the front stoop or in the backyard.

The more geographers reveal about the earth and the more astronomers reveal about the universe, the harder it is for us to believe in the cosmic importance of any particular spot. Viewed from the moon, the grandest metropolis is only a molehill. The earth itself is no more than a speck of grit in a run-of-the-mill galaxy. And our entire galaxy, viewed from a few light years away, dwindles to the size of a struck match. If we fancy that our address gives us unique access to the source of things, we are only flattering ourselves.

None of us lives at the point where the Creation began. But every one of us lives at a point where the Creation continues. We ride on a powerful current, and so does everything else we can touch or taste or see. If the current were to falter, the world would cease to be. Because it is steady, because the order of the universe is so dependable, we forget it is there, as we forget the air we breathe. Spiritual practices are ways of recollecting and experiencing this orderly power. Zen sitting, Navajo chanting, Quaker silence, Hopi kachina dancing, the whirling of Sufi dervishes, the postures of yogis, the prayers of Moslems and Christians and Jews, countless varieties of meditation and song, are all techniques for reaching toward the ground of being.

Quakers describe what they experience in the prayerful silence as a "centering down" to spiritual depths, below the chatter and buzz of our

normal preoccupations, and they speak of the insights that come to them, the words that rise out of the silence, as "openings." Both of these terms have helped me to understand writing itself as a spiritual practice. Ordinarily the mind is bottled up inside the ego like a firefly in a jar. The jar is cluttered with frets and desires, with calculations and calendars, with the day's doings and the night's fears. Our task is to open the jar, or let it be opened, so that a greater reality may come streaming in.

According to the materialistic philosophy that prevails in literary circles, the universe is an accidental collision of atoms, and the only reality beyond the self is the muddle of rival selves we call society, and art is an ingenious game played with empty tokens. But if there is a transcendent source, as I believe there is, then a literature of slick surfaces, private angst and social manners, of sexual capers and money-chasing and political intrigue, seems not only tedious but deceitful; it wastes our time; it scatters our attention; it fattens us on lies. Art that insistently refers to itself, to its own cleverness and importance, its own materials and procedures, seems petty beside art that points beyond itself to the great sustaining order. The ego is too small an enclosure and too feeble a source for enduring art; the social scene is too shallow. Unless you draw from deeper springs, the work will be thin and vaporous. "Why, thirty or forty skins or hides, just like an ox's or a bear's, so thick and hard, cover the soul," says Meister Eckhart. "Go into your own ground and learn to know yourself there." When we say that a person or a song, a story or a poem has soul, we are acknowledging the presence of more-than-personal meaning and power.

For one who senses depths beyond the self, writing becomes a centering down, an inward listening for openings in the stillness, through which authentic words may come. "I know no advice for you save this," Rilke tells the young poet, "to go into yourself and test the deeps in which your life takes rise; at its source you will find the answer to the question whether you must create." If the answer is yes, Rilke says, then "only be attentive to that which rises up in you and set it above everything that you observe about you. What goes on in your innermost being is worthy of your whole love." This may not sound all that different from Richard Hugo's motto: "You owe reality nothing and the truth about your feelings everything." But Rilke is talking about a level deeper than feelings. The depths to which he invites us, the depths from which the individual's life takes rise, are also the source and pattern for everything else. Find your way to that ultimate ground, root your work there, and you will have something worth saying.

Mystics report that every bit of the world radiates from one center—every cricket, every grain of dust, every dream, every image, everything under the sun or beyond the sun, all art and myth and wildness. If they are right, then we can have no more important task than to seek that center. Here is the honey, here is the slippery essence that eludes all language. We dwell midway between two infinities, of the unimaginably large and the infinitesimally small, and between the twin mysteries of birth and death. For better or worse, here we are, in a flickering, fleeting patch of light surrounded by darkness. We have no reliable device for pointing the way to the center of being, as the carpenter's plumb bob points to the center of gravity. We have no maps or birds to guide us there. We have only consciousness, patience, craft.

BOB

FOX

Bob Fox was born in Brooklyn, NY in 1943 of Ukrainian parents. His father, a self-taught mandolin player who read widely, worked in the garment industry. James T. Farrell, Albert Halper and Edward Dahlberg were among the authors he read, in addition to Mike Gold, who made the idea of writing attractive. While in high school, Bob worked at *Sing Out! Magazine* and Folkways Records, an experience that enhanced his multicultural worldview. After making the difficult choice to writer rather than play music full-time, he completed a BA degree in English at Brooklyn College and an MA degree in English at Ohio University in Athens.

I worked my own 73-acre farm for most of the 20 years I lived in southeast Ohio, describing that life in an essay collection, *Song of an Adopted, Displaced Appalachian.* Two collections of my fiction have been published: *Destiny News* and *TLAR & CODPOL* (acronyms for *The Last American Revolution* and *Confessions of A Dead Politician,* two short novels in one volume), both books published by December Press. Awards include the PEN Syndicated Fiction Competition, and a Nelson Algren Short Fiction Award from the Chicago *Tribune*. My short stories, poems, essays and reviews have appeared in numerous literary magazines including *The North American Review, The Massachusetts Review, Witness* and *Fiction.* My most anthologized piece, the short short story, "A Fable," appears in such collections as *Sudden Fiction: American Short Short Stories,* and *Three Genres.*

My most recent book, *Teaching Writing from a Writer's Point of View*, co-edited with Terry Hermsen and published by the National Council of Teachers of English, is based on both the Ohio Arts Council's school residency program with writers, and the creative writing summer institute for teachers, which I helped found and coordinate with Wright State University. I have worked for the Ohio Arts Council since 1977.

Still active as a musician, I've produced a solo album of acoustic blues piano, guitar and vocals, *Primarily Blues,* and performd regularly at small clubs.

Remembering *Jews Without Money*

Bob Fox

Usually, I don't read bestsellers. *Angela's Ashes* came to me from a friend whose repeated insistence, followed by a copy of the book, had me open it one winter evening. I was immediately engaged, haunted by— a memory of hardship, the stories of excruciating deprivation in eastern Europe my mother fled as a child. The recollection bridged McCourt's tale of Irish poverty to another masterpiece, a bestseller during the Great Depression, Michael Gold's "autobiographical novel" *Jews Without Money.* After finishing *Angela's Ashes*, I returned to Gold's book and was struck by the similarities. Parallels and odd coincidences connect them, and the careers of both authors, opposite mirror images, illustrate the blurring of social classes and democratization of opportunity in this country after World War II. McCourt benefited, fulfilling a lifelong love of books by teaching, and a belated career as an author. Gold's career however, was determined not just by the nineteenth century poverty he knew as a child, but by the class wars in which he became an active partisan. *Jews Without Money,* apart from its resonance to me personally, is a book readers of *Angela's Ashes* would enjoy. (Coincidentally, it was reprinted in a facsimile paperback edition in 1996, the year *Angela's Ashes* was published and is still listed in *Books in Print.)* Both books transcend ethnicity and class to encourage empathy. In his introduction to the 1935 edition, Gold hoped his book would answer the demagogic lie that all Jews were millionaires. He relates the story of the arrest of his German translator, whose apartment is visited by Nazi officers, bursting into laughter at the title of the manuscript on her desk. Gold comments: "The dark ages had returned; modern thought was again burning in the flames of a new inquisition."

Jews Without Money was published in 1930 when Gold was 37. He had been struggling with the material for more than 10 years, encouraged by H.L. Mencken among others to turn the stories of his childhood into a book. Gold was embittered by the life of poverty growing up in New York's Lower East Side at the turn of the century. Though recognized and encouraged as a gifted writer, he dropped out of school at age 12 to help support his family. At one point he managed to talk his way into Harvard for a short-lived academic experience. The lack of money to pur-

sue a formal education drove his political activism. During his twenties, he made the first of many attempts to re-capture his childhood in words.

Jews Without Money stands apart from Gold's activist writing; while it was praised as the first "proletarian" novel it does not embody a political agenda. It takes a close, passionate look at the relentless cycles of poverty and the frustration and despair of working class immigrant families.

Frank McCourt, like Gold, struggled for years with how to write the story of his childhood until he, too, found the child's voice/eyes. McCourt, like Gold, intended to convey the desperation of poverty, telling The New York *Times,* "Poverty is rarely portrayed well, and I wanted to portray the stink (of it)." I have found no mention by McCourt of having read or been influenced by *Jews Without Money.* Yet, the authors' struggles with point of view is just one of many similarities.

Both books universalize deprivation and portray societal as well as individual failures. Any treatment of poverty implicates class: the poor are not usually poor by choice. In *Angela's Ashes,* neither the scant welfare system in Ireland nor the haughty and indifferent Catholic church provide a social safety net for the McCourts. The family is barely kept alive by the St. Vincent de Paul society and the meager and cruel generosity of condescending relatives.

In Gold's novel, the immigrant Jews step from steerage in search of the American dream and instead find themselves in filthy, roach-ridden Lower East Side tenements, at the mercy of factory owners, corrupt politicians and gangsters. No social safety net exists to catch people before catastrophe. Yet, family love, humor, and optimistic dreams of the future enable the poor Jews, like the Irish, to persevere. Both books present the gritty feel of a life where hope is continually foiled by circumstance, where a better life remains just beyond reach; they portray the substance and the costs of survival.

Jews Without Money offers this metaphoric summary of the late 19th century immigration, where the Jews succeeded the Irish into the cramped tenements of lower Manhattan:

> The Jews had fled from the European pogroms; with
> prayer, thanksgiving and solemn faith from a new Egypt
> into a new Promised Land. They found awaiting them
> the sweatshops, the bawdy houses and Tammany Hall.

The focus then zooms cinematically to the details of street life:

> People pushed and wrangled.... There were armies of
> howling pushcart peddlers. Women screamed, dogs barked
> and copulated. Babies cried.
> A parrot cursed. Ragged kids played under truckhorses.
> Fat housewives fought from stoop to stoop.
> A beggar sang.

Superstition is part of the tradition the immigrants bring with them as they attempt to acclimate to their new, strange home. This humorous scene occurs during the narrator's fifth birthday party:

> . "I have read in the paper," said my father, "that a Dybbuk has
> entered a girl on Hester Street. But I don't believe it. Are there
> Dybbuks in America, too?"
> "Of course," said Reb Samuel quietly.
> Mendel Bum laughed a raucous brandy laugh. He had eaten of
> everything: the sponge cake, the herring, the quince jam, the apples,
> *kraut knishes,* the *wishniak,* the plum brandy, the Roumanian wine.
> Now his true nature appeared.
> "I don't believe in Dybbuks!" he laughed. "It is all a
> grandmother's story!"
> My father banged on the table and leaped to his feet.
> "Silence, atheist!" he shouted, "in my house I want no wisdom
> from you!"

The scene encapsulates *shtetl* Jews' confusion of superstition and the sacred, a tradition my mother faithfully upheld. I remember her snapping her fingers in circles over my head when I was ill in bed, spitting softly to undo whatever curse was afflicting me, and how she taught me to place my thumb between the first two fingers of my fist (concealed in my pocket, of course) to ward off the evil eye by giving it back. And yes, how during the peak of my adolescent rebellion she was convinced *I* was possessed by a Dybbuk.

Fortunately, I was not treated like the girl in the story within a story, which Reb Samuel continues to tell:

> "The Rabbi studied the matter. Then he instructed two men to
> take her in a wagon back into that forest"(where the Dybbuk

allegedly entered her). "They were told to nail her hair to a tree, drive away with her, and cut off her hair with a scissors.

"This they did. They whipped the horses, and drove. The girl screamed, she raved of fire and water. But when they reached home she was cured. The Dybbuk had left her. All this, my friends, I saw myself."

The fathers of both young narrators, though failures in the marketplace, are brilliant story tellers. Malachy McCourt improvises upon the feats of the Irish hero Cuchulain, teaches Frankie patriotic songs, and implies that he had a price on his head as a member of the old IRA. Mikey's father Herman is equally gregarious, "passionately social," loving to command attention with his tales. He alludes to a vaguely criminal past in Turkey, but now soothes his children to sleep with fantastical tales the boy realizes years later were the Arabian Nights, learned not from books but "from the lips of professional storytellers in Oriental market-places." Like his mentors, Herman acts out his tales.

His voice was heard in the dark. It changed with the moods of the story. Now it was fierce with the basso rumblings of the Executioner of Constantinople. Then it grew tender as a Snow-Maidens, or as the voice of the love-racked young Mountain Prince. Then it was an old witch's shrill voice, or the drunken Turkish giant's.

His stories regularly entertain groups of "pants pressers and housepainters, graybeard grandfathers with snuff boxes; tired mommas in aprons; men and women who sat hypnotized (and) held long debates after each story ... as if this mythology were as real as the sweatshops and the garbage cans."

Herman is not undone by drink but by betrayal. A cousin who hired him shortly after his arrival in this country absconds, during Herman's honeymoon, with the successful business in which Herman had become a partner. He is forced to take work as a housepainter, where lead poisoning and a fall from a scaffold debilitate him.

Angela McCourt, like Herman's wife Katie, endures the deaths of children: Angela loses her twins and a beloved infant daughter to typhoid and diphtheria. Katie's little Esther is run over by a horse cart while gathering firewood in a blizzard, a chore Mikey, as older brother, should have

performed. In our normal lives, sibling rivalry would not have such dire consequences, but under the duress of poverty it results in the death of a contemplative child, one who loved to read while her older brother roamed the streets.

At times, Mikey's family seems prosperous compared to the fatherless McCourts. Despite meager resources, Katie makes their apartment a haven for the needy: Mendel Bum and Aunt Lena live with them in turn, as do disoriented new immigrants and an ill prostitute. Katie puts her family's chores aside to cook or clean for a neighbor in need. Herman berates her for neglecting her own, but she is compelled to help those worse off.

Coincidences link *Angela's Ashes* and *Jews Without Money* in an American tradition of books about the poor. Stephen Crane's naturalistic novel of Lower East Side poverty, *Maggie, A Girl of the Streets,* was published in 1893 the year of Gold's birth in that neighborhood. *Jews Without Money* was published in 1930, the year of Frank McCourt's birth in the slums near downtown Brooklyn. Much of *Angela's Ashes* occurs during the Depression years when *Jews Without Money* enjoyed its enormous success. Alfred Kazin's Depression-era memoir, *A Walker in the City,* published in 1951 pays the following debt to Gold:

> It puzzled me greatly when I came to read in books that Jews are a shrewd people particularly given to commerce and banking, for all the Jews I knew had managed to be an exception to that rule. I grew up with the belief that the natural condition of a Jew was to be a propertyless worker like my (house)painter father and my dressmaker mother ... kin to all the workers of the world, dependent entirely on the work of their hands.

Stylistically, *Jews Without Money* lacks the discursive, lyric amplitude of *Angela's Ashes*. Alfred Kazin comments on Gold's stylistic fury (in his introduction to Carroll & Graf's 1996 edition), how Gold's "short, stabbing sentences" enact his outrage at poverty. Kazin calls Gold a "primitive," yet also recognizes his eye for detail and gift for lyricism, as illustrated in the following description of New York City.

> It is all geometry angles and stone. It is mythical, a city buried by a volcano. No grass is found in this petrified city, no big living

trees, no flowers, no bird but the drab little lecherous sparrow, no soil, loam, earth; fresh earth to smell, earth to walk on, to roll on, and love like a woman.

Like *Angela's Ashes,* Gold's story ends during the narrator's adolescence. Frankie flees Ireland for the U.S.; Mikey escapes despair by enlisting in the cause of the worker's revolution after seeing a speaker on a soap box. It was not that choice, but rather the poverty he survived that determined Gold's literary future. While he believed he advocated an expansive view of literature, in fact he preached a messianic, parochial Marxism.

He wrote for The *Liberator, The Masses,* co-founded The *New Masses,* and contributed columns to *The Daily Worke*r and *The People's World.* Though he wrote plays, performed to mixed reviews, published short stories as well as columns, his worldview is illustrated best by his attack on middle class Humanism embodied in the work of Thornton Wilder. In a review subtitled "Prophet of the Genteel Christ," he called Wilder's style "irritating and pretensious," "slick, smug ... neat, tailor-made rhetoric" and "a great lie." Edmund Wilson noted the essay as the beginning of the literary class war, marking "the eruption of the Marxist issues out of the literary circles into the field of general criticism." (Both quotes are from *Years of Protest* edited by Jack Salzman and Barry Wallerstein, an annotated, illustrated anthology of American writing from the 1930s.)

Wilder never participated in the lengthy controversy that followed. Privately, he admitted to being a bookish person, a humanist. He also admitted membership in a number of organizations which were later blacklisted. The left's attack on humanism, led by Gold, was an eerie predecessor of the outcry against "secular humanism" from the Christian right during the recent Culture Wars. (I'm reminded of an elementary school lesson, where the teacher noted how left and right wings were mirror images of one another, the facing tips of a horseshoe.)

The question of literature in service of political ideas has long been answered by events. Though *Jews Without Money* was reprinted many times throughout the Thirties, and though it was translated into at least 15 different languages, it still did not prevent Hitler's demagogic rewrite of history and the rise of fascism. No doubt the Nazis fueled many fires with copies of *Jews Without Money,* among other texts from the rich and varied cultures whose modes of thought and expression they wished to eradicate.*

Gold is remembered as a "character" of the times, not a literary figure. I resist speculating on the writer Gold might have been with enough economic freedom to continue his formal education within the free public schools of New York City. Gold is of his time, his novel the result of his choices. McCourt found the opportunities denied Gold, returning to this country in 1951, working his way through school as a laborer, and sharing his great love of language and literature with thousands of students during a lengthy teaching career. Regardless of what else Gold might have written under different circumstances, *Jews Without Money* remains a highly readable work of lasting literary merit almost 70 years after it was first published.

I came upon *Jews Without Money* when I was nine or ten, lifting it from a dusty carton that had just emerged from the basement of our Brooklyn apartment building. It had been stored with my father's collection of Tolstoy, Pushkin and Gorky in Yiddish and Russian, hidden from the FBI, whose agents allegedly conducted door-to-door searches for communist materials during the McCarthy era. (In our democracy, the Communist Party, which tried unsuccessfully to root itself in American tradition, was declared illegal, and during the early years of the Cold War, countless careers of former members or "sympathizers," were destroyed or limited by accusation and innuendo.) The book caught my eye because the front cover dangled open, revealing Howard Simon's stark woodcuts covered by my older brothers' crayon scribbles—my parents could not afford coloring books during the Depression.

It wasn't long before I read the novel for the first time. The simple sentences and short chapters were easy to read and the life of the streets was familiar. I was also reading Booth Tarkington's Penrod novels and James T. Farrell's short stories. Inspired by these I began to write about the street life around me, the characters in the neighborhood cast aside by the clamor for middle class success.

I re-read Gold's novel when I graduated from Farrell's short stories to the Studs Lonigan trilogy, Albert Halper's *Union Square,* Edward Dahlberg's *Bottom Dogs,* and Nelson Algren's *Neon Wilderness.* I spent hours in front of the Ashcan School paintings of John Sloan, Reginald Marsh and others at the Brooklyn Museum. By this time I took myself seriously as a writer, experimenting with science fiction and later with surrealism, but always returning to an engagement with place and the people in the margins of society.

When I began dating the daughters of the educated, liberal middle class, *Jews Without Money*, with its distinctive orange cloth cover, appeared ubiquitously in family bookshelves. It put me at ease, providing a link to my more modest working class home. Though critically acclaimed and a bestseller during the Depression, during the Fifties the book had no currency as literature. My English teachers acknowledged its existence. It was an important book in its time but that time was past. It had become a memento.

Jews Without Money remained out of print for many years until Avon began reprinting classics from the Thirties in mass market paperback editions in the early Sixties. Their first edition omitted the last few paragraphs, in which Mikey is inspired by the worker's revolution. The absence may have been an artistic decision, for the ending seems tacked on, or it could have been the chilling influence of the CIA, which a few years earlier funneled money to liberal magazines and critics to develop and promote an anti-communist esthetic. The McCarthy era provided lasting soil for paranoia.

Jews Without Money takes me back to my mother's stories, whose point was the American future she envisioned for her sons. She hoped her desperate childhood would inspire my patriotism, so that I might abandon my idealistic interest in the civil rights movement and the economically deprived. She dismissed my quest for a morally based life as futile idealism. After all, what had my father's youthful activism during the Depression accomplished? His union was now run by the mob. How could I ignore the fabulous American opportunity for material comforts available to those dedicated to their pursuit? Why couldn't I be pragmatic like my older brothers who worked their way through school to become doctors?

I did indirectly fulfill her wishes by becoming an invisible part of middle America. I regard my life as having transcended class, a beneficiary of postwar prosperity that blurred the distinction between working and middle classes. I didn't experience the deprivation my older brothers knew, yet my life was no garden of choices. When it came my turn to attend college, my interest in one private school in Ohio seemed preposterous—Antioch did not offer full scholarships and it was too far away to even consider visiting. I attended Brooklyn College, a commuter campus in the most literal sense, a school resembling a subway station at rush hour, students pushing and shoving in the registration lines, hoping to not get closed out of the noisy, overcrowded required courses. My parents' dream

was achieved however, their three sons safely ensconced in mainstream America at the close of the century.

Jews Without Money reminds me of the economic free for all that carried from the nineteenth into the twentieth century, and the kind of amnesia that results from the difficulty of crossing the bridge between classes. Just as victims of physical trauma don't remember the pain, the upwardly mobile often forget their origins and are unwilling to empathize with the new class of immigrant blue collar workers. The Reagan Revolution, after all, was made possible by successful working class families wanting to lock in their middle class grubstake.

The great Irish writer Frank O'Connor spoke of the kinship between Jewish and Irish writers, how they both were concerned with the family as the basis of survival. *Angela's Ashes* and *Jews Without Money* transcend ethnic and racial boundaries, explore a common ancestry of hardship which binds rather than divides us.

*The Nazis have their contemporary counterpart in the Serbs, whose army destroyed the National Library, National Museum and Oriental Institute in Sarajevo, targeting mosques and museums throughout Bosnia and Croatia, attempting to eradicate all traces of Byzantine art and architecture from the Ottoman Empire. This in addition to ethnic cleansing and mass graves.

JANET

ZANDY

Janet Ballotta Zandy was born in 1945 in Hoboken, New Jersey and grew up in the small north Jersey working-class towns of Union City and Lyndhurst. Becoming a teacher was not seen as a "way out," but rather as a way of honoring the formal learning denied to her own parents because they had to work to support the family.

Teaching working-class literature, compiling and editing anthologies of working-class writing became for her an essential pipeline between the private familial working class self and the public educator and activist self. Zandy is the editor of *Calling Home: Working-Class Women's Writings* (Rutgers UP 1990) and *Liberating Memory* (Rutgers 1995) and "Work-

ing-Class Studies" (1995) a special issue of *Women's Studies Quarterly* where she is general editor. She insists that culture is presence, not absence. Working-class culture is not about the absence of bourgeois sensibilities. Identifying, illuminating, and representing working-class culture in all its variegated complexity and contradiction have been central to her work. She is an associate professor of Language and Literature at Rochester Institute of Technology.

As a kid I would walk the five long blocks to Lyndhurst Public Library on hot August afternoons. The N.J. air was so thick with chemicals and pollutants that it hurt to take a breath. The sky was industrial gray. I did not know then that this was a condition of place and that August summer afternoons elsewhere were different. I loved the cool polished wood and open spaces of the library. I would touch the books, walk up and down the aisles, and then take nothing out. I did not know what to choose. The librarian, if she noticed this eleven-year-old at all, looked down on me as an intrusive presence. I probably became an English major out of this book yearning.

God Job [1]

Janet Zandy

"So he threw it up, not yet knowing a job was God,
and praying wasn't enough, you had to live for It,
produce for It, prostrate yourself, take anything from It,
for was it not God. . . ."

> Tillie Olsen, *Yonnondio*

"[T]he job is not freedom. Your wonderful brain is
freedom . . ."

> Pietro di Donato, *Christ in Concrete*

The documentary photographer Lewis Hine never won a major grant, fellowship, or prize. In 1938, strapped for cash, his son Corydon hospitalized, his wife Sara suffering from chronic asthma, facing foreclosure on his house in Hastings-on-Hudson, he applied for a Guggenheim Foundation grant. His proposal, "Our Strength is Our People," said simply, "This project should give us light on the kinds of strength we have to build upon as a nation. Much emphasis is being put upon the dangers inherent in our alien groups, our unassimilated or even partly Americanized citizens—criticism based upon insufficient knowledge. A corrective for this would be better facilities for seeing and so understanding, what the facts are. . . ." The Guggenheim Committee considered, considered, promised, promised, and then finally turned him down. Hine then applied to the Carnegie Foundation with a proposal for a project on the American Craftsman. That, too, was rejected. The bank foreclosed on his house and Hine was forced to go on relief. Then on Christmas morning 1938 his wife Sara died, and two years later, Lewis Hine broke and, perhaps, broken, died. Such is the cruel, ironic conclusion to the life of America's greatest documentary photographer, Lewis Hine.

Lewis Hine died five years before I was born. I cannot recall when I first saw a Hine photo. Somehow I knew the familiar images before I knew anything about the man who created them. I say "created" because of the craft and beauty of Hine's images and because of the relationship between photographer and subject in his pictures. More often than not, his work has been publicly used for some national self-congratulatory celebra-

tion without credit to Hine or recognition of his deep commitment to social justice. But, for me, Hine has been an essential guide exactly because his photographs are about illumination not celebration. His "photo stories" are both public and private: historical documentation and family album. I can close my eyes and see Hine's photos of immigrants in Ellis Island, his "sky-boys" building the Empire State Building, his street children and tenement mothers. Sometimes the portraits convey the blank look of exhaustion, sometimes the newcomer's shyness, sometimes an unexpected posture, even bravado, but almost always there is the mark of labor on the human body.

Consider Hine's photographs of the "breaker boys" in the coal mines of Pennsylvania. Boys, seven, eight, nine years old, wedged in tight rows, covered with soot, hunched over, are pushed to work and work, faster and faster, sorting and breaking, hour after hour. The 1913 Child Labor Bulletin reported: "These boys picked out the pieces of slate and stone that cannot burn. It's like sitting in a coal bin all day long, except the coals is always moving and clattering and cuts their fingers. Sometimes the boys wear lamps in their caps to help them see through the thick dust. They bend over the chutes until their backs ache, and they get tired and sick because they have to breathe coal dust instead of pure air."

What happens to bodies that never unbend, that never feel the heat of the sun? These young lads, grown into men, were said to carry their "boy on their back." Their spines were often permanently crooked and their shoulders forever carried the hump of work. This is not a birth deformity. This is a work deformity.

I do not carry the hump of childhood work on my back. I was allowed, even encouraged, to study. Tóday I have cuts on my hands from working in my garden, calluses from carrying my brief case, but my fifty-three year old body does not bear the mark of labor as my parents' bodies did, as their parents and grandparents did before them. In snapshots of significant occasions in my parents' lives, the work clothes are gone, the injuries are hidden, and they smile into the camera. They choose to smile. I choose to look behind the smile, not because the smile is false; it is as genuine and real as what lies behind the smile. I choose to look behind, beneath, and around the smile exactly because I am safe. I will not be injured on the job; no chemical burns will tattoo my skin; no knife will slip and cut off my finger. I am physically safe and have time and space to think and to write. In every sense, I can afford to do this and they could not—at least not in this textual way. I do not feel guilt; I feel responsibility. I have

a responsibility to carry this hump of memory and knowledge of the brutal physical reality of work out and into the world.

How do I proceed without domesticating or, worse, betraying the lives of working people?

I remember standing in the doorway to my parents' bedroom in our small apartment in Union City, New Jersey. Each room has a doorway but no door. Only the bathroom with a tub and no sink has a door. My parents' bedroom is in the center of the apartment. On the right is the front or living room with its elaborate 1950's wall paper of ferns and ivy. On the left is the tiny closet of a room I share with my sister. The center of our home is, of course, not the living room, but the kitchen. Every corner of this crowded apartment is clean and tidy.

I am standing in the doorway to my parents' bedroom because I am afraid to enter that space. Accustomed to my father's shift work at the chemical plant, I know there are times when he has to sleep in the daytime because he has worked all night. So, I am used to playing quietly, unseen, hushed so Papa can rest. On this particular day, when I was perhaps seven or eight, something felt different. Papa is in bed in the middle of the day but he isn't trying to sleep. He is trying to get better. From what? And then, standing in the doorway, I see it: the ugly red burns gouged into his chest. I remember he looked at me—maybe he smiled, that would be like him—but did I smile back or did I run away too scared by what I saw to speak?

This was a family where the children were not encouraged to speak up or back or question. From a very young age I knew the boundaries of what could be named and what was permissible for family kitchen talk. Papa getting burned at work was not for the children to hear about or know. *. . . But I saw! I saw!. . . .*

How do I carry this memory? I know that I would be violating and betraying the family if I told such a story about class difference only for the sake of my own academic career. I do not have an academic "career" in the traditional sense of a job path leading to economic success. I have some space and opportunity to imagine ways of representing the circumstances of working-class lived experience, not just for my own family, but for all working people. I am very clear about this, although I am not always so clear about the means to do it or whether I can ever get it right. I feel this difference because I have been negotiating death and grief most of my

adult life. By negotiating I do not mean "closure" in the popular media sense of forty-five seconds of bad news reporting and now on to today's "bright spot." By negotiating I do not mean silencing, forgetting or hiding the grief for the comfort level of other people. I mean instead the difficult task of putting personal grief to collective, democratic use.

I can't go home again because there is no home there. My parents, grandparents, most of my aunts and uncles are dead, the cousins scattered across the country. When I was a very young woman struggling with my father's sudden death, I thought my family was just unlucky, cursed like the Kennedys only without the millions. And then, something happened. I came to understand that my circumstances were class(ed) circumstances. What I experienced was not so much a change in consciousness as a recovery of consciousness. Long before I entered the community of readers of working-class literatures and theories, I was developing class consciousness out of the necessity of coping with the physicalilty of grief and loss. I think now this is a kind of cultural haunting. I used to joke about how I would hear voices of family members reprimanding, scolding, urging, and encouraging me to work hard (intellectually) for us all.

To be sure, I am not a ghost, nor am I an obscure Jude. I am a teacher—writer—intellectual moving between death and life, past and present, one culture and another, and struggling to create spaces of reciprocal visibility, to provide, in Lewis Hine's words, "better facilities for seeing." I could not do my work in the academy, whose culture still seems foreign to me, if I were not grounded in my inherited working-class culture.

All of us (even the owning class) carry within us traces of our family's work histories: paid or unpaid labor, underemployment or unemployment, seasonal work or steady work, legal work or illegal work. Consciously or not, this work inheritance shapes our own attitudes about work, sometimes in imitation, sometimes in rejection. From my parents I have inherited a strong work ethic as I have inherited brown eyes. I see my mother breaking the eggs, rolling the dough, shaping the raviolis. I also see her at the window, waiting anxiously for my father's safe return from work. I realize that their sense of pride in their work could also be used against them on the paid job, facing working conditions that were unfair, and possibly damaging and dangerous. Work also kills. Would my father have died at the age of forty-nine if he were a professor instead of a pre-OSHA chemical plant worker? Possibly, but not probably. Work also kills.

Studs Terkel begins his classic *Working* (1975) with: "This book, being about work, is, by its very nature, about violence—to the spirit as well as to the body." But Terkel, with his usual brilliant dialectical acumen, also says, "Perhaps it is time the 'work ethic' was redefined and its idea reclaimed from the banal men who invoke it. In a world of cybernetics, of an almost runaway technology, things are increasingly making things. It is for our species, it would seem, to go on to other matters. Human matters" (xxviii).

Human Matters

Every third Thursday of the month I attend a meeting of ROCOSH. ROCOSH is a local "COSH," one of the many councils on occupational safety and health that exist all over the country. I have been a member of ROCOSH for more than a decade and march with them every Labor Day and mourn with them on April 28, every Workers Memorial Day. The board is a good mix of men and women. The women do not defer to the men. Most of us come in our work clothes, jackets and trousers, jeans and flannels, some wearing union tee-shirts with bulging cigarette packs in the front pockets. People arrive on time and get right to the evening's agenda: no posturing, no elaborated, abstracted language, no phony politeness. Speakers get interrupted and people openly disagree. Everyone has a say and everyone has a common purpose: the health and safety of workers. I attend these meetings to listen and learn and to bring this information back to my literature and writing classes.

The *New York Times* reports 6,210 work-related fatalities in 1995 or five for every 100,000 workers. The National Safety Council in its 1996 edition of *Accident Facts* lists 5,300 work deaths and 3,600, 000 disabling injuries in 1995. Also, it reports that over 514,000 occupational illnesses were recognized and diagnosed in 1994 according to the Bureau of Labor Statistics. The overall incidence rate of occupational illness for all workers was 63.7 per 10,000 full-time workers. Disorders associated with repeated trauma were the most common illness with over 330,000 cases, followed by skin diseases and disorders (over 65,000) and respiratory conditions due to toxic agents (over 25,000) (72). These are the officially sanctioned figures.

America's Forgotten Environment (1989), a pamphlet published by a coalition of labor, minority, and environment groups, reports 100,000 worker deaths each year from occupationally-caused disease and 10,000 deaths from preventable accidents at the job. OSHA, which is currently

under attack in the Republican congress, spends only $4 per year for every one of its 65,000,000 covered workers.

How can these human matters, the safety and health of workers, surface in a literature course?

Humans Matter: On the Job in Academe

"Humans matter." And they matter not in an abstract, idealized, romanticized way, but in a physical, gritty, tactile way. I carry my working-class inheritance, a knowledge of the physicality of work, into the classroom by creating spaces for a discourse of the working body in a context where machines and technology and market forces matter most.

My technical institute is often on the cutting edge of new techniques in imaging science or computer engineering; it is also on the cutting edge of the brave new university serving the technical needs of corporations and the careerist aspirations of students. All the solid brick, modern buildings on campus have hard edges (except for the circular base of the college of liberal arts.) This is a contemporary architectural style called "brutalism." And the name fits. Students keep their heads down as they face the cutting wind between the sharp edges of the campus buildings. There is a clarity on the campus about goals and purposes: students take their courses, pass their tests, work their coops (making money and valuable contacts), get their degrees, and land well-paying jobs. Whatever their major—graphic arts, information systems, civil engineering, printing, packaging science—these students have a strong work ethic; they have to or they wouldn't make it over the finish line of graduation. Here there are no English or history majors, and scarce talk of students finding themselves. They know exactly where they are. And so must I if I am to do my work of providing a catalyst for students to develop and expand their own humanity, a humanity that is inseparable from the history of work and class struggle.

My students are historically situated in the world of training for and acquiring jobs in a context where the national political rhetoric is of expansion and growth but the lived reality is of scarcity and huge college loan debts. My students are not automatons. Student artists speak knowingly about splitting their future work lives between art for the market and art for themselves; many engineering students also take photographs, play instruments, climb mountains. But some students, especially the younger ones who have logged innumerable hours before televisions, terminals, videos, and who have never eaten a meal without a humming machine in the foreground or background, are not accustomed to imagining or dia-

loguing with other people who are not copies of themselves. But even these students, who seem to possess the most metallic hearts, who are the most indifferent to politics and history, who are most centered on their immediate needs, who are most captured by the latest techno toy, have a work legacy I can tap. And then there are those students, a little older, who are split between jobs, family, and school. Often the women have business ambitions and want the degree to get to the next wage grade; the men may be technicians in local plants or recent sailors or soldiers returning to school not to acquire skills they already possess but to have those skills warranted, certified, credentialed, and degreed. These students have little patience with what they may perceive as liberal arts blather. Their lives are one long time clock. Invariably, these are the students most responsive to working class texts and I rely on them to convey this understanding to other, perhaps more economically privileged, students.

Mike is a good example. Recently married and discharged from the navy, he signs up for my upper division writing course. His first essay is a beautifully written narrative recalling his father's suicide from the perspective of his twelve year old self. When he submits his first draft for my comments, he remarks on how he expects me "to tear it up." He is worrying about punctuation; I am staggered by his capacity to write so powerfully and personally. I return it to him, telling him there's nothing to tear. I do not think he believes me at first. At the end of the quarter he seeks me out as I am ending another class. He blurts out: "I didn't expect to like your class. You seemed liberal and the other students seemed liberal, and I'm very conservative. But I love this class." Why? I cannot in good faith put words in Mike's mouth, but I can safely surmise that three things appealed to him: the course seemed *real*; the "real world" was not out there somewhere. We tested how reality is shaped by language. And we read books and had writing assignments (including oral histories) that considered the lives of working-class people. One of Mike's favorite texts in this course was Michael Wilson's screenplay, *Salt of the Earth.* Mike had no difficulty seeing the parallel work lives of the husband and wife protagonists, the unsafe, exhausting paid work in the mines, and the unsanitary, exhausting unpaid work of the Mexican wives and mothers at home. Unlike some of the other, more economically privileged students, he could identify with the characters on the basis of work and class and not feel outside the text because of ethnic or gender difference. Other students have to negotiate their own class positions vis-a-vis a text that challenges their unstated, market-shaped assumptions about business and that presents the

characters they're most inclined to identify with—managers, owners, and the local sheriff—as oppressors. Rather than investigate their own ideological assumptions, these students would rather write off the film as hokey or dated. It's ideologically safer. Relating the film to contemporary economic realities, such as the huge wage differential between CEO's and worker salaries, I can see that I am trespassing on sacred ground.

"God Job"

In recovering working-class stories, with their frequent descriptions of the physicality and dangers of work, I am recovering not only a lost American labor history, but also students' own transgenerational family work histories. (It is important to note to students, however, that dangerous work is not ancient history but part of the daily work lives of million of workers all over the world—today.) Accustomed to sweaty bodies on the running track, the weight room or aerobic class, many students, like many professors, managers, and technocrats, are not accustomed to acknowledging visually the working bodies in their daily lives—the men and women who clean their toilets, repair their machines, or pick up their litter. Just as consumers resist acknowledging the machine-tending human hand behind the products they buy, students resist the disquieting confrontation with this fourth dimension of reality—physical work. As an academic-activist, a working-class cultural worker, I try to use texts the way Hine created photo stories to structure a reciprocal and democratic visibility. This does not happen without resistance. Some students are plainly uncomfortable with this approach and they complain about "this book being depressing and not fun." I am asking—often very privileged students—to look at the physicality and dangers of work and to risk a discomfort to their own subjectivity. Students who have cut their teeth on violence in every medium (tv, film, video games, music, dance) are squeamish in the face of industrial and work-related violence. The connections I seek are emotional as much as intellectual. I want these young civil engineers and future managers to carry with them out into the future world of their own jobs knowledge about bodies at work—the risks, the exhaustion, the dangers working people face.

One of the ways working-class literature is distinct from bourgeois literature is in its emphasis on the physicality of work. The white-gloved serving hand that might be glimpsed on the periphery in a middle class novel is fully attached to the working body in working-class literature.

Workers and the physicality of labor are foregrounded in working-class autobiographies, novels, poems, and songs. Characters get hurt and die because of the work they do. Work kills and maims. Whatever their differences of gender, ethnicity, race, and regional perspective, Agnes Smedley's *Daughter of Earth*, Tillie Olsen's *Yonnondio*, William Attaway's *Blood on the Forge*, Audre Lorde's *Zami*, Thomas Bell's *Out of This Furnace*, Pietro diDonato's *Christ in Concrete*, Maxine Hong Kingston's *China Men*, Edith Summers Kelley's *Weeds*, Helene Maria Viramontes' *Under the Feet of Jesus*, Jim Daniels' *Punching Out*, Sue Doro's *Blue Collar Goodbyes*, Alice Walker's *The Color Purple* are all literatures (to name a few) grounded in the physicality of work.

Many working-class literatures create a spatial and emotional intimacy between paid and unpaid work: the sustaining, unceasing work at home and the (un)living-wage work on the job. Michael Wilson, blacklisted author of the screenplay for *Salt of the Earth*, remarked in 1953 that his film was an alternative to the current Hollywood 3-D fad. *Salt of the Earth* illuminated the "fourth dimension. . . .called reality—the reality of working people's lives"(109). When the men can no longer "man" the picket line because of a court injunction based on the Taft Hartley act, the women take over and hold the line while the men, who are wrestling with their own macho opinions about the division of labor, take up the women's work of chopping the wood, scrubbing the laundry, and caring for the children. The women's demands for sanitation (running water, indoor plumbing like the Anglo miners) finally seem crucial to the men, who are so sick of chopping wood that they are ready to form a wood chopping union.

Likewise, Tillie Olsen in *Yonnondio* structures a parallel work day in the lives of Anna and Jim Holbrook, who face the oppression of work and summer's heat: he in the packing house; she in the kitchen on "the fifth day of hell-heat" with the temperature 104 degrees outside, 112 in casings (135). At "God Job" Jim must do the workers' speed-up dance "choreographed by Beedo, the B system, speed-up stopwatch, convey. Music by rasp crash screech knock steamhiss thud machinedrum.. . . Become component part, geared, meshed, timed, controlled" (133). In the humid kitchen Anna "works on alone" canning the last of the fruit for jelly, tending the sweaty, heat-cranky children. "Between stirring and skimming, and changing the wet packs on Ben, Anna peels and cuts the canning peaches—two more lugs to go. . . . "Skim, stir; sprinkle; change the wet packs on Ben; pit, peel and cut; sponge" (148-49). In these parallel scenes, Olsen brilliantly conveys the body forced to work as a machine, but she

never relinquishes the humanity of her characters to the machine. Nor is their suffering labor aestheticized and distanced. With her beautiful rhythmic language, Olsen pays tribute to the courage and endurance of Anna and Jim. Above all else, humans matter.

Mike Wallace, in his *Mickey Mouse History and Other Essays on American Memory,* demonstrates the paradoxical relationship many Americans have to history. On the one hand, there is tremendous enthusiasm for the present, the new and the now, and pressure to move on and "achieve closure." On the other hand, as Wallace points out, "we have been on a heritage binge and remain thoroughly obsessed with the past" (x). My students may have had vacation stops at Colonial Williamsburg or Old Sturbridge, even field trips to historical sites, but very few have faced the dangers of work or the disturbing descriptions of physical labor from a worker's perspective found in working-class literature. When I ask them to read *Yonnondio* or *Salt of the Earth,* I know I am also asking them to relinquish the pleasant stance of the distanced tourist and to take up the emotional burden of these stories and these histories.

Two working-class autobiographical novels that address the unaccidental nature of industrial deaths and injuries are Thomas Bell's *Out of this Furnace* and Pietro di Donato's *Christ in Concrete.* Both novels, like *Yonnondio* and *Salt of the Earth*, illuminate the interdependence between domestic work and paid work (Bell more so than di Donato), and both convey the economic and emotional aftermath of an industrial death on a family. At the literal center of *Out of This Furnace*, an immigrant novel of three generation of steelworkers, is the story of Mary and Mike Dobrejack, Slovakians living in the steel town of Braddock, Pa. in the first decade of the twentieth century. "[W]ith July's heat baking the streets and courtyards of the First Ward," Mary collapses in her kitchen and the doctor is summoned. She is pregnant again. The doctor advises bed rest and no exertion and "Mary stared up at him. With six boarders, three children and a husband to look after, meals to cook, clothes to wash, her hours were from four-thirty in the morning to nine at night, seven days a week" how could she rest? (173). There is no rest for her husband Mike either—now old at thirty—as he faces another twenty-four hour work shift: "The first twelve hours were much like any day turn except that sometimes, through a break in the mill's rumble, he could hear church bells. . . . The second twelve hours were like nothing else in life. Exhaustion slowly numbed his body, mercifully fogged his mind; he ceased to be a human being, become a mere appendage to the furnace, a lost damned creature. 'At three o'clock

in the morning of a long turn a man could die with knowing it'" (167). Working-class novels like *Out of This Furnace* are more than an accumulation of work horrors; they also document again and again the human capacity for resistance and for insisting humans are not "its," merely "check number[s]," "Hunky laborer[s]," or human appendages to the machine. In a drunken soliloquy, Mike announces to his friend Stefan:

> It's a terrible and beautiful thing to make iron. It's honest work, too, work the world needs. They should honor us, Stefan. Sometimes when the bosses bring their friends through the mill they watch us make a cast and when the iron pours out of the furnace, you know how wonderful it is, especially at night, I feel big and strong with pride. . . .I don't mind work. But a man should be allowed to love his work and take pride in it. There's good in all of us that would make our lives happier and the world a better place for everybody. But it's never asked for. We're only Hunkies. (196)

The next day Mike kisses Mary good-bye, heads for the steel mill on a spring-like, mild evening, enters the mill gate and goes to work. Before he can finish his shift, a furnace blows and Mike Dobrejack is dead.

Mike's death is reported to Mary; the reader "overhears" the details of the explosion, and experiences the aftermath—the burial, the paltry compensation, and then Mary's and the children's struggle to survive.

In Pietro di Donato's *Christ in Concrete* workers' lives are also sacrificed to "God Job," but in this 1939 novel of Italian immigrant bricklayers, there is no reader comfort zone. The novel begins on the job site with Italian immigrant bricklayers on a brisk March day of Easter week. Immediately, the reader confronts the physicality of humanity: "Old Nick, the 'Lean,' stood up from over a dust-flying brick pile, tapped the side of his nose and sent an oyster directly to the ground."(3) One by one we are introduced to the other bricklayers through their ribald language, jokes, physical descriptions—Burly Julio known as 'Snoutnose' (3) or Mike the "Barrel-mouth"(4) and to Geremio their foreman, proud husband to Annunziata, father of six children, and one more soon to come. Geremio is torn between the intensity of his pride in and duty to his family and the realization that the construction job is unsafe. He tries to stop the work: "Padrone--padrone, the underpinning gotta be make safe and . . ." And gets the expected response: "Lissenyawopbastard! if you don't like it, you know what you can do!"(9) And what can Geremio do? "The new home, the coming baby,and his whole background, kept the fire from Geremio's

mouth and bowed his head" and became, "[n]o longer Geremio, but a machinelike entity. And "the men were transformed into single, silent beasts." (9) And on Good Friday Geremio "stared dumbly at the structure and mechanically listed in his mind's eye the various violations of construction safety"(11) and the concrete was poured. And the inadequate building supports burst and the "floor vomited upward"(14). Geremio is catapulted in "directionless flight" landing upright with arms outstretched, crucified, and facing the huge concrete hopper and the gray gushing concrete. In five long pages, di Donato describes the agony of Geremio's death:

> His genitals convulsed. The cold steel rod upon which they were impaled froze his spine. He shouted louder and louder. 'Save me! I am hurt badly! I can be saved I can—save me before it's too late!'But the cries went no farther than his own ears. The icy wet concrete reached his chin. His heart appalled. 'In a few seconds I will be entombed. If I can only breathe, they will reach me. Surely they will!' . . . He had bitten halfway through when his teeth snapped off to the gums in the uneven conflict. The pressure of the concrete was such, and its effectiveness so thorough, that the wooden splinters, stumps of teeth, and blood never left the choking mouth. . . .
> He tried to breathe, but it was impossible. The heavy concrete was settling immutably and its rich cement-laden grout ran into his pierced face. His lungs would not expand and were crushing in tighter and tighter under the settling concrete. . . . He screamed, "Show yourself now, Jesu!". . . .and the fighting brain disintegrated and the memories of a baffled lifetime sought outlet. (16-18)

Pietro di Donato sums up the day after Geremio's funeral in this understated, powerful way: "The day that followed was lived"(30).

I know of no other working-class novel that so powerfully confronts the reader with the horror of death on the job. In teaching this material, I wish to carry responsibly the lives of working people into the classroom. It is difficult, perhaps impossible, to measure the impact of working-class literature like *Christ in Concrete* on students. To be sure, this is not about evoking their guilt; rather, it is about, as Hine might put it, naming the guilty. Students are asked to be brave enough to take in, subjectively, the lived reality of these stories. And many do, as revealed in these written responses from my 1997 course, New American Literature:

We know that our ancestors, immigrant workers built this country, yet the stories and injustices are not always readily available to learn from. Christ in Concrete exposes harsh and often dissimilar experiences from our own, but. . .we may relate in personal ways. It made me consider my position in society as a worker, my economic position, the modern workplace conditions. What is my status? Who is in control? God? Boss?
(Rachel Heinold-Belock)

I can relate to Paul's feeling of pride and accomplishment during the scene where he constructs his first corner. I can understand the importance of his obtaining a job to support his family because my grandparents did the same thing. In Christ in Concrete *Geremio's work leaves behind a legacy as evidenced by the way Nazone calls him "Little Master Paul." Though to a lesser extent and under much different circumstances, I also feel the pressure to live up to the hard-working image of my father.*
(Rich Gille)

I really liked the novel. I was drawn into the book from the first word. My grandfather was a bricklayer and also the first generation of his family born in America, although he was Irish not Italian. He told many stories about his job, and this may sound really funny but I appreciate the architecture of RIT because my grandfather laid the bricks for many of the buildings. I, however, have a different take on the Job. Besides the danger of falling off scaffolds, there is also a hidden danger which ended up taking my grandfather's life. Years of working with cement and dust and asbestos, caused my grandfather to develop emphysema, which took his life at age 63. My grandfather's story is much like Geremio's. He was taken advantage of by the Job, safety precautions were never taken and they both experienced discrimination by the American bosses. . . .The Job took both of their lives and left little in return. My family as well as Geremio['s] had to say good bye way too early and the compensation board offered little support, . . . [leaving] both families struggling to survive in this great country of America, the land of opportunities and dreams,
(Gretchen Bush)

In a 1933 letter to Florence Kellogg about the "value of human values in photography beyond mere illustration," Lewis Hine writes:

> Just now I think it is a very important offset to some misconceptions about industry. One is that many of our material assets, fabrics, photographs, motors, airplanes and whatnot "just happen," as the product of a bunch of impersonal machines under the direction, perhaps, of a few human robots. You and I may know that it isn't so, but many are just plain ignorant of the sweat and service that go into all these products of the machine.
>
> ...
>
> One more "thought"—I have a conviction that the design, registered in the human face thro years of life and work, is more vital for purposes of permanent record, tho it is more subtle perhaps, than the geometric patterns of lights and shadows that passes in the taking, and serves (so often) as mere photographic jazz (49-50).

Human matters. Humans matter.

Notes

1. A shorter viersion of this essay, "The Job, The Job: The Risks of Work and the Uses of Texts" was published in *Coming to Class: Pedagogy and the Social Class of Teachers* edited by Alan Shepard, John McMillan, and Gary Tate, Boynton/Cook, 1998.

Works Cited

Accident Facts. 1996. Itasca, IL: National Safety Council.

America & Lewis Hine: Photographs 1904-1940. 1977. Millerton, NY: Aperture.

Attaway, W. [1941] 1993. *Blood On the Forge.* New York: Doubleday.

Bell, J. and F.Wallick. 1989. *America's Forgotten Environment.* Washington: D.C.: Urban Environment Conference.

Bell, T. [1941], 1976. *Out of This Furnace.* Pittsburgh: University of Pittsburgh Press.

Brogan, K. 1995. "American Stories of Cultural Haunting: Tales of Heirs and Ethnographers." *College English.* Vol.57, No.2 (February): 149-195.

Daniels, J. 1990. *Punching Out.* Detroit, Mich: Wayne State University Press.

di Donato, P. [1939] 1993. *Christ in Concrete.* New York: Signet.

Doro, S. 1992. *Blue Collar Goodbyes.* Watsonville, CA: Papier-Mache Press.

Kaplan, D. 1992. *Photo Story: Selected Letters and Photographs of Lewis W. Hine.* Washington, D. C.: Smithsonian Institution Press.

Kelley, E.S. [1923] 1982, *Weeds.* New York: The Feminist Press.

Kingston, M. H. 1980. *China Men.* New York: Knopf.

McCrank, M. 1991. "Architect Lists RIT Campus 9th in Nation for Aesthetics" *Democrat and Chronicle.* (Dec. 12).

Nordheimer, J. 1996. "One Day's Death Toll on The Job." *New York Times.* Dec 22: Section 3, 1,10-11.

Olsen, T. 1975. *Yonnondio.* New York: Laurel.

Rimstead, R. 1996. "What Working Class Intellectuals Claim to Know." In *Race, Gender and Class: Working-Class Intellectual Voices.* Vol. 4 No.1: 119-141.

Rogovin, M, and M. Frisch. 1993. *Portraits in Steel.* Ithaca, NY: Cornell University Press.

Rosenblum, W. 1977. "Foreword." *America & Lewis Hine.* Millerton, NY: Aperture.

Rosenfelt, D. S. 1978. "Commentary." *Salt of the Earth.* NewYork: The Feminist Press.

Smedley, A. [1929] 1973. *Daughter of Earth.* New York: The Feminist Press.

Trachtenberg, A. "Ever-the Human Document," *America & Lewis Hine.* Millerton, NY: Aperture.

Viramontes, H. 1995. *Under the Feet of Jesus.* New York: Dutton.

Walker, A. 1982. *The Color Purple.* New York: Washington Square Press.

Terkel, S. 1975. *Working.* New York: Avon.

Wallace, M. 1996. *Mickey Mouse History and Other Essays on American Memory.* Philadelphia: Temple University Press.

Wilson, M. [1953]1978. *Salt of the Earth.* New York: The Feminist Press.

Zandy, J. "Liberating Memory." In J. Zandy, ed. 1995. *Liberating Memory: Our Work and Our Working-Class Consciousness.* New Brunswick, NJ: Rutgers University Press.

DAVID

SHEVIN

David Shevin grew up in Rochester, New York. He is a professor of English at Tiffin University in Ohio and a recipient of a Poetry Fellowship 1994 from the National Endowment for the Arts. He is the author of *Needles and Needs: Poems* (Bottom Dog Press, 1994), *The Discovery of Fire* (winner of 1989 Ohioana Poetry Award) and *Growl*, a book of poetry satires (Carpenter Press). He is also the co-editor with Larry Smith of the working-class collection, *Getting By: Stories of Working Lives* (Bottom Dog Press, 1996).Over the last twelve years, he has steadily held office with the Tiffin-Fostoria chapter, NAACP.

Get a load of this: at the end of 1998, just the other week when military planes started bombing Iraq again, a smart 20-year-old gal (a favorite student who is breaking gender barriers in ROTC) came into my office in uniform to discuss King's dictum that "Peace is not merely the absence of war. It is the presence of justice." Her topic choice!

Who would have imagined women in uniform contemplating King's teaching when we were "Neat and Clean for Gene" and ready to integrate the segregationist South (and North)? Some journey. James A. Monroe High School in Rochester was reputed to be one of the more integrated cultures in the city. Those yearbooks look whiter than I would have thought, but we were working in the right direction.

"How's 'The Brain?'" one of my classmates asked during a visit to my hometown of Rochester. That was me: the kid working on the school newspaper and literary magazine; the kid who'd carry a Gregory Corso poetry book from New Directions to read during classes; the kid who'd demand that we all think critically about what we did on those hot, hot national issues and in our local behaviors.

Paperbacks were cheap then, and some have followed me for a lot of years. Some make a surprisingly good basic Marxist library supplemented by dear forgotten prophecies: Sinclair Lewis forewarning of fascism in *It Can't Happen Here*, John Steinbeck repeating his love of blue collar culture in *Travels With Charley*. And here and there, I've got my own articles and books, and enough smart students that I've got the confidence that there are young people paying the same sort of attention that I did.

"'How's 'The Brain'"? Same old same old.

I Used to Be an Earthworm

David Shevin

The Black United Students contingent was steamed, and called an emergency meeting that night. There was good reason: a stupid and destructive act of vandalism deserved response. At issue was the defacement of three pictures displayed in the well of Tiffin University's classroom building, the pictures of the three black Homecoming Queen contestants in a field of nine.

The vandalism itself was an act of stupid, mean and displaced anger. Someone the night before had slashed and scrawled up the pictures with slogans like "You suck" and "Nigger"—as soon as this was discovered, Student Government had the display taken down for repair.

Righteous anger pervaded the meeting, and the large attendance testified at how difficult life already was for blacks at the school without added torment. Gradually, the crowd started a methodology to sort out the issues. Was there a certainty of who the perpetrator was? No. Could the perpetrator have come from within the community of black students? Unlikely, but possible.

The contestants all registered how violated they felt by the incident. Then the meeting turned to look at the contest itself—a selection by fundraising, no less or more fixed than other popularity shows. The community voted for Queen candidates by donation, no up or down limits. Funds went to sports equipment and cheerleading uniforms, usable stuff for the school.

"Look," said Donny Williams, "It doesn't matter who did this. The point is, what that person would hate most is to see one of our sisters be Queen. So we should make damned sure that's what will happen. We should pool all the money behind one candidate, raise more money in town, and see that she wins."

A consensus grew around this idea, but which of the three? "We ought to help Kim. She's paid her dues here. She's a senior. The others are sophomores, and they can run again." This quickly became a popular idea among all assembled, excepting two women whose egos were set for a Homecoming Queen title, and were asked to withdraw. The challenge was a large one, to set a greater cause before the personal goal. "It isn't

fair," one started crying. In fact, there was a quick torrent of tears, which ended as suddenly as it began. By the evening's end, those gathered had reconciled to this creative plan using the available tools as a best response.

I was pleased that as advisor, I had been invited to see this exercise in the creative channeling of anger. If the students had asked, "Hey, prof, what should we do?" I would have had a hatful of the wrong answers for them. "March! Demonstrate! Make a public issue of this!" Instead, they coordinated an answer that won Kim Thompson the first runner-up position, and put her picture in the paper to represent the Homecoming celebration.

How does it happen, that anger can turn to such good, good invention? There began the search for other models. Enough stuff gets tossed into the bins of experience, knocks around there, detail crushing over detail until it's hard to retrieve some materials at bin bottom. In a recent dispatch from the miraculous journalist Molly Ivins, she documents how significant the struggle for civil rights was in her education to be a skeptic of conventional wisdom. "I discovered," says Molly, "that if they'll lie to you about something as important as race, they'll lie to you about anything." Molly Ivins was mad. You can tell because the madder she gets, the more control she has. When was it that the process began when I learned that those who divided us playing race games were lying their heads off?

Race always gets played, by either side of the argument, as the tool by which exclusion or inclusion gets justified. Ivins's realization sits as a second nature, but like all memories, it must have a beginning, in that unsifted bottom-of-the-bin dust that's partly past memory and partly the lens we manufacture to assemble piles of the world's information. Was it mom parting company from her racist brother, who came by cursing the black clientele of his Joseph Avenue grocery, his short fuse getting doused with cold anger? The family fear for him when he drove into the same neighborhoods, handgun in tow, to do business on insurance accounts? These long hours built him an admirable suburban home while at our house the anger was never welcome.

Summers at Labor Zionist camps, my uncle's kind of anger got ridiculed. We'd spend afternoons in lecture and discussion groups where freedom riders were lionized and veterans told stories of activist heroism. Placing a couple of memory shards together, it was Freedom Summer of 1964 that an early weak link shattered; riot, windows shattering and police dogs tearing tore my hometown. The loudspeaker at camp played Leadbelly. "Come all you colored people and listen to me, / don't try to make your

home in Washington, D.C./'cuz it's a bourgeois town. / I got the bourgeois blues/Sure gunna spread the news."

Once home that August, I was on my way over to visit the Merzels on Crosman Terrace. The Congress of Racial Equality had a picket line up in front of a slumlord's house—maintenance, rather than pricing was the issue for this picket. How empowering it was, that the good fight had come to my very neighborhood. I picked up a sign as though it was my stumbling brother. I sang about keeping my hands on the plow with these other righteous folk. Was it strange for the organizers to see that round white kid integrating the picket? I don't remember chuckles, but this is distinct almost 30 years later: I asked an organizer what I could best do to help out. He had nothing to tell me, and I felt angry, excluded from all of the teaching that had been summer's education.

Eleanor Roosevelt had quit the D.A.R. over the organization barring Marian Anderson from Constitution Hall! This was one of mom's favorite moral lessons. Couldn't I have a piece from this rich cake of righteousness?

The late activist Barbara Deming noted that nonviolent activists generally shy from confronting anger, confusing the anger of moral force with the anger of affliction: "This anger asserts to another not: 'you must change and you can change'—but: 'your very existence is a threat to my very existence.' It speaks not hope but fear. The fear is: you can't change—and I can't change if you are still there. It asserts not: change! but: drop dead!

"The one anger is healthy, concentrates all one's energies; the other leaves one trembling, because it is murderous. Because we dream of a new society in which murder has no place; and it disturbs that dream. Our task of course, is to transmute the anger that is affliction into the anger that is determination to bring about change." Places to put energy didn't stay hidden long. All through high school, I volunteered in an after school literacy tutoring program in the same neighborhood where my uncle contracted business, armed for trouble.

Does anyone go about his business less angry than an earthworm does? There was a dutiful, uncompromised metaphor that went straight to the heart. Igal Roodenko, a ragged and elderly printer who had volunteered services for decades to the War Resisters League, told me a comparison at Kent State University, at the fifth anniversary of the armed children ordered to shoot the unarmed children. It still sticks. "I always looked for a symbol for my work," Igal said. When he came to visit in Cincinnati a couple of years later, he reiterated his thinking on symbols. "The Black

Panthers had a powerful symbol. But the panther is a destroyer. Change has had enough destroyers. So I liked the bulldozer for a while. It helps build, it moves the earth. But that, too, crushes any lives in its path. Now I like the earthworm. An earthworm always moves forward, and it excretes fertilizing nitrates and aerates the soil. He nourishes the ground wherever he goes."

How innocent, explaining at parties and latenight talk sessions ("If you were an animal, what would you be?") that I was ambitious to be a good earthworm. Why not?

And it was in Cincinnati, late 1970s, that we held fundraising events and concerts for Annie Small. Here the details clutter and smudge. Passions and moments merge into one another. The personal and the political may be the same for argument's sake. Still, remembering the moment of immersion with a lover who left too soon for the grave and remembering that moment's social outcry is not a true equivalence. For one of those events, I was writing to Meridel LeSeuer, who was graceful in declining, complaining of a leg ailment. "These legs, which have walked enough picket lines to circle the world three times," she wrote. As well as the focus comes, this was the story that peppered the papers:

Annie bought the house that racially integrated a previously white Price Hill street. A branch of the Ku Klux Klan, locally active, harassed Annie going to and from the house, lit crosses on the lawn. Finally, two of the men conducting this thorny diet of persecution broke into her house and were met by gunfire. One of the men died, and Annie faced a manslaughter charge. The benefits were part of raising defense funds.

Tempers were escalating as the trial, which ended in acquittal, approached. A visible and active Klan chapter marched in Hamilton, a town 30 miles north of the city. That same day, a sizable counter-demonstration marched as well. So many of the great old warriors walked that day in Hamilton! Ann Braden was there. Reverends C. T. Vivian and Fred Shuttlesworth, both cofounders of the Southern Christian Leadership Conference were on the move, as was Maurice McCracken, then of the West End Community Project.

Owing to the escalation of actions and publicity, the Ku Klux Klan was becoming increasingly public about recruiting in Southwest Ohio. They announced their recruitment in handbills and ads in the Cincinnati papers, accepting applications in a motel room in Middletown, nearby Hamilton. This was not long after that large numbers march. It was a sleety day and there were what seemed like countless hours on a picket line outside the motel through the recruitment hours. About a dozen of us picketed. I was

standing between two ministers: Maurice McCracken and Reverend Fred Shuttlesworth. Fred has become, quite literally, a monument in Birmingham where he was the unblinking rock bulwarked against segregation through that city's struggle. In addition to the statue, a boulevard now bears his name.

Still, that was a cold and lonely afternoon. We were snarled at and thrown threats by men who came to and from the motel. A single reporter from Hamilton stopped by for about ten minutes. Otherwise, the press was long gone from the story. It seemed an unwelcome and thankless moment to stand on that line. "If we weren't here, we'd feel badly," Reverend McCracken reminded us. "These people don't go away by themselves. Suppose no one stood up to them?"

Was this a good earthworm's work? Were there better routes to publicize that universal, two-word truth about power: 'THEY LIE!'? If a grab for righteousness was warming me, did it recognize how frightened, alienated and dangerous, how vulnerable like a wounded animal my opposition was? Can the dying truly ever be healed or converted?

It was probably four years later that I watched Monte Sher clean his spectacles during a long silence at his study window. I'd been throwing some tantrums, and paid Monte to listen — he did very well as a therapist, I thought. He certainly did exactly what I paid him for. I was getting no positive strokes or reassurance anywhere, so I bought some in therapy. What should I do with all of this rage, these dreams of vengeance?

Does an Orthodox Earthworm dream of comeuppance? What a scare!

The lens that focuses old details can clarify a lot. By any standard, there were abundant reasons for anger. My work life was a ten course feast of persecution; I was trying to heal a personal loss like a new wi-dower; trusted friends had turned unexpectedly mean and I was due to attempt my comprehensive graduate examinations for a second, final time. So deep was my rejection of anger that I could not understand why I even carried the emotion. Sweet potato pie, who would not be seething in such circumstance?

"Look at that guy out there," Monte said. There were pines out his window. A fellow made his way through the rain across the street. "That coat isn't nearly warm enough. Is he walking around angry?" I said that I didn't know. I was so squirrelly in those days, I probably didn't. "of course he's angry," Monte continued. "He's angry, and you can't help or deny much of it. The best you can hope for is to do something with it that will make the anger smaller. Because it won't ever go away."

Earthworms are praiseworthy, but that day I started to lose my religion. Near Christmas 1990, I was again standing next to Reverend McCracken on a picket line in Southwest Ohio. The Ku Klux Klan was staging a cross raising and rally on Fountain Square in downtown Cincinnati. City council had approved a permit, and much publicity had been bandied in the Cincinnati papers and broadcast media. Our vigil was organized by Peaceworks, affiliated with the Center for Peace Education. They had painted the word "love" on signboards in dozens of languages, "to surround the hatred with love." About fifteen hooded Klansmen, under heavy police guard, shouted hatred through megaphones.

On this vigil, between two and three thousand citizens came out to affirm decency, and protest race hatred. Lately I've been thinking a lot about McCracken, the minister so central in the peace and civil rights communities in Cincinnati. His life was an exercise in the creative channeling of righteous anger. We lost Maurice near Christmas 1997, well into his nineties, cantankerous and noble to the end.

A few years ago Temple University Press published a biography of "Mac," *Building the Beloved Community*. The book is by Judy Bechtel, an English professor at Northern Kentucky University, and a fellow from Cleveland named Robert Coughlin. Activist Tim Kraus worked hard at distributing the book, and was good enough to get Mac's inscription for my copy. Mac Has been stubborn enough to outlive most of his enemies. The Presbytery booted Mac out for his war tax resistance during the frozen Fifties. They wound up reinstating his ministry in the mid-1980s. When Mac was first suspended by his church he addressed his supporters: "The noted historian, Charles A. Beard, was once asked what major lesson he had learned from history and he answered that he had learned four. They are these: 'First, whom the gods would destroy, they first make mad with power. Second, the mills of God grind slowly, yet they grind exceedingly small. Third, the bee fertilities the flower it robs. Fourth, when it is dark enough, you can see the stars.'

"We will be helped to walk the way of faith if we accept without rebellion the fact that life is a struggle and that none escapes its pain and suffering."

Mac's leadership never lacked for humor or denied the complexity of issues. It was functional and unyielding. Mac knew the anger of concentrated energy.

Too, Mac knew how to teach—he'd sit me down and instruct about his own mentor, Herbert Bigelow, in the tones of a man sharing a confi-

dence. "Bigelow is someone you have to know," he'd urge in a voice that allowed no protest. Bigelow was a precursor to Mac's profile, an activist who worked constructive change from his pulpit at the People's Church. Bigelow had fought for some of the city's first labor legislation and agitated against U.S. involvement in the First World War. When Cincinnati first installed gas lighting, Bigelow was abducted, tarred and feathered for his anti-monopolistic crusade. He survived, and wrote of the issue as an ethical turning point for the community.

"You know, I got to preach at Bigelow's funeral. You ought to find his book. He says everything about the energy utilities," Mac concluded, so I was off between stacks at Acres of Books and the Ohio Book Store until I found a 1916 copy of Bigelow's sermons, *The Religion of Revolution.* These meditations on the gospel to apply to every progressive issue were fiery, angry as abolitionist rhetoric, full of Jeremiah's thunder. Each was on target. Then to another copy, and another; it was a book that needed to feed many eyes. Bigelow seethed and instructed.

Deming's contrast to that was the anger that is murderous. How sad and cowardly was a recent personal encounter with that walking cadaver. Ostensibly, because of work to organize Martin Luther King Day activities in Tiffin, I started to receive anonymously mailed "Death to Jews!" literature through the mails. These were newsletters originally generated from Marietta, Georgia by agitator J. B. Stoner.

The good folks at the Tiffin-Seneca Public Library had acquired a sound catalogue of books on civil rights struggles, and as a persistent naysayer, Jesse B. Stoner turns out to have had some considerable destructive influence. Stoner is a fellow of my father's generation came out of Tennessee and has affiliated with Klan and Nazi networks through the South. His "Crusade Against Corruption" newsletter is one of a long line.The organization's slogans are "Race Mixing Is Corruption," and "Preserve the White Race." There are a number of references to his history in Wyn Craig Wade's 1987 book *The Fiery Cross: The Ku Klux Klan in America*, as Stoner has served as bridge figure between Nazi and Klan factions in his career.

By 1946, he was publishing letters in the *Atlanta Constitution* explaining that he supported the U.S. role in the war effort because he resented Hitler's efforts to get rid of our Jews for us. "Every nation has a right to get rid of its own Jews." Unlike the national claims of European Nazis, Stoner laid his rationale as a Christian. He was taped in a speech to

an Atlanta Klavern: "I'll never be satisfied as long as there are any Jews here or anywhere. I think that we ought to kill all Jews just to save their unborn generations from having to ho to Hell." About that time, he was getting letters off to Congress, asking for congressional resolution that Jews are "children of the devil."

In 1980, Stoner was indicted and convicted for the 1958 bombing of the Bethel Baptist Church in Birmingham—the famous instance in which four schoolgirls were killed. This was the logical outgrowth of many years of Klan activity. A number of Klaverns had thrown Stoner out because his vitriolic calls for genocide of the Jews were too much even for them. So in 1952 he formed his own affiliation, the Christian Anti-Jewish Party. In 1959 (one year after the mass murder he was later to be convicted on), he renamed the group the organization the Christian Knights of the Ku Klux Klan and proclaimed himself Imperial Wizard.

Freelancing among Klan affiliations, Stoner headed wherever trouble promised a chance for violence. After the Birmingham bombing, for example, Stoner headed for St. Augustine, Florida, where a Klan meeting he spoke at left as a mob and beat four black men senseless. At the meeting, Stoner and his buddy Connie Lynch were railing against the following of "Martin Lucifer Coon."

Subpoenaed to testify before the House Unamerican Activities Committee, Stoner was an uncoopertive witness. Through the '60's, in addition to his duties as Wizard, he also served as general counsel to the Neo-Nazi National States Rights Party in Georgia. A frequent speaker to Klan audiences in thos days, he would instruct the crowds on bomb construction. In the years leading to his conviction, Stoner was widely implicated in a bombing when he was in Atlanta on September 15, 1962. The Sixteeneth Street Baptist Church was destroyed that day.

In the 1970's, he was given some national notoriety as a guest on Tom Snyder's "Tomorrow" program, where he discussed the generation of African "mud people" and "ape people" in the United States. In 1980, he hosted a dinner to honor Klansmen Jerry Paul Smith and Coleman Pridemore. Stoner was finally under indictment for the 1958 Birmingham bombing at the time. Smith and Pridemore had just been acquitted of gunning down the anti-Klan protestors in Greensboro, North Carolina, and Smith had announced that he was going to run for Sheriff.

A recent book on the ultra-right notes that Stoner has yet to serve any prison time for his conviction. And these days, too, his following chooses my mailbox as a dropping-point for threats and rage. This indeed is the

anger that "speaks not hope but fear." Too, it's self-righteousness that gives righteousness a bad name.

One of childhood's most precious traits is the capacity to be floored by the obvious—and it was Barbara Deeming's activist gift to maintain that shock that keeps me coming back to her teaching. "Yes," she affirms in a letter, "there it is in the Bible: There could be no more revolutionary statement: 'Love your neighbor as yourself.'" "That is revolutionary," I want to tell her, "and they make it so hard."

So often, in the classroom and taking the word to the community, I pick up the many Good Books. It still has force to put King's "Knock at Midnight" sermon before students and insist, "Well, look what he wrote!" Just the other week when the new *Heartlands Today* came off the press, I read my class a poem about cooperation, for my review of William Stafford's collected poems, "You wrote a review? In a book?" The class wanted to hear it, and did, and heard about the bravery of this conscientious objector from Kansas, who endured what he did fighting the good fight through the Second World War.

I haven't lost a bit of the excitement my teachers must have felt when they pointed for me: "Look. Here it is. In a book." Those writers who forged a way in our times to see the road clear, to find the moral path were my advocates and teachers. What physically slight men were James Baldwin and William Stafford—the world's smallest giants.

How hard it was to advocate the Golden Rule as the Gulf War made raining death on little brown people our national Nintendo game! Those of us who marched against that action were being suffocated by yellow ribbons, ribbons that were often posted by good people with sheltering impulse. All of Seneca County had kin stationed in Saudi Arabia, it seemed. Can you argue with the love that says "I wear this for my brother stationed near Jedda. He's a good guy and I worry about him"? I ran a parable in the Tiffin paper. It seemed a good place for that particular anger:

"My first War of Vengeance was in 1961. At least, it's the first one I remember. My East Side neighborhood in Rochester was predominantly Irish Catholic and Jewish. The Hillel School bus let me off at the base of Pinnacle Hill, where the foster kids from the Hillside School smoked cigarettes and cursed. Dressed in the ceremonial yarmulke (skullcap) and hurrying past them, I'd hear the echo of taunts and threats on the way to the safety of home.

"Now, 1961 was still a couple of years before Vatican II. In the East Side parishes of Rochester's archdiocese, Easter vigil prayers included

a supplication for the deliverance of the perfidious Jews. This spring, the Hillside kids were particularly fired up. My presence as a bona-fide, dyed-in-the-wool Christkiller in their midst was as good a cause for warfare as any. This wasn't the last time I was ever shoved to the concrete, but it's a sensation one never gets used to. About five of the Hillside Army set to work kicking and screaming. One had a small board. My collar kept getting grabbed and I was being screamed at nose-to-nose. 'Jew Boy! Christ Killer! Sheenie!' Away from the Hollywood screen, battles and fistfights are very swift. This one was over quickly and I don't think I got any licks in at all. Counting losses: broken glasses and some bruises.

"I was hardly a model of discipline in the fifth grade. I was guilty of numerous offenses, the most regular of which was reading Western series books while Mr. Steinhardt wanted the class' attention. Still, I was fairly confident that having killed Christ was one rap on which I was innocent; Christ was this mysterious icon who held significant power in that other realm — where the tough kids hung out.

"What happened in the subsequent weeks? I could count myself a veteran of a Holy War, a battle of sacred vengeance. This gave me surprisingly little glory among my classmates. They'd either seen worse, or were fearful of me. A victim carried the curse of bad luck. The Hillside guys still smoked and cursed at the corner of Pinnacle and Crossman. They were still unhappy, angry people. Maybe they are even today— who can tell? To the best of my theological knowledge, their action did not bring Christ back to life.

"The glasses were replaced. I was reminded of their cost and implored to stop getting myself into trouble. The bruises all healed—sheer luck as war casualties go. And the issues were left unresolved. Since 1961, I still haven't seen aggression address any issue of difference effectively, or warfare bring reconciliation. However, the stakes have gotten higher. While I haven't seen warriors made happy by their battles, or their victims converted, I have seen handfuls of crises deftly negotiated.

"My dad wears a threatened expression when he describes his time as a World War Two sergeant in Europe. It's a familiar look these days. We see it worn by both supporters and opponents of the Pentagon's current expedition. A country at war puts everyone into struggle. One friend, a psychologist who has devoted years to Israeli-Palestinian reconciliation, describes how difficult it is since the bombing began to work with her Palestinian friends. Others who have been activists on the national Peace Dividend campaign are sadly counting losses.

"The first time I saw a hot war was the civil war in El Salvador. Delegated to a peace conference at the Universidad Centroamericana in 1986, I was treated splendidly by my hosts, a coalition of professors and trades unionists. The release of eleven political prisoners was attributed by several human rights organizations to the conference's public airing of issues. I tried to keep up with three of my hosts who I was particularly taken with. But within two years, one was disappeared, one killed in an office bombing, and the third assassinated by an army death squad.

"My hosts were all people devoted to serious analysis and reconciliation. Their first order of business was a negotiated cease-fire. Their program included many political intricacies; overall, it was extraordinary in its modesty. Their victimization did not resolve the causes of El Salvador's war.

"Though my dad seldom pronounces on the war when he took up arms, others are not reticent. The war against Hitler was a cause for ambivalence for Dr. King, whose teachings keep growing in stature. On his recent holiday, I was reading King's writings on war and peace. Hitler proceeded by law, and the Hungarian resistance were lawbreakers, he reminded us. That struggle was a terrible moment in history, and now we are in a more dangerous age, he continued. It is an age when the world can't afford to think in terms of waging war any longer.

"Today, a sign before the White House proclaims that 'War isn't the solution, it's the problem.' What a good lesson plan. Next visit to Rochester, I'll have to drop that one by the Hillside School." People I did not know in the community started to call and tell me how much they appreciated that story. They all recognized stories like that, had their parallel experiences to tell. Rethinking that revolutionary old Golden Rule is a universal, the one that most makes us choose our brand of anger, and what we'll do with it. Now, one and a half Clinton administrations past the Gulf War, we hear the news (refusing to be helpless in anger! activating phone trees!) as, again and again, the engines fire up and the bombers place Baghdad in their sights. "The decision to use force is never cost-free," the Arkansas Traveler announces on the eve of the House impeachment vote, adding, "God bless America."

There are moments that I feel like Meridel must have—that the shoes can wear thin from walking the angry off. There are very good reasons for the anger that changes. The next demand always comes with this nagging instruction: "Looky here, former earthworm. You got something better to do?"

Post Script:

Gerbilicious Winter

The silver maple shrugs its shoulders, undresses, leaving
its cover all over the floor, and it's getting cold out.
A firebush tries to warm it — in the newly turned field,
the three gerbils (Earl and Mister Magic and Spot)
are out for exercise and exploring the furrows.
How is it that the wet of the first frosts remembers
the spring dew? Why is it the foul dirt of weeping
joins other soils in the sweet, deep possibilities
of forgiveness, and new tracks? Earl is the most
adventurous of gerbils, tracks far smells as they move
down, down toward the pond's bed. The rest
of the congregation follows slowly. Above them,
and to the side, a naked tree. There is time
before darkness, and Earl turns, and asks, "What
shall we render unto the Lord for His goodness
to us?" The other wise gerbils look to him
(Mister Magic has a piece of root in his mouth)
and the knowing they return begs human knowledge.
They know what we would not admit to,
that the meanest of drunks are the ones drunk
with power, that the way of the wicked makes itself
outcast, that the rarest of traits are generosity
and gratitude, so rare they are the only ones
truly remembered. Truly, like the spring dew at first frost.
They know because animals do not have souls,
they are souls.

To the one side, the naked tree, perfect and still.

-David Shevin

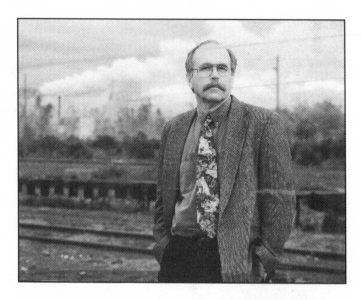

LARRY

SMITH

Larry Smith is the author of two books of prose, *Working It Out* (Ridgeway Press 1998) a novel set in post-industrial Lorain, Ohio, and *Beyond Rust* (Bottom Dog Press, 1996), stories and essays set in the Ohio Valley. His books of poetry include *Scissors, Paper, Rock* (Cleveland State University Poetry Center) and *Steel Valley: Postcard and Letters* (Pig Iron Press). In addition to teaching writing and film studies at Firelands College of Bowling Green State University, he is the director at Bottom Dog Press. With David Shevin he co-edited the collection, *Getting By: Stories of Working Lives* (1996). He has written reviews and articles and two literary biographies, *Kenneth Patchen* (Twayne) and *Lawrence Ferlinghetti: Poet-at-Large* (Southern Illinois University Press). He co-produced two docu-drama films on authors Kenneth Patchen and James Wright. Smith received a grant from the National Endowment for the Humanities and a Fulbright Fellowship to Italy. He and Mei Hui Huang have co-translated the collection *Chinese Zen Poems: What Hold Has This Mountain*? (Bottom Dog Press, 1998).

I grew up in the industrial Ohio Valley area where work was cheap and hard, and where family expended to neighborhood and town. My father worked in the steelmill as a railroader, and my mother kept our family of five going at home. In the schools I found those teachers who encouraged me and a world of learning that extended my own; I also found this at the movie matinees and at home watching late night films and talk shows with my mom and older brother.

I wrote and recited my first poems in Mrs. Merzi's seventh grade English class, had English grammar and usage drilled into my head in Mrs. Monaco's freshman class. And yet, as a product of the Sputnik pro-science era, I marched off to Muskingum College as a math major. There I discovered a world of culture and thought in the writings of Henry David Thoreau, Walt Whitman, Sherwood Anderson, James Wright, and others. I began to write my life in journals and in long letters home to my girlfriend. Like many other working-class college students, I was torn between the two worlds of academia and home, which ignored each other. I have spent twenty-five years working out this conflict while teaching others like myself at a two-year community college.

In 1970 I was a graduate student at Kent State University where I came to realize the depth of the American struggle. I find peace now in a practical Zen outlook, in the good work of others, and in spreading the words in all sorts of ways and directions. My wife Ann, who grew up a block away from me, is an inspiration for her ways of continuing to care for others. We do good work, eat good, and don't forget where we came from. My working-class roots come from fertile grounds, and I labor to reclaim them.

My Working-Class Identity:
Or How I Lost and Found It at the Movies

Larry Smith

Right off, I'm letting go of the high brow stuff here and admitting that I learned most from the movies. I grew up on them as a regular meal and became what I ate. But while I serve up this truth here, I ask you to take it with a grain of salt, for that is precisely what the movie world is—a view of life taken with grains of salt. Ever hear the expression, "You have to eat a pound of salt together before you know someone"? Well, along with the warm popcorn, I ate much salt at the movies, realizing early that their inflated and oversimplified view of reality needed salting down for its half truths. Some of that salt went onto the whole myth of working-class people that I found there, only parts of which I swallowed. Recognizing now that it's no simple thing how a social image and a personal identity are formed, I offer my account of the process.

The working-class world that I grew up in was close and pervasive. My hometown was in the industrial Ohio River Valley near Steubenville, with its roar and rush of trains, its steady traffic of coal barges beneath the dark clouds of blast furnaces and Bessemers. Everywhere around me I found the working-class culture in everyone I knew. Except for the movies and then television, it was the only class that I knew existed. Thesefolks were poor, working poor, or working class; and though some might run stores and businesses, we were all of one world—one step away from the immigrant experience, one street or hill outside the millgate, one generation away from the Great Depression. Those who pretended they were more than others, were ignored for their foolishness. I honestly can't recall people trying to cast shadows upon others, though I know that early scars caused some immigrants to labor hard to show the other "Americans" that they were "as good as anyone."

In school I found no echo of this working-class world, but read instead of Dick and Jane or Ted and Sally playing in their quiet suburbs with their happy dog Spot. This world seemed as distant as *an education*. I found my own life reflected more in the language of popular culture, where in the democratization of popular arts—film, television, music (country, blues, rock)— the working class at last had a say. For, though each of the pop arts can distort as well as reveal, undeniably they present a public

image of a working-class world. On a screen and scale larger than life they make valid a life most Americans experience. While selective in its treatment, film, in its very inclusiveness of lense and microphone, gives mass culture a form to display itself. As a kid of the 1950's escaping the noise and heat of the streets, I paid my dime at the window and walked into the cool matinee light where a world of film joined my own.

As a working-class kid, then, I saw and heard fragments of my world projected onto the big screen, and I felt somehow confirmed. There before me was the ragged family of the Joads from John Ford's *The Grapes of Wrath* (1940) hanging onto each other with humor and humble dignity, and they spoke quiet truths as in Tom's parting "I'll be there" speech to Ma. There too was Marlon Brando as Terry Malloy in Elia Kazan's *On the Waterfront* (1954) showing how much a person would take to speak the truth for another—another union of spirit. At twelve years old I watched my neighborhood butcher projected onto the big screen speaking his life through Ernest Borgnine's humble *Marty* (1955). I witnessed the simple heroism of Paul Newman's Rocky Graziano in Robert Wise's *Somebody Up There Likes Me* (1956), and while others may have pitied him, to us he was heroic—Heck, they'd made a movie of his life.

Among other things, films are great teachers of empathy. As a high school student I dug Sidney Poitier in *Blackboard Jungle* (1955) as a sly buddy with guts enough to hold his ground, and in the film adaptation of Lorraine Hansberry's *A Raisin in the Sun* (1961), I followed him into his Black home and watched the struggles and torn repentance of his life. Though most of these works were based on books, I didn't know it at the time, and when I found them later, it was like meeting an old friend. What I'd already learned in the movies were lessons in life and writing about characters and character. Oh, I also watched the *Summer Place* romance of love-struck teenagers with yachts and Corvettes—the Troy Donahue's and Sandra Dee's of Hollywood's vision of the upper class. I was, of course, drawn to their beauty, seduced by their world of fast cars, but I always went home to my own life where people worked hard for two-week vacations and struggled to pay off bank loans on their Chevy's and Fords.

It's hard to explain how the movies affected my life and later my writing of fiction and poetry because it's complex and moves in countercurrents. While movies could confirm the validity of my world, they could also deny it, and that's where you had to be ready with the salt. The movies could damage us by wounding our self-image. It did this through oversimplification—perpetuating class stereotypes of ignorance, filth, and vio-

lence—and through projecting the great myth of rising up through denial. Here was the story we watched again and again—born into a boisterous and destructive poverty, some gifted kid through hard work and luck would rise above the stink of his working-class background to enter the clean and quiet world of middle class. All working-class people knew we were supposed to be seeking escape from our world, to disappear and then rise again (by our bootstraps no less) into the great middle middle with its comfortable suburban anonymity. [Even the Black family in *A Raisin in the Sun* seeks this.] Here the working-class culture was mythologized and exploited by turning it into a plot devise, a backdrop for a hero to dismiss. The social and personal result of this sad and destructive misconception leads to the self-fulfilling prophecy of a working class population that denies its own value, a culture whose real stories are valued only around the kitchen table. A kid without any salt could accept such a view that what matters is **not** what's around him or her but what a person can achieve by successful ladder climbing to the great middle, as in the film *All the Right Moves* (1983) where Tom Cruise's character is encouraged by all, even his family, to move on through college.

Certainly when some of us made it to college, we encountered this same pattern of denial, but as I soon discovered, even this act could be depicted in film. When the adaptation of Philip Roth's *Goodbye, Columbus* came out in 1969, I had already experienced my own class conflict in college. I too had been seduced by an upper-class world of culture that didn't see fit to acknowledge my own. I too had struggled with cultural ambiguity and learned to fight for the integrity of my own family and past, something that could strengthen you if you allowed it. I remember watching television's families, first the Nelsons, then the Cleavers, later the Brady's and wondering what was so great about their white bread world of brownies and milk, when I could go out to the kitchen for a plate of leftover spaghetti and a cool bottle of Dad's Root Beer. When I finally read Roth's honest novel, I knew that I too had a story to tell.

One of the things a working-class life can teach you is to know the difference between the truth and lies, and to attack the latter directly with a heavy stick of bluntness. "Who do you think you are?" "Where do you get that crap?" "Give me a break!" My favorite expression remains the ever-concise "Bullshit!" It can awaken anyone from pretense like a Zen slap. There is the story in our family of my wife's Italian-American grandmother who used to watch the *Perry Mason* detective show on television. As we would cluster around her soft living room couches and chairs, amidst the shelves of ceramic saints, we would be watching two things: the show and

Grandma, her getting into it, cheering and jeering. "Don't listen to him. Get him! Get him!" she would shout at the set. I remember once asking her to predict the verdict and her looking down at her carpet then back at me. In a soft clear voice she declared, "It's all a bullshit, television. It's all a bullshit. Don't you know that?" Through surprise and laughter we were awakened into the real. This is the salt of the salt-of-the-earth.

While films could offer us lies to spit upon or toughen ourselves against, so too on the screen we occassionally witness what we all hope for in a film—a humanizing vision that makes all of life more tolerable and rewarding. Happily I continued to encounter films that realistically portray the working class family and neighborhood, as in the courageous beauty of ordinary people in Martin Scorsese's *Alice Doesn't Live Here Anymore* (1974), Michael Ritt's powerful characterization in *Norma Rae* (1979), Richard Pearce's endearing *The Long Walk Home* (1990), Robert Benton's enobling tale of the smalltown friendship and pride in *Nobody's Fool* (1994), or John Foley's family tale of initiation in *Two Bits* (1995), to name only a few. They all fit well what film critic Stanley Kaufmann calls "The Necessary Film":

> I suggest that the fundamental way, conscious or not, in which we determine the quality of a film is by the degree to which the re-experiencing of ourselves coincides with our pride, our shames, our hopes, our honor. . . .To the degree that film exposes a viewer to this truth of himself, in his experience of the world or of fantasy, in his options of actions or of privacy, to the degree that he can thus accept a film as worthy of himself or better than himself, to that degree a film is necessary to him; and it is that necessity, I would suggest, that ultimately sets its value. (*Figures of Light* 282)

Kaufmann is right when he goes on to advise us that our way of evaluating films has "become more and more involved with our way of evaluating experience: not identical with our standards in life but certainly related—and, one hopes, somewhat braver" (*Figures of Light* 283). We all have our list of essential films that have moved and shaped our lives; at the end of this essay I'll list some of the working-class films that have most affected my own life and work.

Surely, I still had a lot to learn about writing, but it was the movies that gave me my start and first wised me up enough to learn when the truth

came along. In a real way they were the folk literature of my life. By the time I started writing on my own outside of the college classroom, I had already seen thousands of characters, followed hundreds of story lines, watched the development or decline of relationships, heard the truth spoken beautifully and directly from human lips, felt the sweep of life through time, witnessed the selection of images and details to reveal, sensed the moments of conflict and truth. So that in high school, when I discovered Sinclair Lewis's *Main Street* along with J.D. Salinger's *Catcher in the Rye*, I had a double kick of pleasure in having my experience in life and film confirmed in writing. Wow, I thought, so there can be books like this. This was something I could do. I already knew a world that needed telling.

Later in college I found real influences close to home in Sherwood Anderson's *Winesburg, Ohio*; in James Wright's poems of Martins Ferry, Ohio; in Kenneth Patchen's poems of steel worker families around Youngstown. But, thanks to films, I was not confined to the Midwest or the working class. If I could find the universal, I could learn from anyone: from F. Scott Fitzgerald's prep school crowd in *This Side of Paradise* or his old sport Gatsby, from James Joyce's *Dubliners*, William Carlos Williams' human landscape around Patterson, New Jersey; William Faulkner's intricate mesh of families in the South, Gary Snyder's Pacific Mountain common wisdom or the *Cold Mountain* Zen poems of Han Shan. I felt at home in Toni Morrison's Lorain, Ohio, but also in Albert Camus's grainy world of the French Algiers or Michael Ondaatje's wild prose in his cinematic portrayal of life around Cairo and Italy in *The English Patient*. The world of literature was mine to eat, mine to make. And I thank the movies for this too, for teaching me to learn from the many and not be trapped or swept away by any of it. Having swallowed a pound or two of salt now, I know I remain true to my working-class family and neighbors, and take my pop's good advice to "Never forget who you are and where you came from."

Here are some of my **necessary films** and their credits. Though I have written of this elsewhere, I would clarify the character and qualities of a good working-class film as one that deals honestly with the issues and values of a working-class culture. It must recognize its strengths as well as its weaknesses, convey its struggles yet acknowledge its values in directness, hard work, ingenuity, and humor, along with its merits of fairness, cooperation, and community. Themes often include a crusade for social justice, a depiction of people as salt-of-the-earth, a presentation of social realism, a critique of big business (or institutions), depiction of and

insight into union and labor conflicts, a close study of work (its process as well as its cost and reward), an accurate portrayal of class conflict, and an honest recognition of people in their daily struggle with poverty and labor. My emphasis is on the culture of the working class. Some are good, and others great, but all reveal my world to me and open me to how I might share it:

*** Some Strong Examples of Working-Class Films ***

The Grapes of Wrath (1940; dir. John Ford; cast: Henry Fonda, Jane Darnell, John Caradine; adaptati on of John Steinbeck's 1939 novel of dustbowl Oakies headed west to promise land of California where they find American Dream gone sour)

Meet John Doe (1941; dir. Frank Capra; Gary Cooper, Barbara Stanwyck, Edward Arnold, Walter Brennan, Spring Byington, James Gleason, Gene Lockhart; subj.: Populist themes emerge out of story of man hired to launch promotion of corrupt politician)

Sullivan's Travels (1944; dir.: Preston Sturges; cast: Joel McCrea, Veronica Lake, Robert Warwick,William Demarest; subj.: Movie director looks for new content in life of down- and-out as hobo, only to discover meaning)

The Corn Is Green (1945; dir.: Irving Rapport; cast: Bette Davis, Nigel Bruce, John Dall; Wealthy Miss Moffat seeks to reform Welsh coal-mining village through a chosen miner)

The Best Years of Our Lives (1946; dir. William Wyler; cast: Dana Andrews, Harold Russell, Myrna Loy, Frederick March; subj.: returning veterans from WW II reintegrate with hometown lives, yet struggle with war wounds; won 7 Academy Awards)

Bitter Rice (1948-Italian; dir. Giuseppe De Santis; cast: Silvana Mangano, Doris Dowling, Vittorio Gassman; subj.: social realism in treating migrant rice workers in Po Valley)

The Bicycle Thief (1949-Italian; dir. Vittorio De Sica; cast: Lamberto Maggiorani, Lianella Carell, Enzo Staiola; subj.: classic realism in treating working man's life during the week his beloved and essential bicycle is stolen)

The Glass Menagerie (1950; dir.: Irving Rapper; cast: Jayne Wyman, Kirk Douglas, Gertrude Lawrence, Arthur Kennedy; subj.: Tennessee Williams play of Southern family facing emotional strain and financial decline. 1973; dir.: Anthony Harvey; cast: Katherine Hepburn, Sam Waterston, Joanna Miles, Michael Moriarty. 1987; dir. Paul Newman; cast: Joanne Woodward, John Malkovich, Karen Allen, James Naughton)

Death of a Salesman (1951; dir. Laslo Benedek; cast: Frederick Marsh, Cameron Mitchell, Mildred Dunnock; subj.: Arthur's Miller's Pulitzer Prize winning drama of middle-aged salesman facing age and business decline. 1985; dir. Volker Schlondorff; cast: Dustin Hoffman, John Malkovich, Charles Durning, Kate Reid)

The Salt of the Earth (1953; dir. Herbert Biberlman; cast: Will Geer, David Wolfe, Rosaura Revueltas; subj.: New Mexico mineworkers are abused for going on strike; strong women characters help them survive; docudrama tone; film resulted in blacklisting of Geer, Biberman, producer Paul Jarrico, and screenwriter Michael Wilson)

On the Waterfront (1954; dir. Elia Kazan; screenplay by Budd Schulberg, based on harbor labor conflicts from articles by Malcolm Johnson; cast: Marlon Brando, Karl Malden, Lee J. Cobb, Rod Steiger, Eva Marie Saint; subj.: struggle for character in a corrupt longshoreman's world, pits ex-fighter and priest against the mob takeover of union)

East of Eden (1955; dir. Elia Kazan; cast: James Dean, Julie Harris, Raymond Massey, Jo Van Fleet, Burl Ives; subj.: adaptation of John Steinbeck's novel of two brothers in rivalry for father's love in the shipping business)

Marty (1955; dir. Delbert Mann; cast: Ernest Borgnine, Betsy Blair, Joe Mantell; subj.: simple Bronx butcher finds love in neighborhood girl and Paddy Chayefsky's fine filmscript)

Somebody Up There Likes Me (1956; dir. Robert Wise; cast: Paul Newman, Piere Angeli, Everett Sloane, Eileen Heckart; subj.: film biography of boxer Rocky Graziano's career, based on Graziano's autobiography)

The Catered Affair (1956; dir.: Richard Brooks; cast: Bette Davis, Debbie Reynolds, Barry Fitzgerald, Rob Taylor; subj.: Paddy Chayefsky story of working class cabbie)

A Raisin in the Sun (1961; dir. Daniel Petrie; cast: Sidney Poitier, Claudia McNeil, Ruby Dee, Diana Sands; adaptation of Lorraine Hansberry's play treating black Chicago family as they struggle to survive; Hansberry did the screenplay.)

Alice's Restaurant (1969; dir.: Arthur Penn; cast: Arlo Guthrie, Pat Quinn, James Broderick; subj.: based on Guthrie's talking song of being arrested and inducted for littering)

Goodbye, Columbus (1969: dir. Larry Peerce; cast: Richard Benjamin, Ali McGraw, Jack Klugman; subj. adaptation of Philip Roth's novel portraying urban and suburban Jewish families)

Midnight Cowboy (1969; dir. John Schlessinger; cast: Dustin Hoffman, John Voight, Sylvia Miles; subj.: dishwashing cowboy comes to NYC to become a sexual stud, yet meets cold reality of prostitution and homelessness shared with city friend. Oscar for picture, director, screenplay; based on novel by James Leo Herlihy, was given early "X" rating)

Fat City (1972; dir.: John Huston; cast: Stacey Keach, Jeff Bridges, Susan Tyrrell, Candy Clark; adaptation of Leonard Gardener's novel about relationship between two prize fighter at beginning and end of career)

Sounder (1972; dir. Martin Ritt; cast: Cicely Tyson, Paul Winfield, Kevin Hooks, Carmen Mathews; subj.: 1930's sharecropping family saga in rural Louisianna)

Alice Doesn't Live Here Anymore (1974; dir.: Martin Scorsese; cast: Ellen Burstyn, Kris Kristofferson, Diane Ladd; subj.: single mom's quest to find herself lands her in western dinner)

One Flew Over the Cuckoo's Nest (1975; dir. Milos Forman; cast: Jack Nicholson, Louise Fletcher, William Redfield, Brad Dourif, Danny De Vito; subj.: film adaptation of Ken Kesey's novel of social misfit committed to insane asylum where he turns inmates into organized rebellion against the system)

Bound for Glory (1976; dir. Hal Ashby; Cast: David Carradine, Melinda Dillon, Randy Quaid; subj.: treats folksinger Woody Guthrie's on the road and union organizing life)

Rocky I (1976; dir. John G. Avildsen; cast: Sylvester Stallone; Burgess Meredith; Talia Shire, Burt Young; subj.: story of prize fighter who makes a comeback to the top through spirit and hard work; won Oscar for best picture, director, editing; followed by four sequels)

Harlan County, U.S.A. (1977; dir. Barbara Kopple; subj.: Academy Award winning documentary of Kentucky mine workers'strike against the Eastover Mining Company)

Coming Home (1978; dir. Hal Ashby; cast: Jon Voight, Jane Fonda, Bruce Dern; subj.: Wounded Viet Nam veteran returns home to speak the evils of the war and to begin again; reveals the big business of the military)

The Deer Hunter (1978; dir. Michael Cimino; cast: Christopher Walken, Robert DeNiro, Meryl Streep, John Savage; subj.: examines hellish worlds of Vietnam War and Ohio Valley steeltown with some depth; won Oscar for best picture)

Days of Heaven (1978; dir.: Terrence Malick; cast: Richard Gere, Brooke Adams, Sam Shepard, Linda Mantz; subj.: saga of migrant workers at turn of century—love triangle with land owner compromises their relationship; beautifully filmed in Midwest)

Breaking Away (1979; dir. Peter Yates; Cast: Dennis Christopher, Dennis Quaid, Daniel Stern; subj.: reveals rivalry and class distinctions between college students and working class "Cutters" in Bloomington, Indiana)

Norma Rae (1979; dir. Martin Ritt; cast: Sally Field, Beau Bridges, Ron Leibman, Pat Hingle, Barbara Baxley; subj.: Field plays real-life Southern textile worker who is won over to unionization by northern labor organizer, then becomes local champion; she won Oscar for this role.)

The Triangle Factory Fire Scandal (1979; dir. Mel Stuart; cast: Tom Bosley, David Dukes, Tovah Feldshuh, Lauren Frost; subj.: retelling of Triangle Shirtwaist Factory abuse and fire of March 25, 1911)

Coal Miner's Daughter (1980; dir. Michael Apted; cast: Sissy Spacek, Tommy Lee Jones, BeverlyD'Angelo, Levon Helm; subj.: life story of country singer Loretta Lynn, rise from poverty to fame and identity struggle)

Tell Me a Riddle (1980; dir. Lee Grant; cast: Lila Kedrova, Melvyn Douglas,

Brooke Adams; subj.: film adaptation of Tillie Olsen's celebrated story of working class grandparents adjusting to age, poverty, and approaching death)

Inside Moves (1980: dir.: Richard Donner; cast: John Savage, David Morse, Diana Scarwid, Harold Russell; subj.: group of misfit friends clustered around neighborhood bar struggle to stay afloat emotionally and financially.)

9 to 5 (1980; dir. Colin Higgins; cast: Jane Fonda, Lily Tomlin, Dolly Parton, Dabney Coleman; subj.: secretarial revolt against harassing boss; comedy based on a story by screenwriter Patricia Resnick)

Raging Bull (1980; dir. Martin Scorsese; cast: Robert DeNiro, Joe Pesci, Cathy Moriarity, Frank Vincent; subj.: tough life portrait of prizefighter Jake LaMotta; strong on tone and detail)

Coal Mining Women (1982; dir. Elizabeth Barret; documentary of Colorado coal miners; treats gender issues)

Diner (1982; dir. Barry Levinson; cast: Steve Guttenberg, Daniel Stern, Ricky Rourke, Kevin Bacon, Ellen Barkin, Paul Riser; subj.: 1950's group of young men who hang out at Baltimore diner)

Silkwood (1983; dir. Mike Nichols; cast: Meryl Streep, Kurt Russell, Cher, Diana Scarwid, Craig T. Nelson; subj.: Union activist, Karen Silkwood, fights for safe working conditions at atomic energy plant)

Heart of Steel (1983; dir. Donald Wrye; cast: Peter Strauss, Pamela Reed, John Doucette, John Goodman; subj.: contemporary setting in Ohio Valley, as steel mill layoffs force workers and families to struggle to get by)

Daniel (1983; dir.: Sidney Lumet; cast: Timothy Hutton, Mandy Patinkin, Lindsay Crouse, Edward Asner; subj.: adaptation of E.L. Doctorow's novel based on the children of Julius and Ethel Rosenberg...set in 1960's protest atmosphere.)

Educating Rita (1983-British; dir. Lewis Gilbert; cast: Michael Caine, Julie Walters; subj.: adaptation of Willy Russell's play about young working class wife going to university where she becomes entangled in life of boozing professor of literature)

All the Right Moves (1983; dir. Michael Chapman; cast: Tom Cruise, Craig T. Nelson, Lea Thompson; subj.: high school football player struggles to leave local steel mills future for one at college)

El Norte (1983; dir. Gregory Nava; cast: Trinidad Silva, Zaide Silvia Guterrez, Rodrigo Puebla; subj.: saga of brother and sister who come north from violent torn Guatemala. Struggle to migrate is followed by struggle to survive in El Norte, America; written and produced by Anna Thomas for the PBS American Playhouse Series)

Tender Mercies (1983; Bruce Beresford; cast: Robert Duvall, Tess Harper, Berry Buckley, Wilford Brimly, Ellen Barkin; subj. Country singer struggles to put his life together with help of young woman and her son; original screenplay won Oscar for Horton Foote)

Places in the Heart (1984; dir. Robert Benton; cast: Sally Field, Lindsay Crouse, Ed Harris Amy Madigan, Danny Glover; subj. Small Texas town in Depression 1930's where young widow struggles to survive on cotton farm; cinematographer Nestor Almendros; Benton's screenplay)

Once Upon a Time in America (1984; dir. Sergio Leone; cast: Robert DrNiro, James Woods, Elizabeth McGovern, Treat Williams, Tuesday Weld; subj.: historical intermeshing stories of Jewish youths on New York's Lower East Side as they rise to lives of love and crime as the Jewish mafia; based on Harry Grey's novel *The Hoods*)

Birdy (1984; dir.: Alan Parker; cast: Nicholas Cage, Matthew Modine; subj.: two veterans from Viet Nam recuperate, one in a mental institution with severe withdrawal with flashbacks to their working class family life in Philadelphia; based on novel by William Wharton)

Streetwise (1984; dir. Martin Bell; documentary of sad lives of street children of Seattle; a harrowing and heartbreaking study of eight main characters)

The River (1984; dir. Mark Rydell; cast: Sissy Spacek, Mel Gibsen, Scott Glenn; subj.: family struggles to work and keep farm despite threats from river; screenplay by Robert Dillon)

The Doll Maker (1984; dir. Daniel Petrie; cast: Jane Fonda, Levon Helm, Amanda Plummer; subj.:adaptation of Harriet Arnow's Appalachian saga of a Kentucky family who moves to Detroit of work during WW II.)

Country (1984; dir.: Richard Pearce; cast: Jesica Lange, Sam Shepard, Wilford Brimley; subj.: couple struggles to keep family farm from foreclosure)

Sweet Dreams (1985; dir.: Karel Reisz; cast: Jessica Lange, Ed Harris, Ann Wedgeworth; subj. film biography of country singer's struggles with relationships and career)

Alamo Bay (1985; dir. Louis Malle; cast: Ed Harris & Amy Madigan; subj: Texas Gulf Coast fishing meets migration of Vietnamese immigrants)

The Color Purple (1985; dir.: Steven Spielberg; cast: Whoppi Goldberg, Danny Glover, Margaret Avery; subj.: adaptation of Alice Walker's acclaimed novel of poor black girl who gains self-esteem and control of her life)

The Women of Summer (1986; dir. Suzanne Bauman and Rita Heller; documentary of 1920's Bryn Mawr Summer School for Women Workers in Industry as present day interviews are used to reflect back on this period of Labor Schools in America)

Gung Ho (1986; dir.: Ron Howard; cast: Michael Keaton, Gedde Watanabe, George Wendt, Mimi Rogers, John Turturro; subj.: Japanese owners reopen American auto plant in economically desperate town and find they must work together)

Native Son (1986; dir. Jerrold Freedman; cast: Carroll Baker, Matt Dillon, Victor Love [as Bigger Thomas], Elizabeth McGovern, Opra Winfrey; subj. African American young man struggles in racist 1930's Chicago. Richard Wright's novel is co-produced with PBS's for American Playhouse.)

Wall Street (1987; dir. Oliver Stone; cast: Charlie Sheen, Michael Douglas, Martin Sheen, Sean Young; young NY broker makes it big on Wall Street, only to find the cost in integrity, money and work addictions and "insider trading")

La Bamba (1987; dir.: Luis Valdez; cast: Lou Diamond Phillips, Esai Morales, Rosana De Soto; subj.: story of Mexican-American rock singer Richie Valens and his tragic death)

Business as Usual (1987-British; cast: Glenda Jackson, John Thaw, Cathy Tyson; subj.: charge of sexual harassment, Transit and General Workers Union, police brutality...)

The Business of America (1987; dirs.: Larry Adelman, Lawrence Daressa, Bruce Schmelechen; subj.: documentary of decline of U.S. steel industry through its workers)

Radio Days (1987; dir. Woody Allen; cast: Woody Allen, Julie Kavner, Diane Weist, Josh Mostel, Mia Farrow, Jeff Daniels, Danny Aiello; subj.: set in 1940's Queens working class family, the film is richin family rites and tales)

Matewan (1987; dir.: John Sayles; cast: Chris Cooper, Will Oldham, Mary McDonnell, Bob Gunton, James Earl Jones; subj.: 1920's coal mining strike in Matewan, West Virginia dramatized by John Sayles excellent filmscript and directing)

Tin Men (1987; dir. Barry Levinson; cast: Richard Dreyfuss, Danny DeVito, Barbara Hershey, John Mahoney; subj.: setting is Levinson's home grounds 1960's Baltimore, as aluminum siding salesmen hustle the home crowd)

Bull Durham (1988; dir. Richard Shelton; cast: Kevin Costner, Tim Robbins, Susan Sarandon; subj.: rough life of minor league baseball team and its fans)

High Hopes (1988 British; dir. Mike Leigh; cast: Philip Davis, Ruth Sheen, Edna Dore; subj.: working class couple from the 1970's struggle to survive on earnings as a messenger.

Dominick and Eugene (1988; dir. Robert M. Young; cast: Tom Hulce, Ray Liotta, Jamie Lee Curtis; subj.: twin brothers, one an intern, the other a retarded garbage collector, care for each other in Pittsburgh setting)

Cinema Paradiso (1988; dir. Giuseppe Tornatore; cast: Jacques Perrin, Salvatore Cascio, Mario Leonardi, Philipe Noiret; subj.: semi-autobiographical story of director Tornatore's youth as projectionist assistant in small Italian town; Academy Award for best foreign film)

The Milagro Beanfield Wars (1988; dir.: Robert Redford; cast: Ruben Blades, Richard Bradford, Sonia Braga, Melanie Griffith, John Heard; subj.: adaptation of John Nichols' novel of New Mexico struggle between landowners and rugged workers)

Mystic Pizza (1988; dir.: Donald Petrie; cast: Julia Roberts, Annabeth Gish, Lili Taylor, Vincent D'Onofrio; subj.: Trio of waitresses discover life in small town pizzeria)

Working Girl (1988; dir. Mike Nichols; cast: Harrison Ford, Melanie Griffith, Sigorney Weaver, Joan Cusack; romantic comedy about secretary with ambition, struggle with corporate business ladder)

American Dream (1989; dir. Barbara Kopple; documentary of Hormel Meat Packers' Strike in Austin, Minnesota)

Born on the Fourth of July (1989; dir. Oliver Stone; Cast: Tom Cruise, William Defoe, Caroline Kava; subj.: wounded Vietnam vet's questioning America, based on real-life saga of author Ron Kovic)

Roger and Me (1989; dir. Michael Moore; documentary/comedy. Filmmaker/ Narrator Moore tries to track down General Motors chairman Roger Smith to address closings in Flint, Michigan; lively and heavily ironic treatment in documentary style. It was followed in 1992 by Moore's 24 minute short, PETS OR MEAT: THE RETURN TO FLINT.)

Do the Right Thing (1989; dir. Spike Lee; cast: Danny Aiello, Ossie Davis, Ruby Dee, Spike Lee; subj.: tension in black and Italian community in Brooklyn)

Driving Miss Daisy (1989; dir. Bruce Beresford; cast: Morgan Freeman, Jessica Tandy, Dan Aykroyd; subj.: adaptation of Alfred Uhry's stage play about how simple black man as chauffeur and old Southern woman become deep friends.)

White Palace (1990; dir. Luis Mandoki; cast: Susan Sarandon, James Spader, Jason Alexander, Kathy Bates; subj. Young businessman becomes swept up in romance with waitress at White Palace Hamburgers, based on Glenn Savan's novel)

Avalon (1990; dir. Barry Levinson; cast: Aidan Quinn, Elizabeth Perkins, Armin Mueller-Stahl, Joan Plowright, Lou Jacobi; subj.: loose autobiography of Levinson family's coming to America,starting businesses and families in Baltimore)

To Sleep with Anger (1990; dir. Charles Burnett; cast: Paul Butler, Danny Glover, Carl Lumbly, Mary Alice; subj. African American working class family struggles with wicked visitor in Los Angeles home)

Come See the Paradise (1990; dir. Alan Parker; cast: Dennis Quaid, Tamlyn Tomita, Sab Shimono; subj: Japanese American internment in U.S. camps)

The Long Walk Home (1990; dir. Richard Pearce; cast: Sissy Spacek, Whoopi Goldberg, Dwight Schultz; narrated by Mary Steenburgen; mid-1950's racial tensions in segregated South as it affects middle class woman and her hard-working Black housekeeper.)

Life Is Sweet (1991-British; dir. Mike Leigh; cast: Alison Steadman, Jim Broadbent; subj.: bittersweet story of twin daughters in working class family--slice of life.)

Backdraft (1991; dir. Ron Howard; cast: Kurt Russell, William Baldwin, Robert De Niro, Jennifer Jason Leigh, Scott Glenn; subj.: firefighters battle flames and each other)

Frankie and Johnny (1991; dir. Gary Marshall; cast: Al Pacino, Michelle Pfieffer, Hector Elizando, Nathan Lane; subj.: romance comes into life of a small diner when ex-convict short order cook falls for waitress)

Boyz N the Hood (1991; dir. John Singleton; cast: Laurence Fishburne, Cuba Gooding, Jr., Ice Cube, Nia Lons; subj.: Black, divorced father tries to raise his son well in the midst of South Central Los Angeles; Singleton first film won much praise)

School Ties (1992; dir. Robert Mandell; cast: Brendan Fraser, Chris O'Donnell, Matt Damon; subj.: working class Jewish student wins football scholarship to prep school where he encounters anti-Semitism, set in 1950's.)

Hoffa (1992; dir. Danny DeVito; cast: Jack Nicholson, Danny DeVito, Armand Assante; subj.: film biography of Teamster leader Jimmy Hoffa based on filmscript by David Mamet)

Glengarry Glen Ross (1992; dir. James Foley; cast: Al Pacino, Jack Lemon, Alec Baldwin, Ed Harris; subj.: adaptation of David Mamet's drama of desperate real estate salesmen)

Mac (1992; dir. John Turturro; cast: John Turturro, Michael Badalucco, Carl Caputto, Ellen Barkin, John Amos; subj.: three brothers run father's consruction company in mid-1950's Queens area amidst personal turmoil)

Untamed Heart (1993; dir. Tony Bill; cast: Marisa Tomei, Christian Slater, Rosie Perez, Kyle Stone; subj.: in diner setting busboy with heart ailment falls in love with waitress)

Benny and June (1993; dir. Jeremiah Chechik; cast: Johnny Depp, Mary Stuart Masterson, Aidan Quinn, Julianne Moore; subj.: auto mechanic and mentally ill younger sister meet misfit Buster Keaton youth and romance)

A Bronx Tale (1993; dir. Robert De Niro; cast: Robert De Niro, Chazz Palminteri, Joe Pesci, Lillo Brancato, Francis Capra; subj.: slice of life in , Italian-American working class Bronx 1968 as hard working father struggles to keep son away from Mafia, from a play by Palminteri)

Lost in Yonkers (1993; dir.: Martha Coolidge: cast: Mercedes Ruehl, Richard Dreyfuss, Irene Worth, David Strathairn, Brad Stoll; struggling scrap salesman during WW II leaves his two sons with tough old grandmother in and simple-minded sister in Yonkers; adaptation of Neil Simon play)

This Boy's Life (1993; dir. Michael Caton-Jones; cast: Robert De Niro, Ellen Barkin, Leonardo Di Caprio; subj.: based on unsettled life story of novelist Tobias Wolff as he and mother search for a good man)

What's Eating Gilbert Grape (1993; dir. Lasse Hallstrom; cast: Johnny Depp, Juliette Lewis, Leonardo DiCaprio, Mary Steenburgen; youth struggles to keep his family going by working things out with retarded brother and obese mother)

Nobody's Fool (1994; dir.: Robert Benton; cast: Paul Newman, Jessica Tandy, Bruce Willis, Melanie Griffith; subj: Newman plays tired older man working construction job in small New England town, hanging out with cro-

nies and trying to relate to son and grandson; based on Richard Russo's novel)

The Postman/Il Postino (1994; France-Italy; dir. Michael Radford; cast: Massimo Troisi, Philippe Noiret;subj.: friendship of Italian postman and famed Chilean poet Pablo Neruda

Hoop Dreams (1994; dir. Steve James; documentary of two African American high schoolers who face the manipulative world of a sports career in basketball)

The Burning Season (1994; dir. John Frnkenheimer; Cast: Edward James Olmos, Luis Guzman, Kamala Dawson; subj.: rubber tappers union struggles in Brazil)

Crooklyn (1994; dir. Spike Lee; cast: Alfred Woodard, Delroy Lindo, Zelda Harris; subj.: an African American family struggles to get by on meager salaries of father as musician and mother as teacher, nostalgic portrait of Lee's family in 1970's seen through sister's eyes)

My Family/ Mi Famiglia (1995; dir. Gregory Nava; cast: Jimmy Smits, Esai Morales, Edward James Olmos; subj.: a Mexican American faily's sago of coming to and surviving in Los Angeles)

Mr. Holland's Opus (1995; dir. Stephen Herek; cast: Richard Dreyfuss, Glenne Headly, Jay Thomas, Olympia Dukakis; subj.: Musician-composer resorts to teaching high school music and finds he loves it)

Two Bits (1995; dir. James Foley; cast: Jerry Barrone, Mary Elizabeth Mastrantonio, Al Pacino; subj. nostalgic reliving of working class family and youth in South Philadelphia) during the Depression; screenplay by producer Joseph Stefano)

Roommates (1995; dir. Peter Yates; cast: Peter Falk, D.B. Sweeney, Julianne Moore; subj.: Polish immigrant baker living in Pittsburgh raises grandson who becomes a doctor; based on co-screenwriter Max Apple's life)

Harlem Diary (1995; dir. Jonathan Stack; documentary drama of nine Harlem youth who chronicle their life stories trying to survive in the projects; produced for Discovery Channel, but show in theaters as well)

Beautiful Girls (1996; dir. Ted Demme; cast: Matt Dillon, Timothy Hutton, Noah Emmerich, Natalie Portman, Annbeth Gish, Uma Thurman, Lauren Holly, Rosie O'Donnell, Uma Thurman; subj. young working class man returns to Massachusetts for class reunion and confrontations between beautiful girls and lost guys)

A Family Thing (1996; dir. Richard Pearce; cast: Robert Duvall, James Earl Jones, Irma P. Hall; subj.: tractor salesman Duvall traces bloodline to policeman Black brother in Chicago)

The Big Night (1996; dir. Stanley Tucci and Campbell Scott; cast: Stanley Tucci, Tony Shalhoub, Isabella Rossellini; subj.: tale of two Italian-American brothers in Long Island and their struggle to keep their little authentic restaurant and lives afloat)

Spitfire Grill (1996; dir. Lee David Zlotoff ; cast: Alison Elliott, Ellen Burstyn, Will Patton; subj.: young woman comes from prison to small town in Maine to begin life again working in local diner; screenplay by Zlotoff)

Sling Blade (1996; dir. Billy Bob Thornton; cast: Billy Bob Thornton, Dwight Yoakam, J.T. Walsh; subj. retarded adult man, Karl Childers, struggels in a small Southern town; surprise low budgeted, independent film nominated for 1996 Oscar as Best Film)

Hidden in America (1996; dir. Martin Bell; cast: Beau Bridges, Bruce Davison, Shelton Dane, Jena Malone; displaced autoworker and family struggle to get by after wife dies, sharp and poignant depiction of hidden poverty in America)

Fargo (1996; dir. Joel Coen; cast: Frances McDormand, William H. Macy, Steve Buscemi; subj.: murder and kidnap plot involving woman police detective and car salesman, set in Fargo, North Dakota; script by Joel and Ethan Coen)

Brassed Off (1996-British; dir. Mark Herman; cast; Pete Postlethwaite, Tara Fitzgerald, Ewan McGregor, Stephen Tompkinson; subj.: Colliery workers and families face closing of mines with victory of their brassed band and defiance of Conservative government)

Secrets and Lies (1996-British; dir. Mike Leigh; cast: Brenda Blethyn, Marianne Jean-Baptiste, Timothy Spall, Claire Rushrook; slice of life of working class family dealing with young Black woman's discovery of her white mother.)

The Full Monty (1997-British; dir. Peter Cattaneo; cast: Robert Carlyle, Tom Wilkinson, Mark Addy, Paul Barber, Steve Huison; subj.: unlikely bunch of out of work steel laborers decide to reverse their fortune by performing as male strippers in local club)

Ulee's Gold (1997; dir. Vincent Nune; cast: Peter Fonda, Patricia Richardson, Jessica Biel, Christine Dunford; subj.: beekeeper father brings dysfunctional family together through struggles.)

Good Will Hunting (1997; dir. Gus Van Sant; cast: Robin Williams, Matt Damon, Ben Affleck, Minnie Driver; subj.: Rough Boston youth with genius for math shows up MIT academics, wins girl, and gains confidence with counselor; written by Damon and Affleck who received writing Oscars.)

See Also: Tom Zaniello. *Working Stiffs, Union Maids, Reds, and Riffraff: An Organized Guide to Films About Labor.* (Ithaca, NY: Cornell University Press, 1996).

Steven J. Ross. *Working-Class Hollywood: Silent Film and the Shaping of Class in America.* (Princeton, N.J.: Princeton University Press, 1998).

Carey Nelson. *Repression and Recovery: Modern American Poetry and the Politics of Memory.* (University of Wisconsin Press, 1989).